To: Jeff,

Best Wishes!

THE
ESSENTIAL

OTHER HUMOR BOOKS BY ISLANDPORT PRESS

Not Too Awful Bad
by Leon Thompson

A Flatlander's Guide to Maine and *Adventures in Vacationland*
by Mark Scott Ricketts

Headin' for the Rhubarb and *Live Free and Eat Pie!*
by Rebecca Rule

Finding Your Inner Moose
by Susan Poulin

Bert and I . . . The Book
by Marshall Dodge and Robert Bryan

THE
ESSENTIAL

GEORGE DANBY

ISLANDPORT PRESS

ISLANDPORT PRESS

P.O. Box 10
Yarmouth, Maine 04096
www.islandportpress.com
books@islandportpress.com

Printed in the USA.
First Islandport Edition, October 2014

ISBN: 978-1-939017-07-9
Library of Congress Card Number: 2013922647

Publisher: Dean L. Lunt
Book jacket design by Karen F. Hoots / Hoots Design
Interior book design by Teresa Lagrange / Islandport Press
Original cover illustration by George Danby

ACKNOWLEDGMENTS

George Danby would like to thank:

Richard J. Warren, V. Paul Reynolds, Mark Woodward, Wayne Reilly, Stewart Jackson, Bruce Reynolds, Lee Grabar, Dan Namowitz, Todd Benoit, Susan Young, Tom Groening, Erin Rhoda, and Matt Stone.

Dedicated to Nick and Sarah

FOREWORD

"*I'm going to make a long speech because I've not had the time to prepare a short one.*"

—*Winston Churchill*

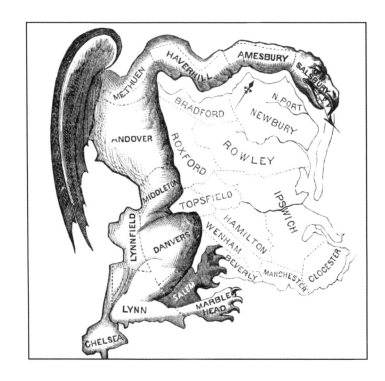

Imagine that you are assigned to describe a complicated public policy issue, along with something about the personalities and politics of the players involved. Now imagine that you must do this in only 500 words. How about 200 words? Or, how about a half-dozen words (and include some humor, please), and by the way, I want it by tonight.

Such is the life of the editorial cartoonist—part graphic artist (who must draw by hand, if you can imagine such a thing), part political philosopher, part psychologist, part humorist, and, mostly, keen observer. What an amazing skill and unusual set of talents to find in one person.

Throughout history, and especially throughout American history, political cartoons have amused, enlightened, and, in the case of the targets thereof, often enraged. I'm convinced that the art form has survived and prospered even into our day of iPhones and the Internet because it taps into one of the most basic (and often overlooked) human characteristics: We are all, to one degree or another, visual learners. A picture can literally be worth a thousand (or more) words because it bypasses our rational language-processing apparatus and goes straight to someplace more emotional, and often more powerful.

There is no better example of this than a cartoon that appeared in the *Boston Gazette* in March of 1812, above, which aptly captured the political effect of Governor Elbridge Gerry's attempt to design voting districts to favor his political party and minimize the voting power of his opponents. From this ingenious cartoon was born an unforgettable image which captured the essence of the political act—and gave us a term still in wide use today. (Unfortunately, both the term and the practice are still in wide use, which is one of the real problems of modern American politics, but that's another subject.)

Every morning of my young life, I was served a generous portion of political cartooning from one of the real masters of the art, Herblock (Herbert L. Block) of the *Washington Post*. I haven't the slightest doubt that my political views were strongly influenced (some would say, warped) by Herblock's merciless images of Richard

Nixon with hooded eyes, dark stubble, and generally evil demeanor. I still remember specific cartoons, like the one of Nixon accepting a torch—actually, it was a tarry brush—from Joseph McCarthy. Often, Herblock captured the issue of the day more memorably than any story, and he did so with practically no words and just a few simple sketches.

And so it is with George Danby. Now, one might jump to the conclusion that as an active Maine politician, I readily agreed to write a glowing foreword for this collection of George's work in hopes of avoiding his sharp pen at some point in the future—and one would be right. But he really is good. More than good, I would argue, in spite of my obvious bias.

George has an uncanny knack, essential to the cartoonist's art, of getting to the essence of the matter in a way that's memorable, accurate, and usually funny (if being the butt of a joke published in the state's largest daily newspaper is your idea of funny). A perfect example of this, and one of my favorites, was probably one of the simplest cartoons George ever drew. Published early in my first term as governor, all there is to the drawing is a little box in the middle of the white cartoon space with the word ANGUS in it, with the title "Governor King's Organizational Chart." In a few strokes, he captured my alleged tendency to micromanage and try to be involved in everything. Not in the least accurate, you understand, but pretty funny.

George has been entertaining and enlightening us for almost forty years with insight, humor, and integrity. In my view, he's one of the best in the country, and we're lucky that most of those forty years have been spent in Maine.

As you leaf through this wonderful collection, I guarantee that you'll laugh, enjoy memories of battles past, recognize old friends, and, in the case of folks like me, occasionally wince. But after all, that's the point. It's all good.

Thanks, George.
— US Senator Angus King, June 2014

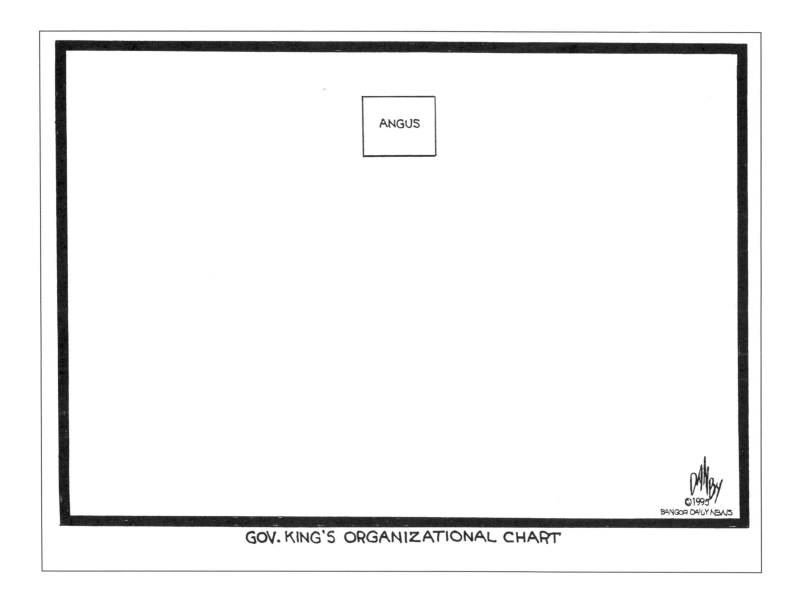

ANGUS

GOV. KING'S ORGANIZATIONAL CHART

©1995
BANGOR DAILY NEWS

3

INTRODUCTION

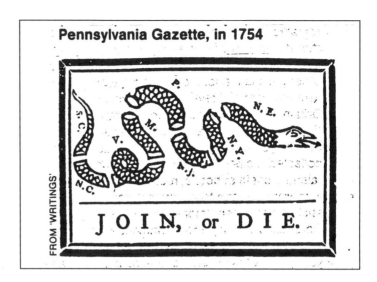

In 1754 the *Pennsylvania Gazette* published a cartoon entitled "Join or Die." The cartoon was created by Ben Franklin. This began a revolution, of such, in newspapers, proclaiming to be the first editorial cartoon.

In the late 1800s, Australian-born American cartoonist and caricaturist Joseph Keppler greatly influenced the growth of satirical cartooning in America, as did German-born American cartoonist Thomas Nast, "the father of the American cartoon." By the early 1900s editorial cartoons had become a staple of editorial pages in many daily newspapers. I am happy to be a part of that revolution. This revolution also included a truly American art form: the newspaper comic strip.

As we entered the twenty-first century, however, comic strips and editorial cartoons began to fall victim to low newspaper circulation and smaller newsprint size. Both forms of art are waning in America today. That makes me a newspaper dinosaur, but a proud one.

Next to late-night talk show monologues and SNL, editorial cartoonists have the only other platform for timely, next-day satire on all current events. That is amazing! I am also part of that rare breed of newspaper person who still uses pen and ink. Surrounded by computers, computer graphics, and clip art, I get to create something original, on a daily basis, by dipping a pen quill into a bottle of ink and scratching it onto a Bristol-board surface to create my daily cartoon. Ben Franklin would be proud!

With the daily reactions from many, many readers—who look at my cartoons in print, online, on Facebook and Twitter—I don't feel like a dinosaur at all. I feel like a vibrant part of the daily output of the newspaper world. And with the growing interest in graphic novels, I don't believe cartoons are waning in popularity at all; they are just becoming popular in other formats, as well.

I created the first set of cartoons in this book in the 1970s. They show the love I have for this fast-paced art, producing work on a deadline, every day. My job is one of not only artist, but also writer, director, and producer. These drawings show the progression of my work, from my first cartoon, published while attending high school, to my first nationally syndicated cartoons.

The drawings from the 1980s show the work I created while working for the *New Haven Register* and the *Providence Journal-Bulletin*, along with syndication work for the *New York Times*, the *New York Daily News,* the *Washington Post* (national weekly edition), *USA Today, Time* magazine, the *National Review,* many dailies, and five hundred weeklies.

The remaining cartoons begin in the early 1990s, as I settled into my role as staff editorial cartoonist for the *Bangor Daily News*, to the present day. All of my drawings deal with issues on a local, state, national, and international scale. I hope you enjoy this visual history. Now, I need to go wash my inky hands!

THE
1970s

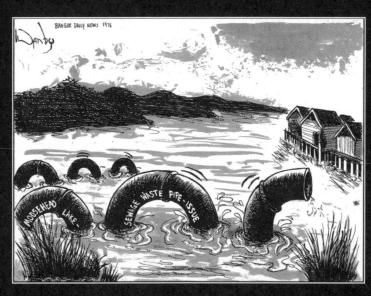

BANGOR DAILY NEWS 1976

MOOSEHEAD LAKE

SEWAGE WASTE PIPE ISSUE

1970s

Desks arranged haphazardly in an open office space. A haze of cigarette smoke looms in the air. The rhythmic click-clack of typewriters overpower the conversations between stressed-out coworkers trying to make daily deadlines.

I was just a teenager when I found myself in the middle of a newsroom fueled by coffee and cigarettes. The staff, writers and editors alike, was driven to break headline news, unveil the latest scandal, and report a heartwarming hometown story for tomorrow's newspaper. I found myself at the center of it all.

At the naive age of sixteen, I published my first editorial cartoon in the *Providence Journal-Bulletin*. The light, uneasy lines are the reflection of a young cartoonist's work. By the time I published my first editorial cartoon in the *Bangor Daily News*, the lines created by my pen strokes were bolder, more confident.

I struggled initially to keep up with the fast pace and pressure of daily deadlines. However, the 1970s were a gold mine of inspiration. I missed my opportunity to draw President Richard Nixon, as he had already resigned in the wake of the Watergate scandal. I made up for it with my first presidential caricature of Gerald Ford, who took over presidency declaring, "I assume the presidency under extraordinary circumstances… This is an hour of history that troubles our minds and hurts our hearts." He ultimately presided over the worst economy since the Great Depression of the 1920s.

Equal rights were a pressing topic in the country. Title IX was enacted as a measure to end gender discrimination in the academic arena. The court ruling of *Roe v. Wade* legalized abortion across the country, February was established as Black History Month, and African Americans worked to carry on the message of Dr. Martin Luther King Jr. in the wake of his 1968 assassination.

Presidents of the decade (and decades to come) struggled with foreign policy. Ford worked toward peace between Egypt and Israel and developed new limitations on nuclear weapons with Soviet leader Leonid Brezhnev. President Jimmy Carter took office in 1977 aiming to uphold human rights. The 1978 Camp David agreement brought amity between Egypt and Israel, but did not mark an end to unrest in the Middle East.

By the 1970s, many Americans had read or heard of Rachel Carson's 1962 book *Silent Spring*. Local government became concerned with sewage contamination, littering, disposal of toxic waste, and smog, and vehicles deemed "gas guzzlers" started to fill news headlines.

James Longley was elected Maine's first independent governor. The man was often criticized for inflation and increased taxation. I had a knack for drawing Longley's face, which landed a gig with the editorial department of the *Bangor Daily News*. Longley wasn't a big fan of the press, but he became fond of my caricatures of him. He wrote me letters of thanks and praise, signing off with a smiley face—the extent of Longley's drawing ability.

I was still easing into the routine of daily deadlines. My style was beginning to form, including a carefully drawn signature on each image that became more of a scribble over the years.

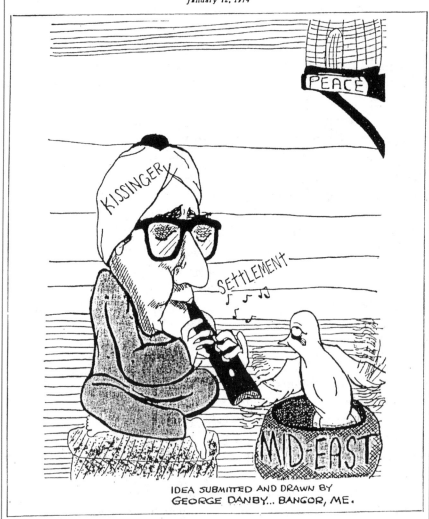

Editorial

Providence Journal-Bulletin

January 12, 1974

PEACE

KISSINGER

SETTLEMENT

MID-EAST

IDEA SUBMITTED AND DRAWN BY
GEORGE DANBY... BANGOR, ME.

My first published cartoon, at age sixteen. The *Providence Journal-Bulletin* editorial cartoonist, John Fawcett, asked readers to send in ideas for his Saturday cartoon. I sent him ideas and drawings. He liked what he saw and my cartoon career began.

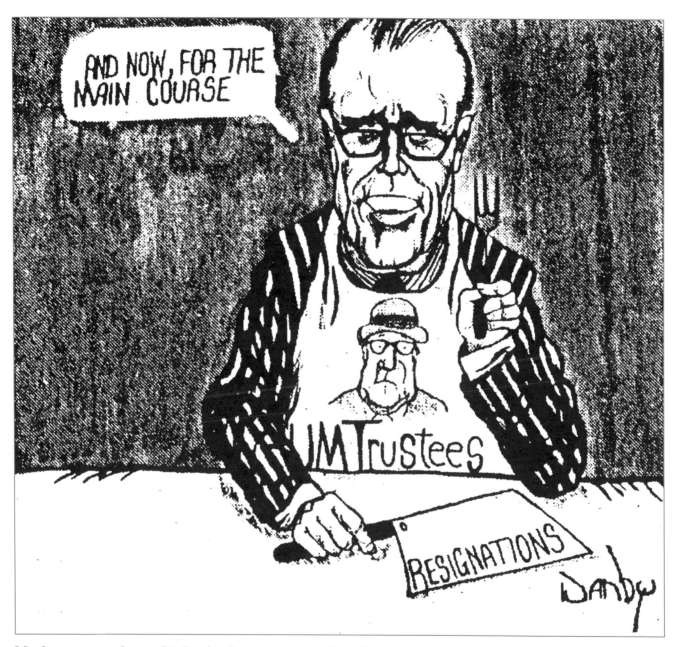

My first cartoon for my high school newspaper and my first caricature of Governor James Longley.

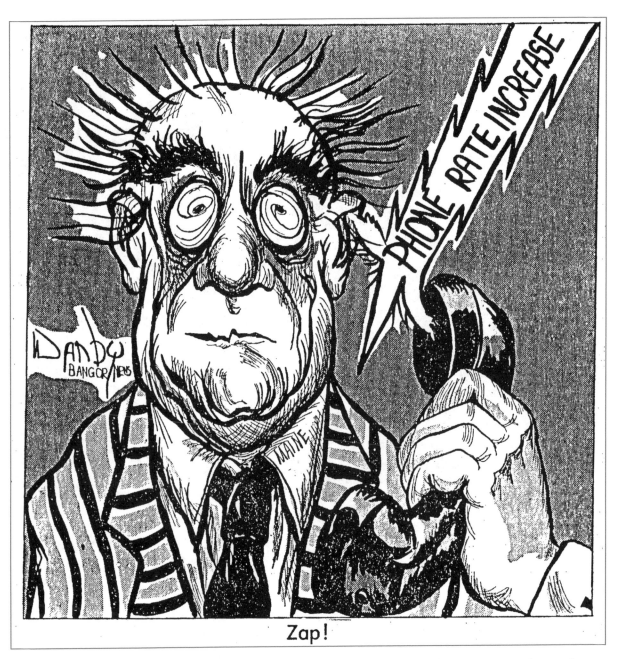

Zap!

My first cartoon published in the *Bangor Daily News*. Notice how the signature changed over the years.

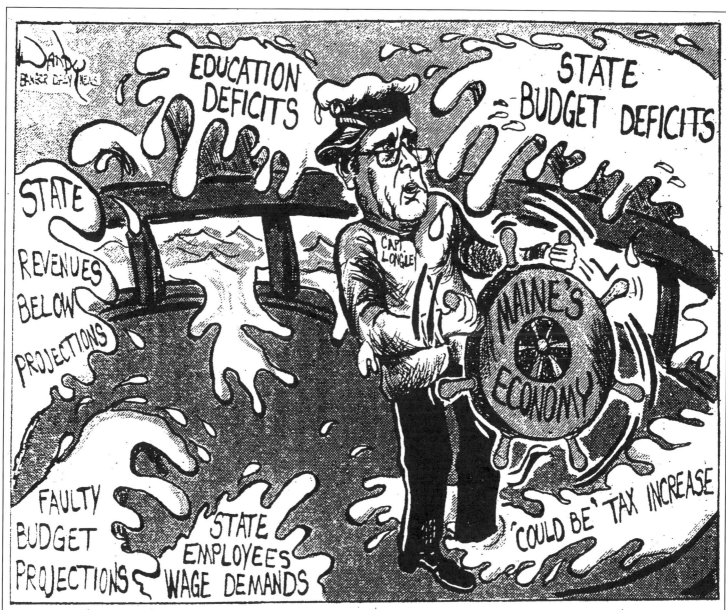

"Don't get alarmed, I've got control of everything!"

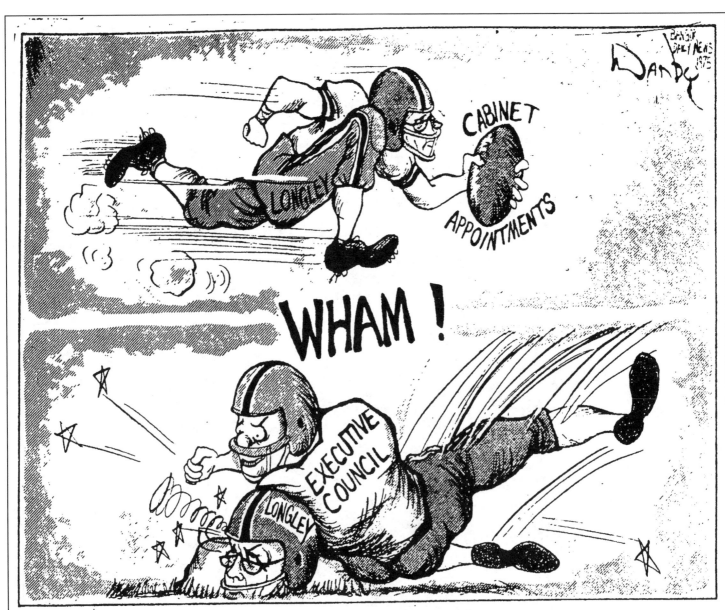

Not gaining much yardage

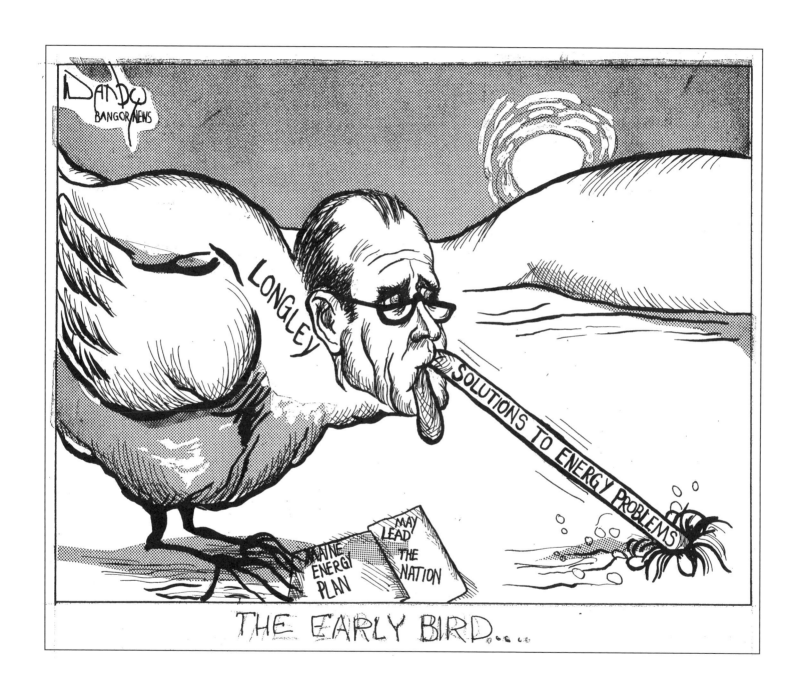

THE EARLY BIRD...

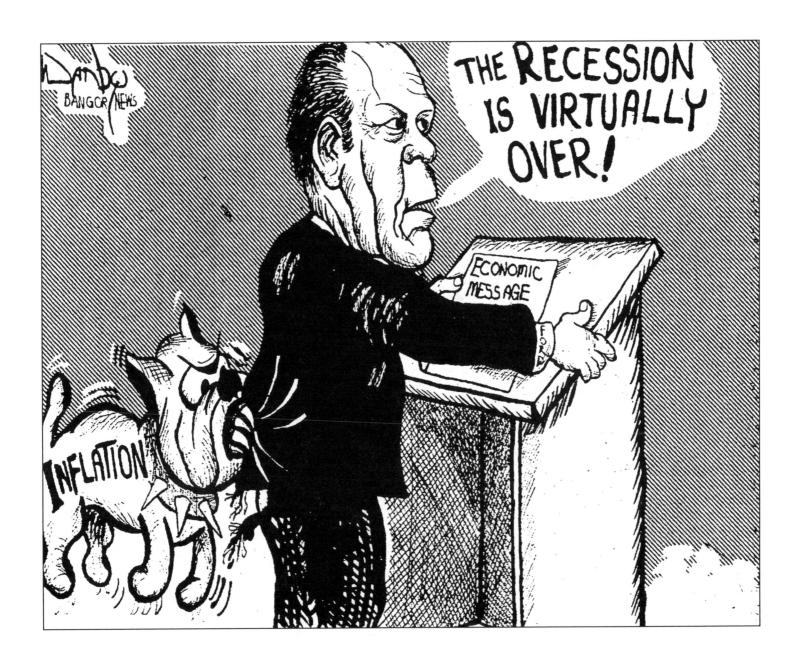

14

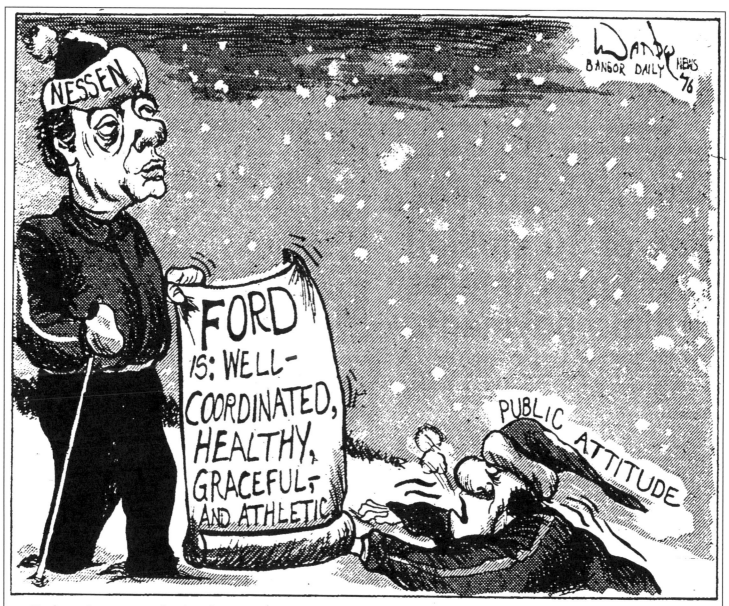

"That's wonderful . . . now how does he stand on the issues?"

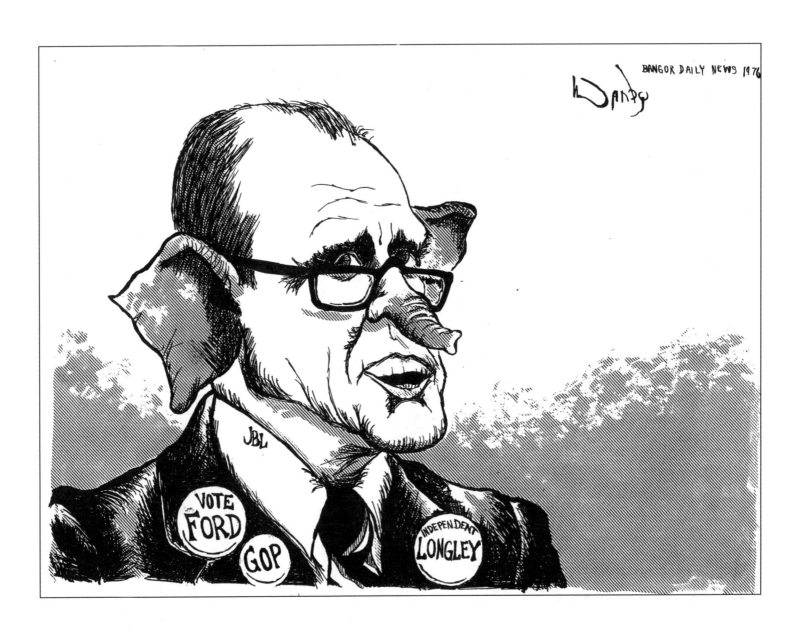

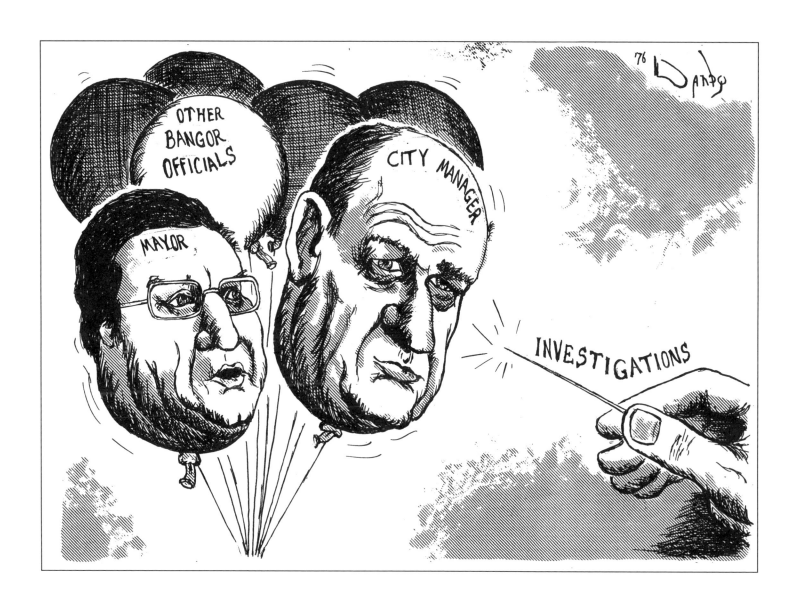

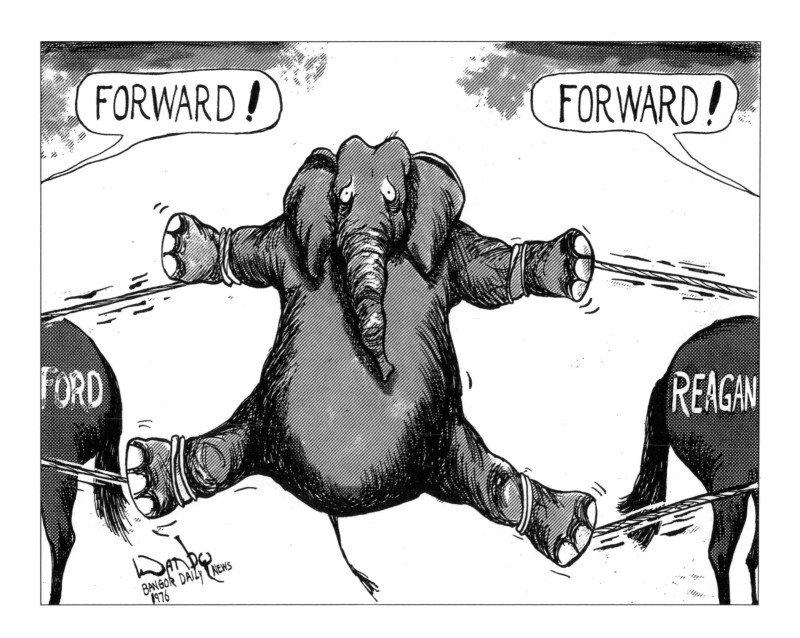

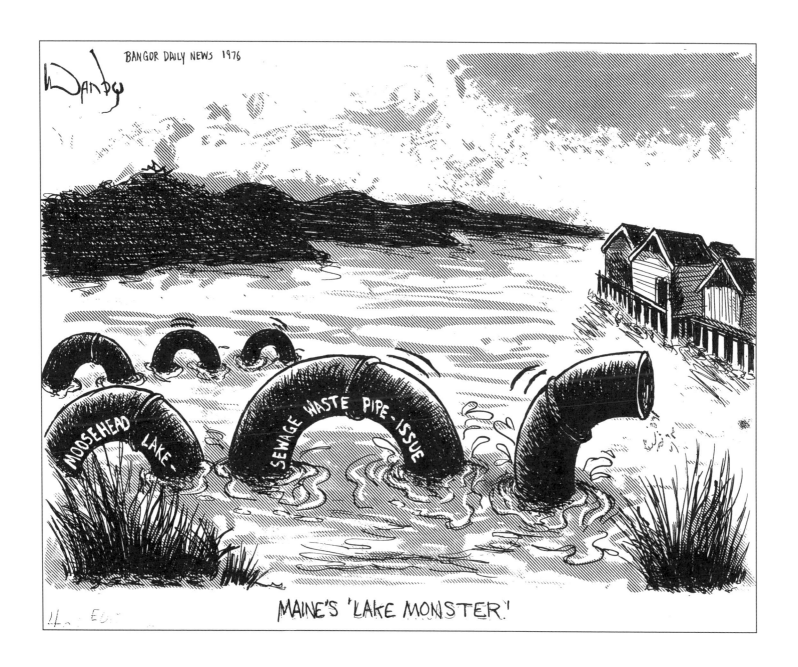

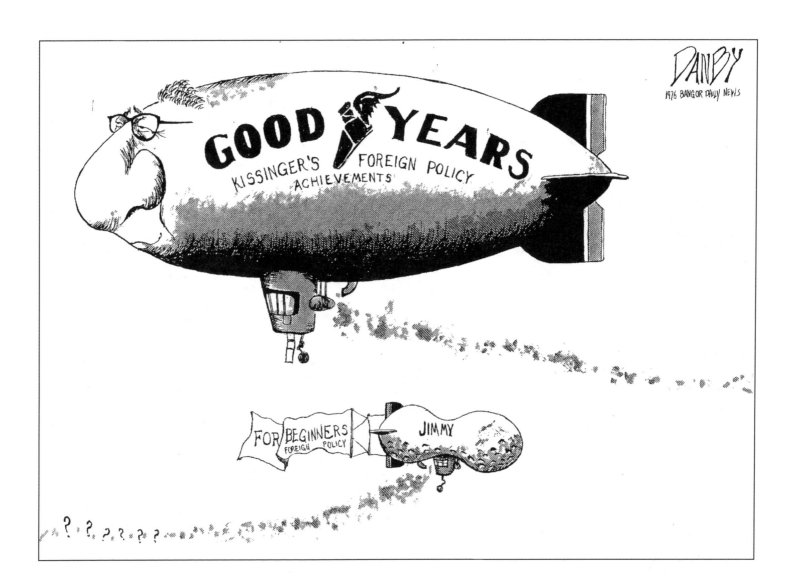

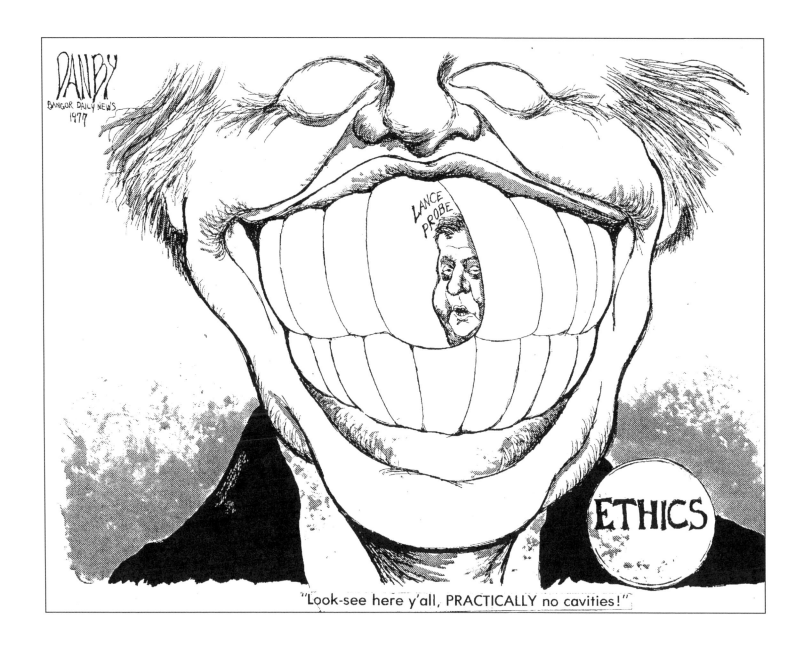

"Look-see here y'all, PRACTICALLY no cavities!"

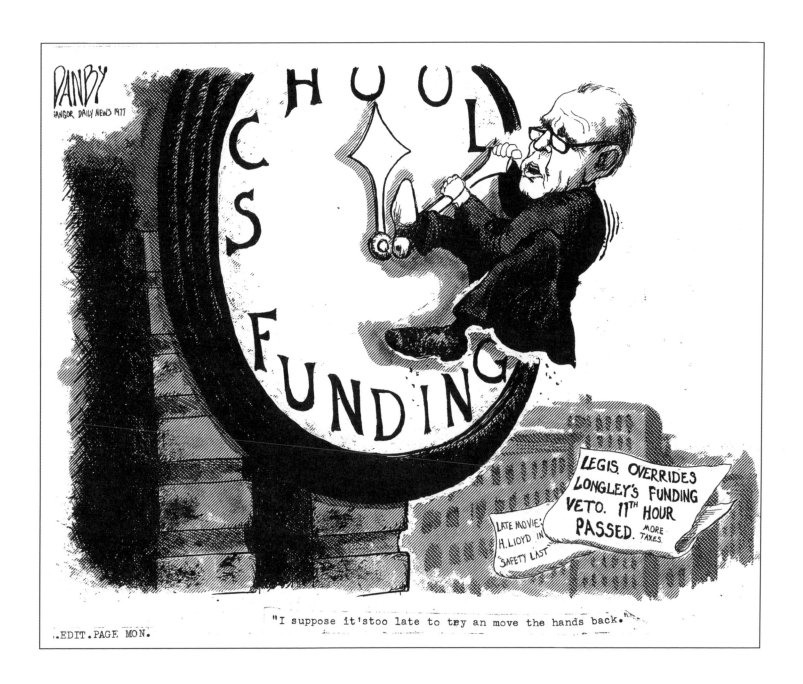

"I suppose it's too late to try an move the hands back."

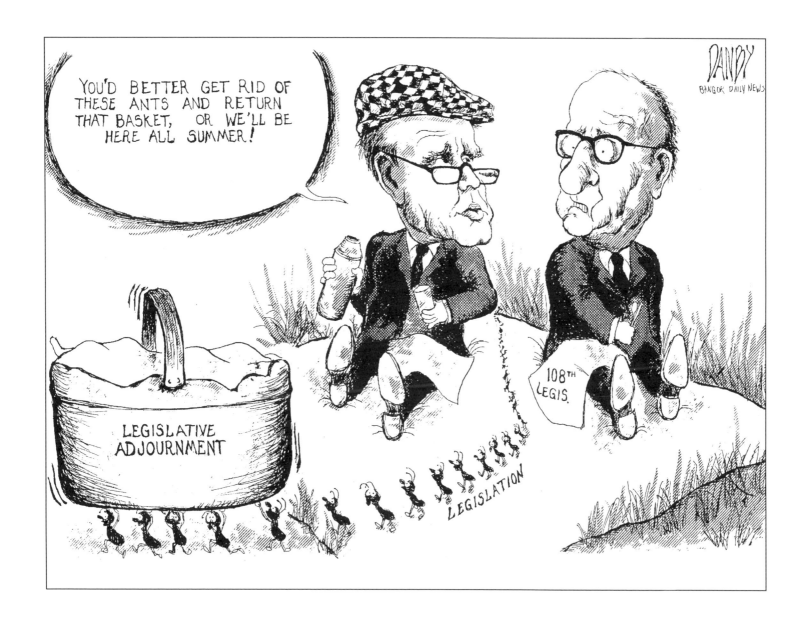

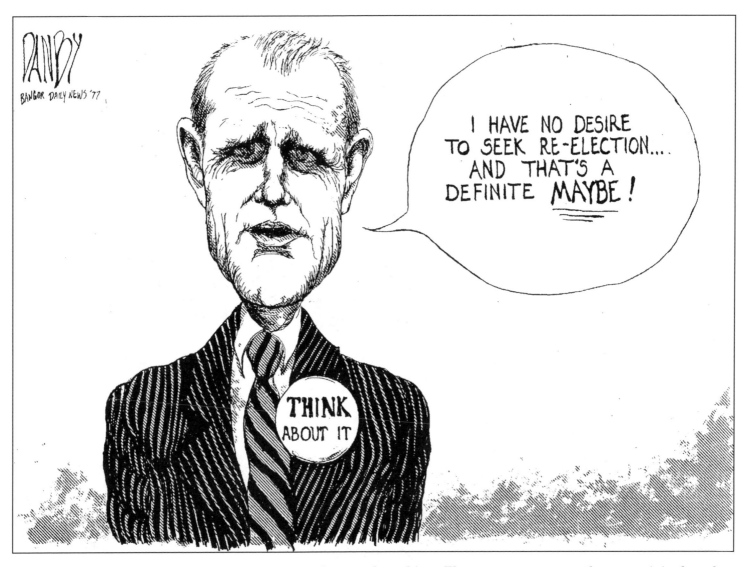

Governor James Longley enjoyed cartoons where he was the subject. The governor requested many original works, always replying with a very complimentary letter and a "happy face," suggesting that was the extent of his drawing talent.

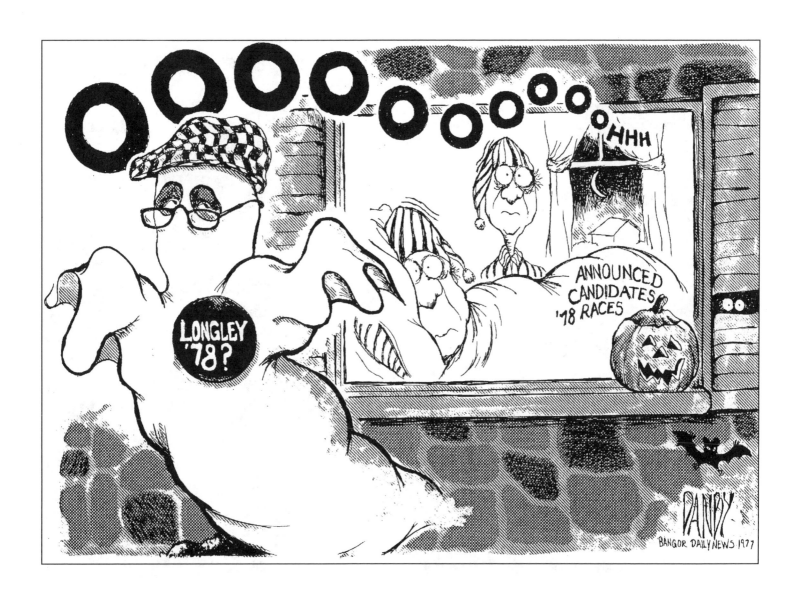

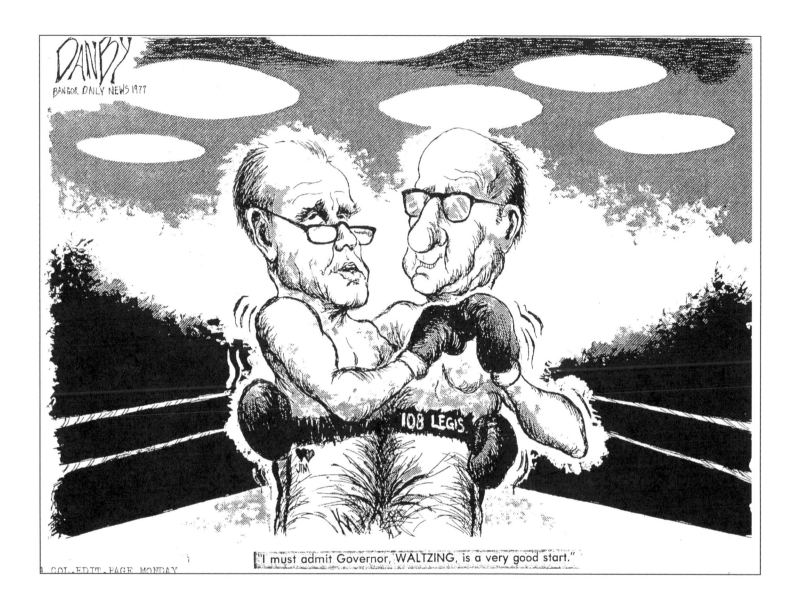

"I must admit Governor, WALTZING, is a very good start."

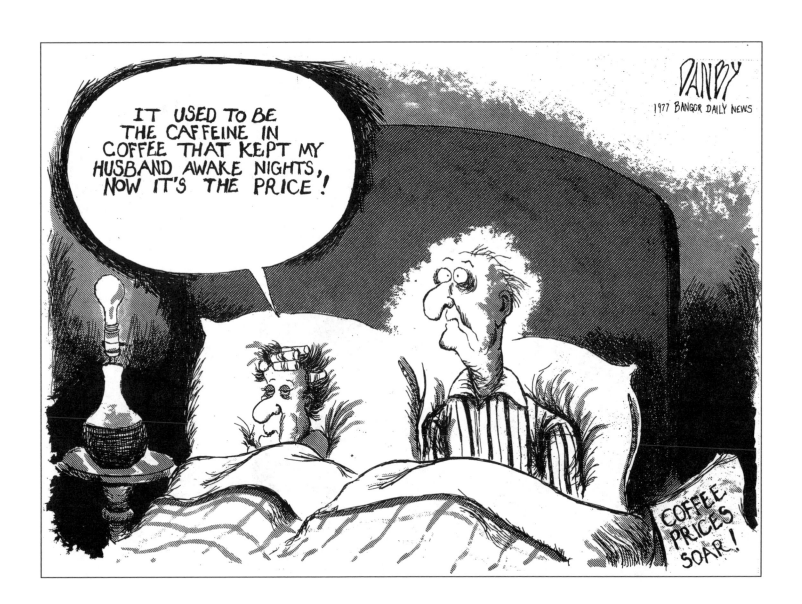

28

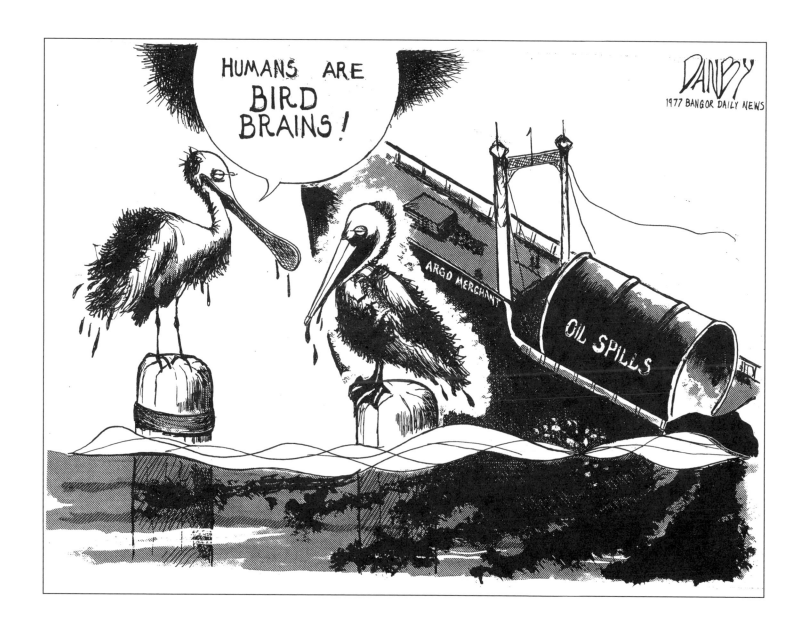

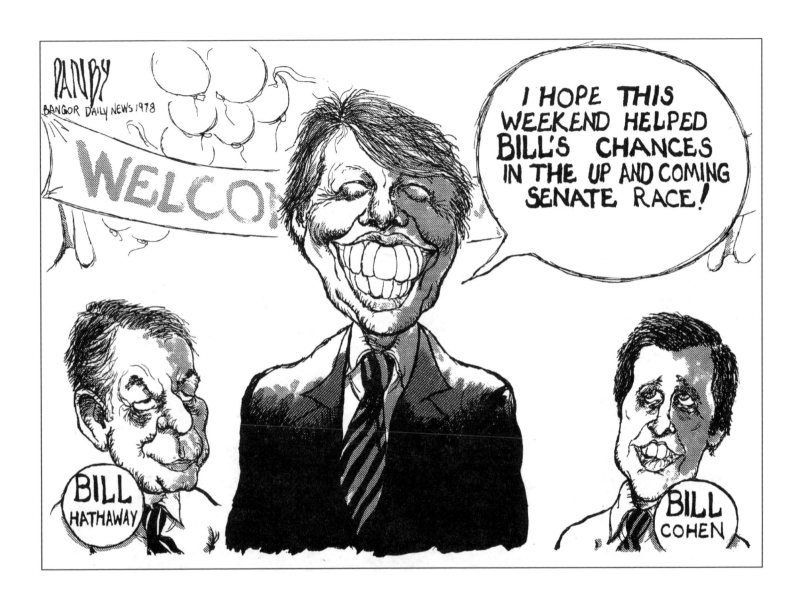

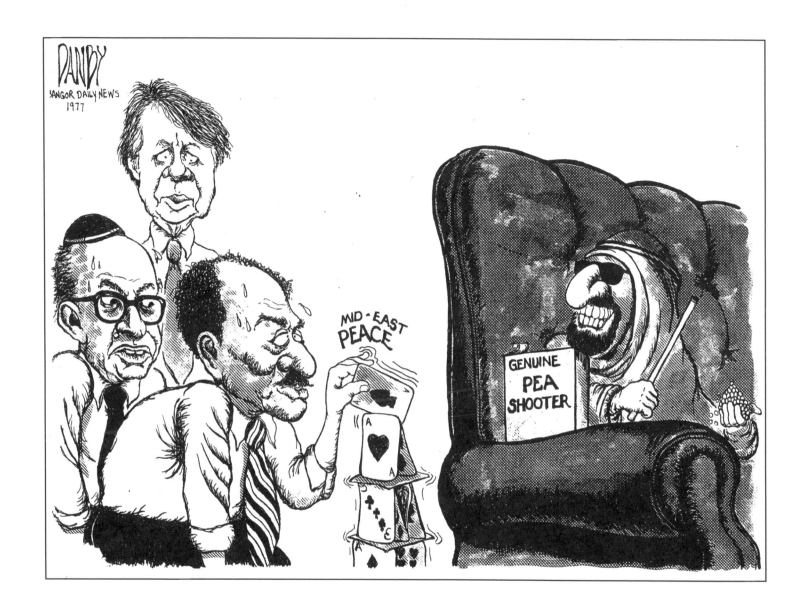

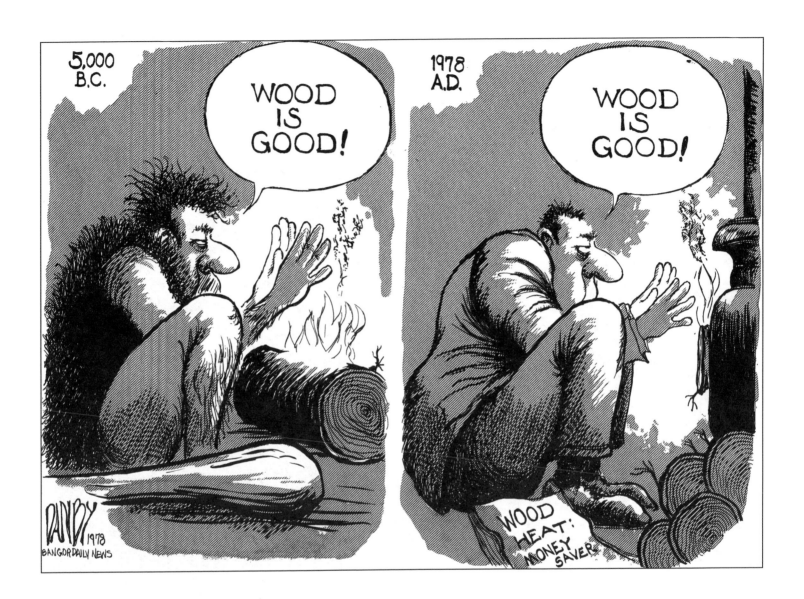

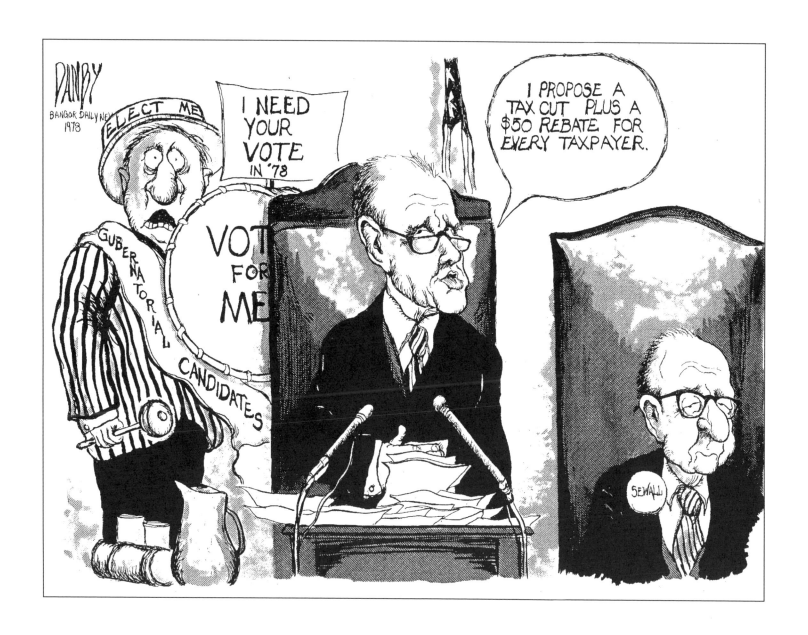

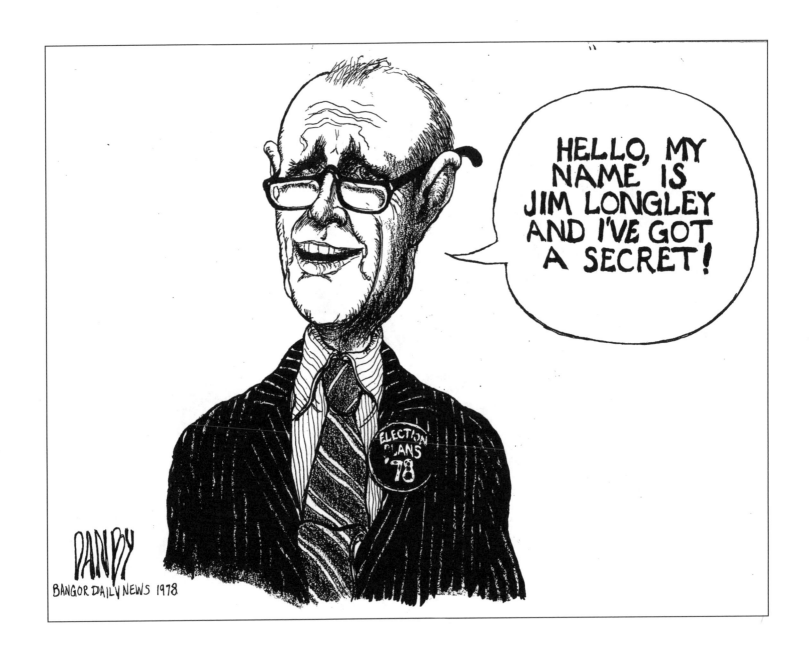

34

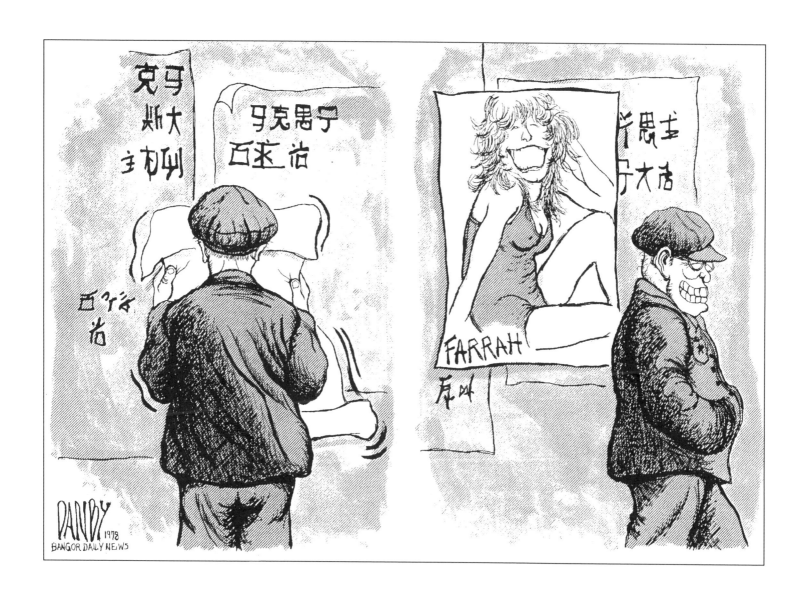

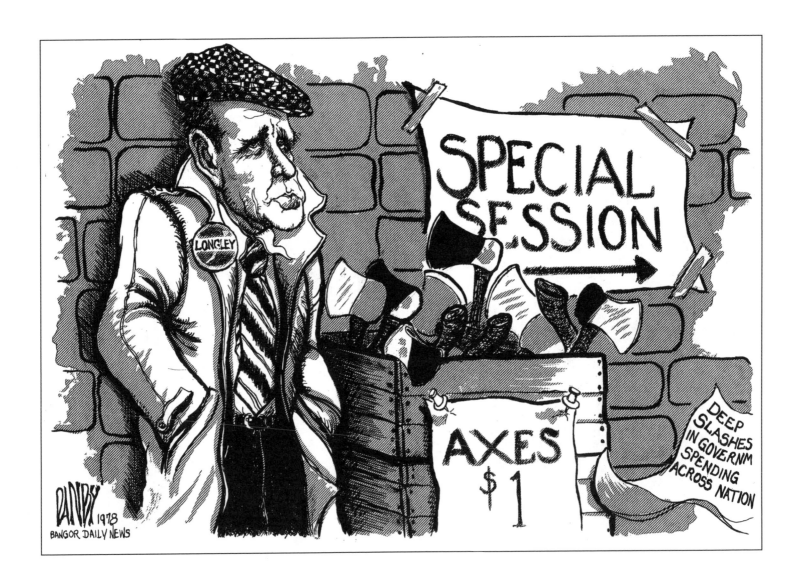

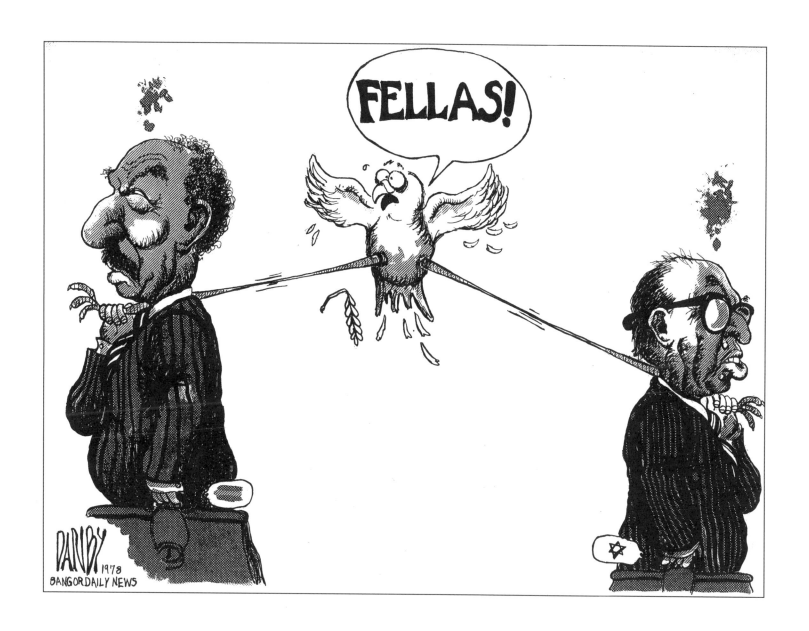

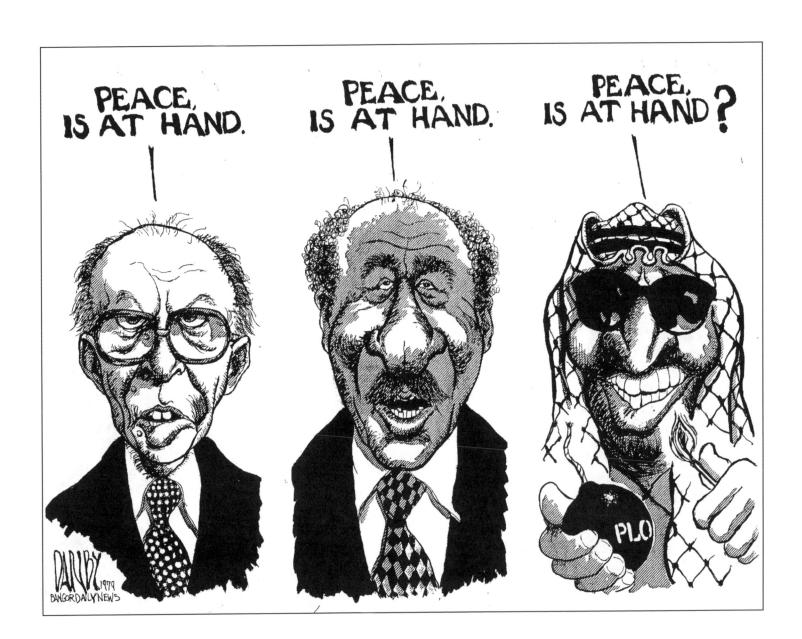

38

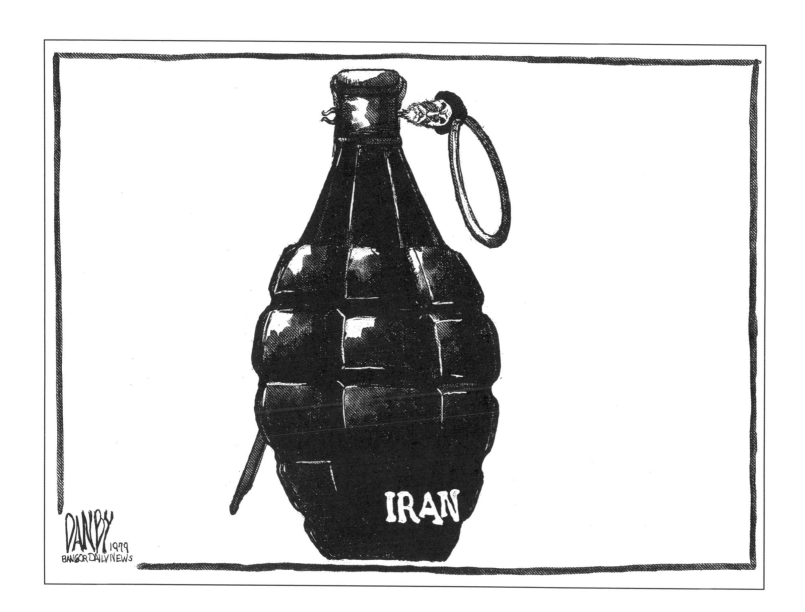

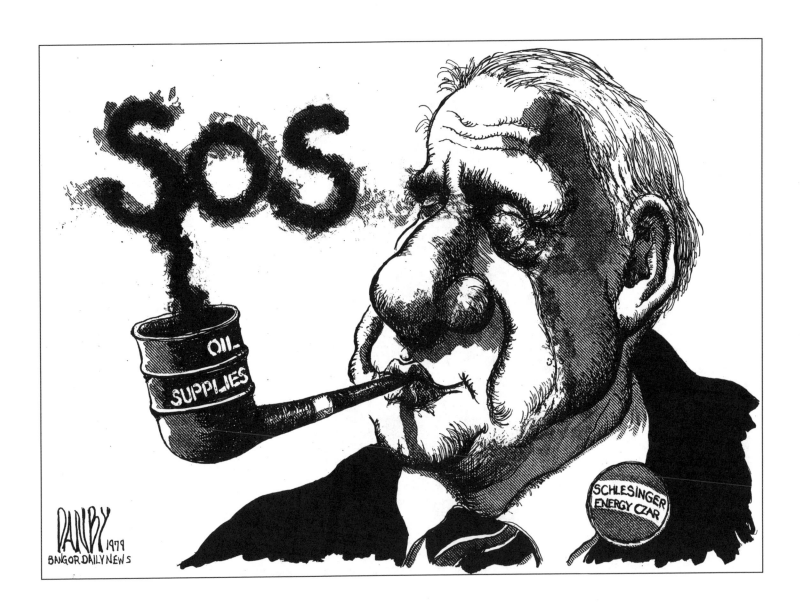

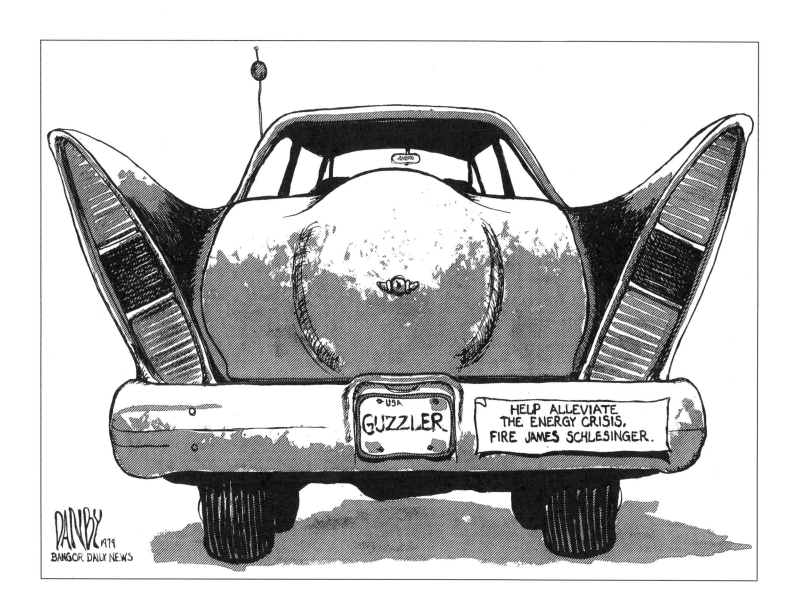

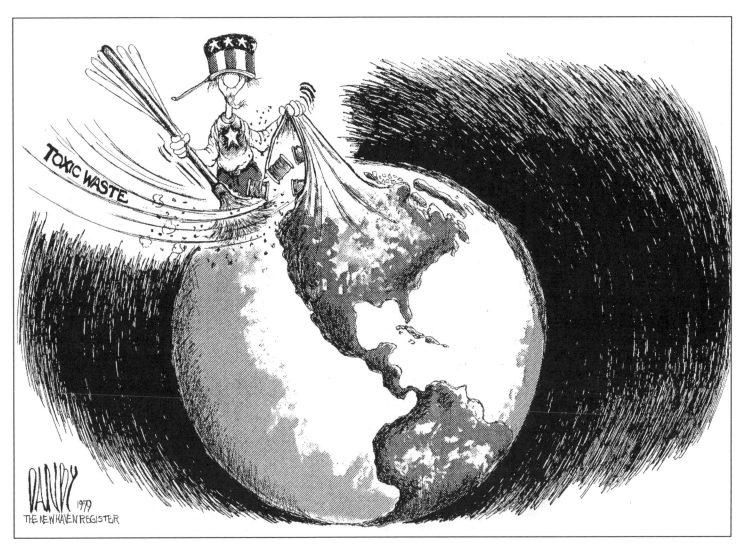

My first cartoon as staff editorial cartoonist for the *New Haven* (Conn.) *Register*, early 1979.

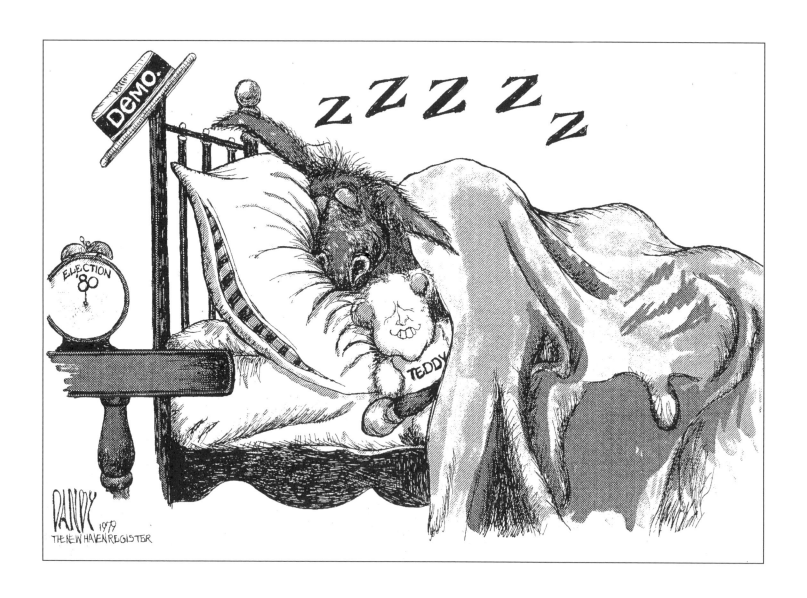

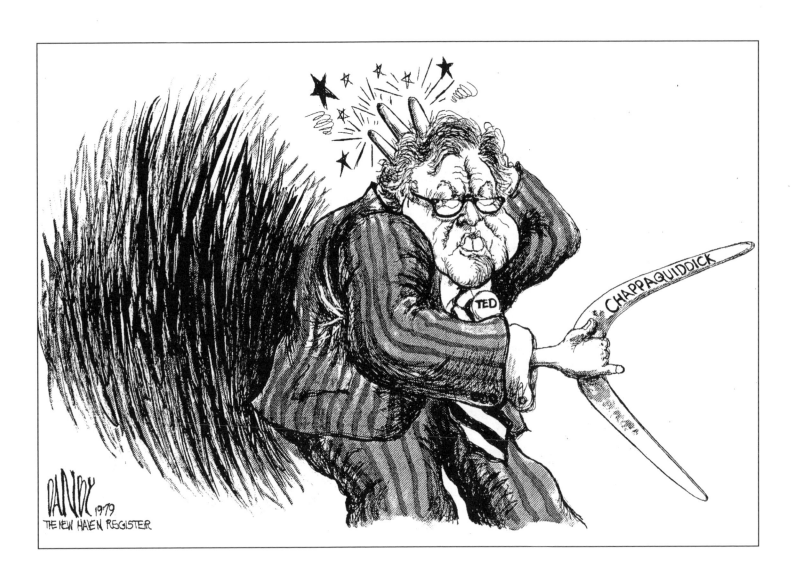

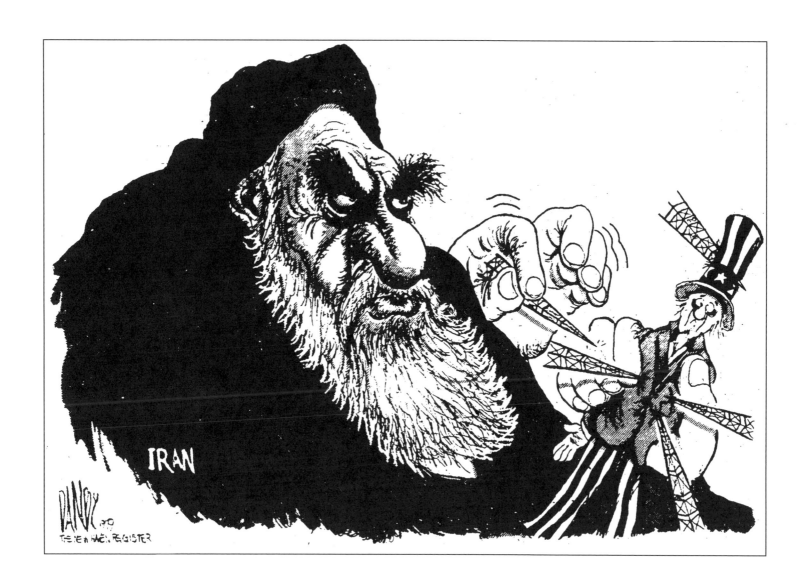

IRAN

THE
1980s

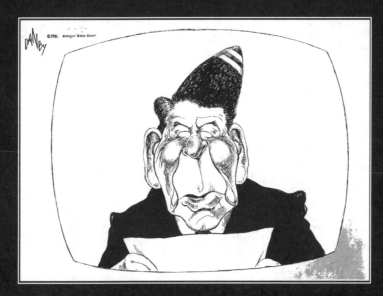

1980s

Bell-bottomed pants were out and big hair, neon, oversized shoulder pads, jelly shoes, and parachute pants were in. Music videos on MTV became all the rage, while Madonna, Michael Jackson, MC Hammer, Whitney Houston, and New Kids on the Block ruled the radio. The decade brought good and bad in pop culture trends, as well as in politics, economics, foreign policy, and public health.

I was making a mark for myself in the world of editorial cartooning. McNaught Syndicate picked me up, distributing my work across the country. My cartoons were being published not only in the *New Haven Register,* the *Providence-Journal Bulletin,* and the *Bangor Daily News*, but also *Time* magazine, *National Review, New York Daily News,* and *Fortune* magazine, to name a few. Interior Secretary James Watt, news anchor Sam Donaldson, *60 Minutes* producer Don Hewitt, George H. W. Bush, and Donald Rumsfeld were some of the few who sent requests for original artwork from me.

It was still early in my career when, in 1981, the Centers for Disease Control and Prevention began identifying strange cases of a pneumonia-like disease; this disease wasn't named HIV until 1986.

The technology boom was just starting to rumble; IBM launched the first personal computer, coining the acronym "PC." Women were embracing gender equality and celebrating momentous occasions. Sally Ride became the first American woman to launch into space. Science started to play a role in criminal investigations; the first conviction based on DNA evidence came in 1987.

After Carter's stint in the White House, President Ronald Reagan was elected and served two terms, from 1981 to 1989. Reagan aimed to curb inflation and spur economic growth through increased employment and tax cuts. He led the country during the longest period of peacetime and prosperity it had experienced thus far.

It became an era of oversight, though, when the FBI targeted thirty-one political officials during a sting operation dubbed ABSCAM. Six US representatives and one US senator were convicted for corruption, bribery, and theft. The large sting operation not only heightened awareness among politicians that they were being watched, but also inspired the movie *American Hustle*.

As Americans were grumbling about consistently rising prices and increasing taxes, my colleague Mark Woodward and I created a "clip and mail" taxpayer survey. The cartoon survey was clipped and returned by more than 3,000 readers. Woodward and I later dumped the contents of the tax survey on the desk of then governor John McKernan.

Being a cartoonist is a unique trade. I have to capture a story in one rather small box when writers have columns of words to explain a situation. Talking shop with other cartoonists, such as *Doonesbury* creator Garry Trudeau, *Hagar the Horrible* creator Dik Browne, as well as Robert Osborn and Herbert Block, helped me learn more about the trade. By the time I returned to the *Bangor Daily News*, I had really hit my stride in communicating with my audience.

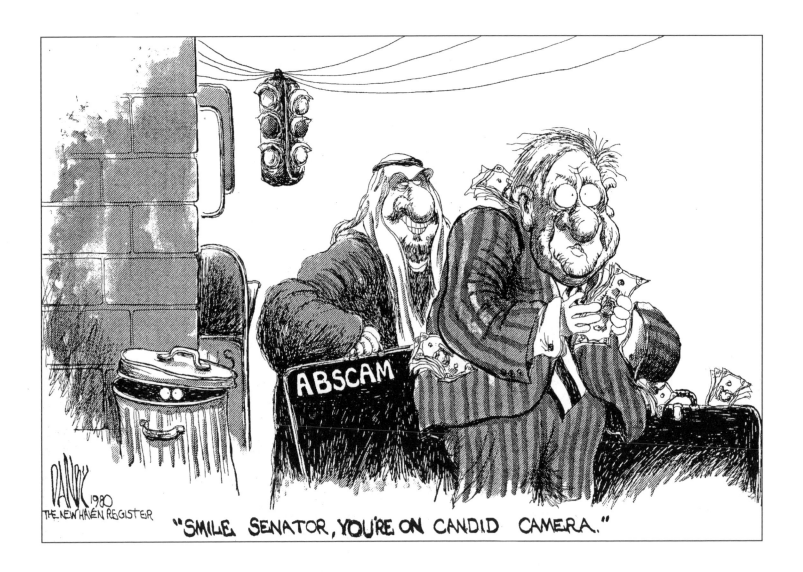

"SMILE, SENATOR, YOU'RE ON CANDID CAMERA."

48

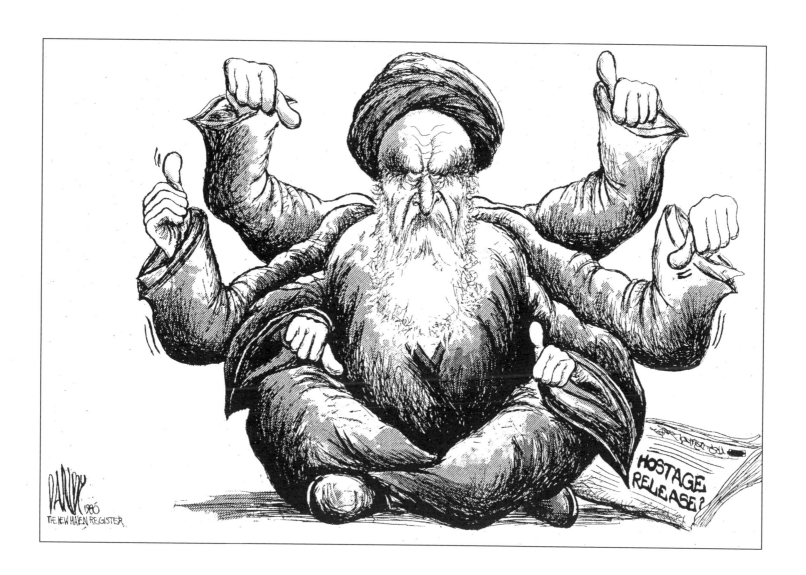

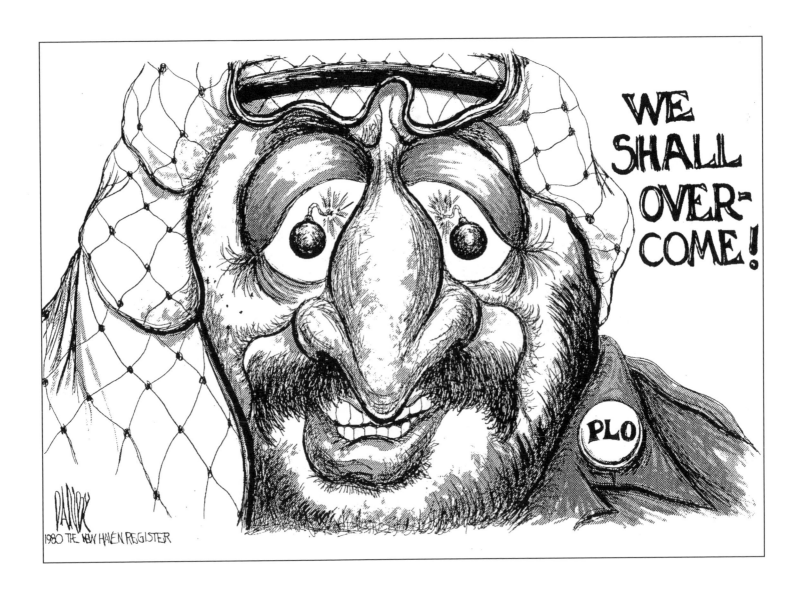

WE
SHALL
OVER=
COME!

PLO

DAROX
1980 THE NEW HAVEN REGISTER

50

BILLYGATE:

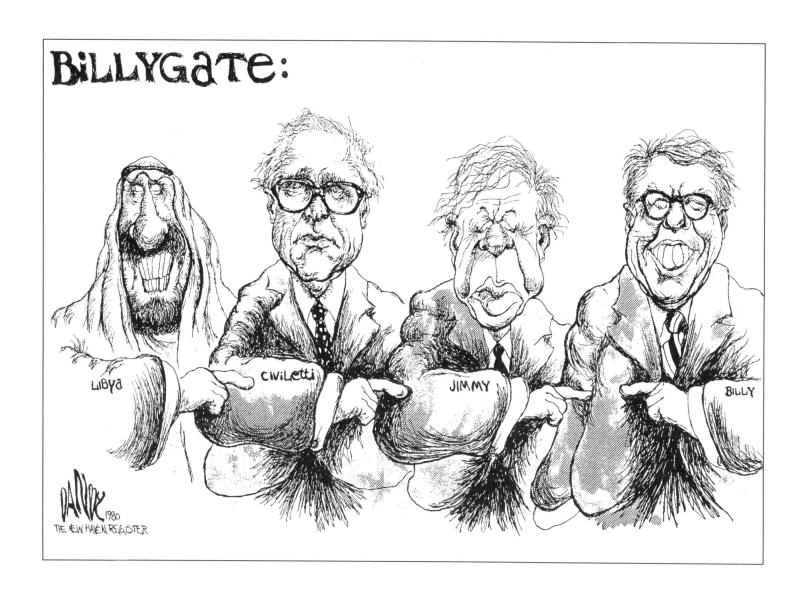

LiBya CiViLetti JIMMY BILLY

DANOK
1980
THE NEW HAVEN REGISTER

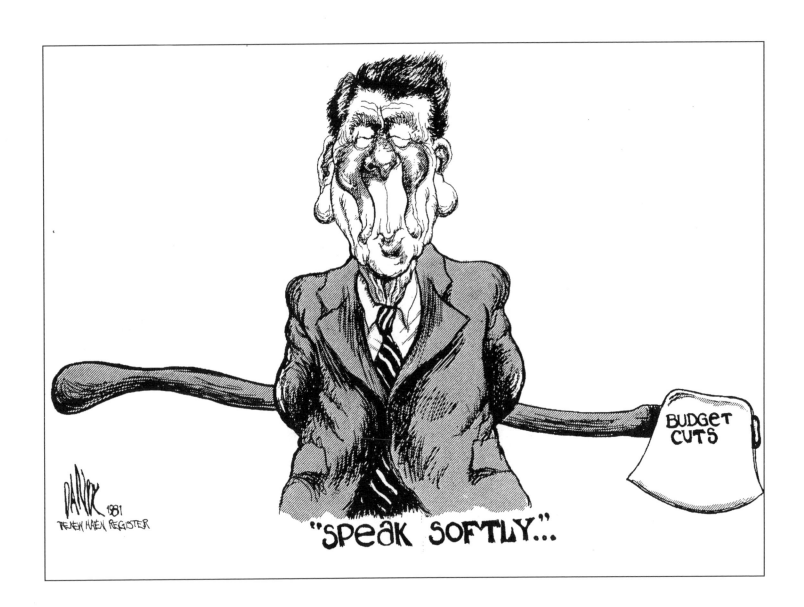

"SPEAK SOFTLY..."

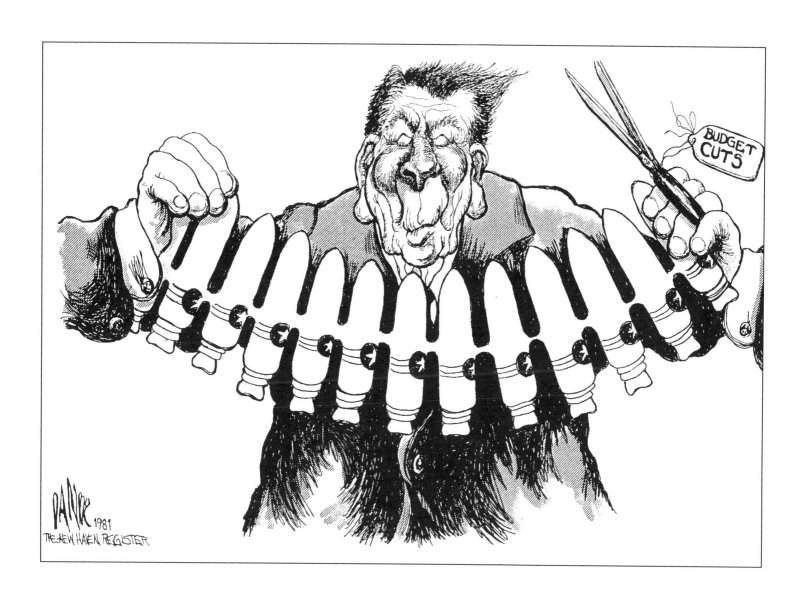

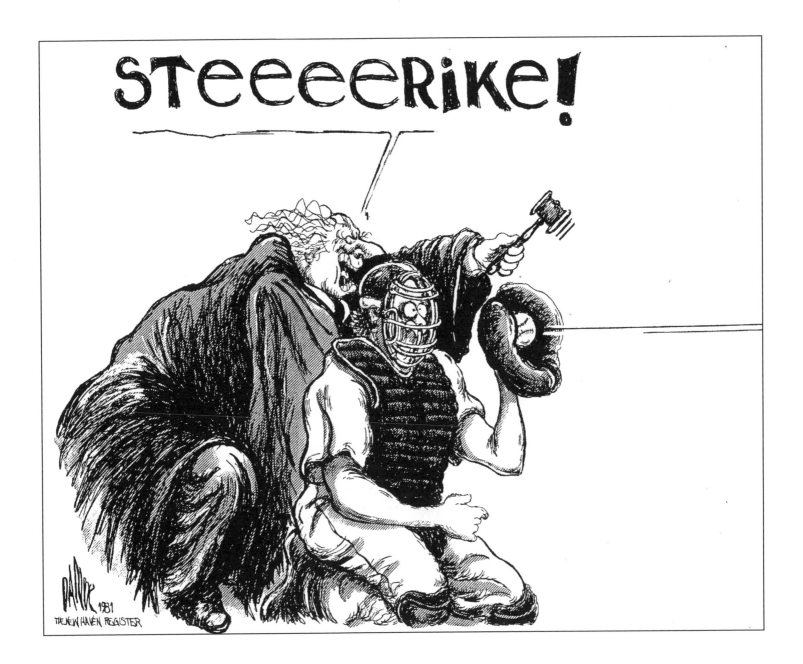

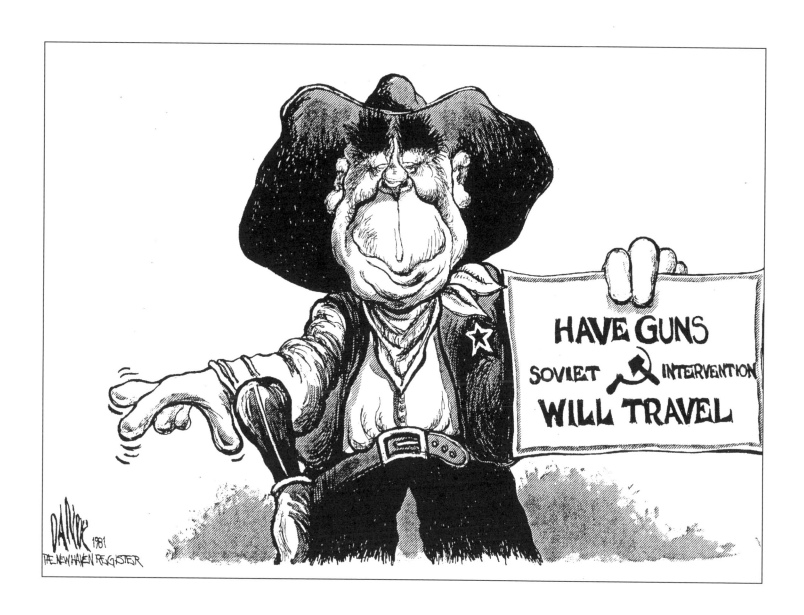

HAVE GUNS
SOVIET INTERVENTION
WILL TRAVEL

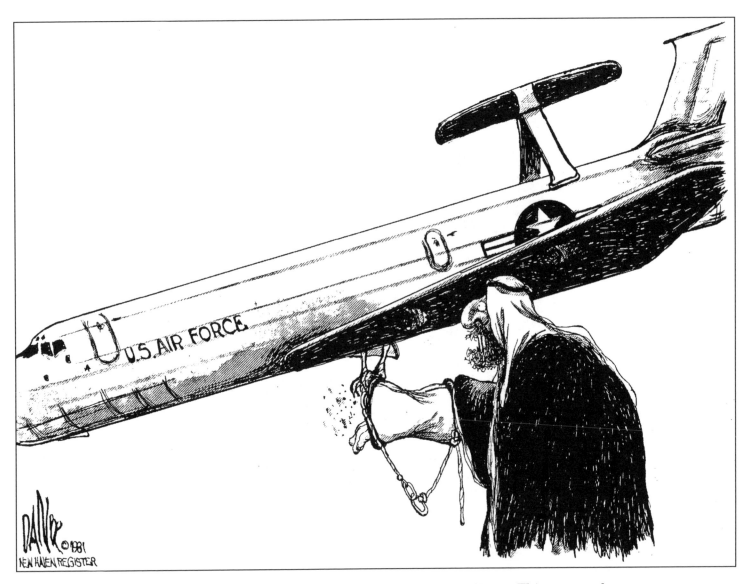

1981 – National newspaper syndication begins with the McNaught Syndicate. This cartoon began twenty years of newspaper syndication and was my first to appear in *Time* magazine.

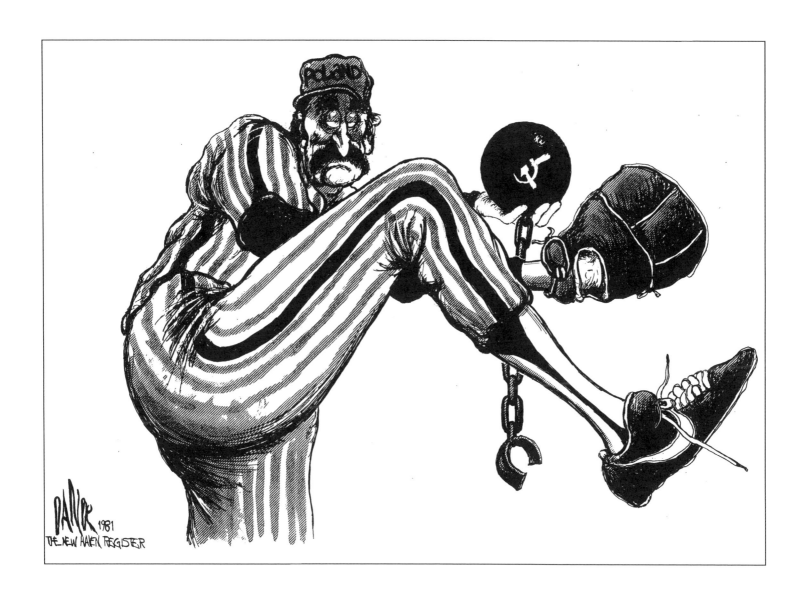

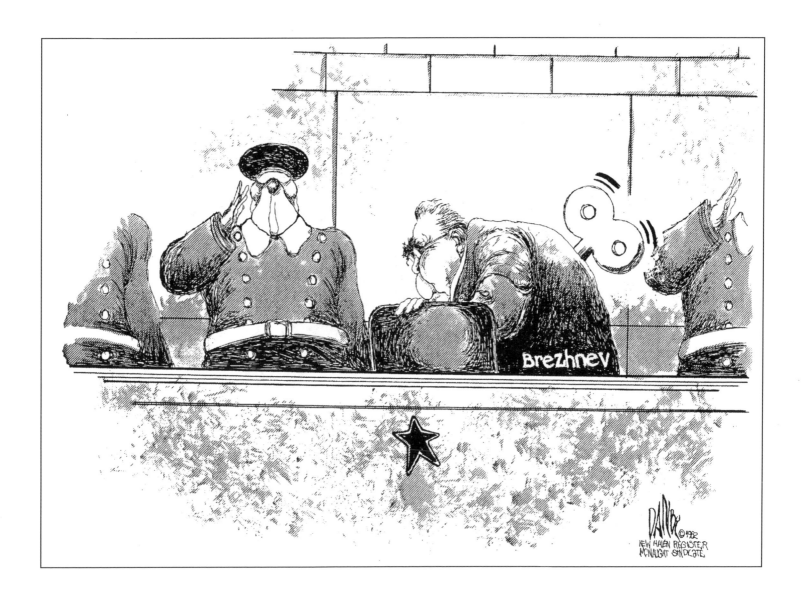

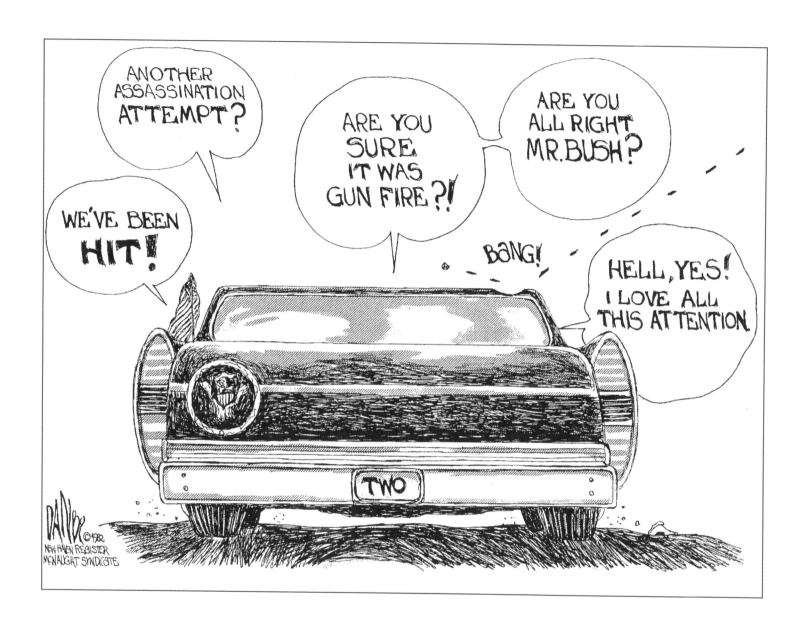

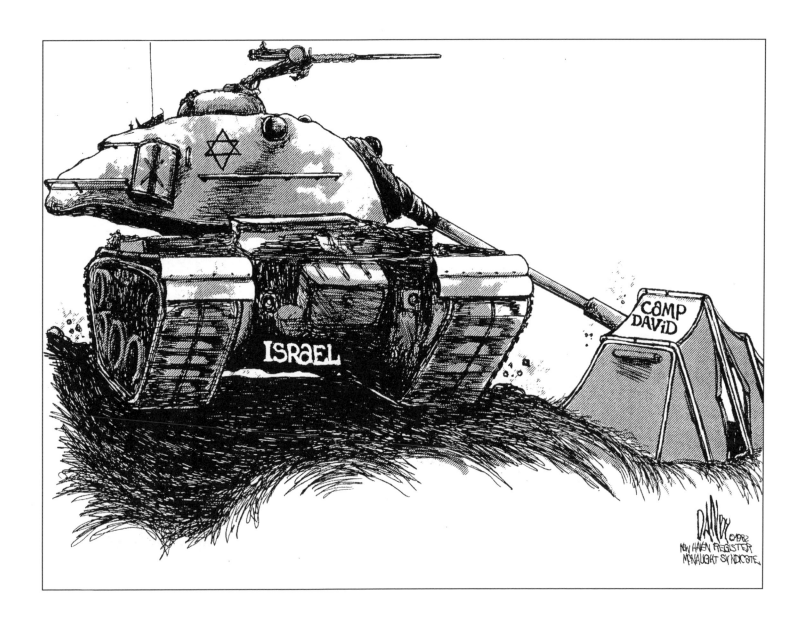

60

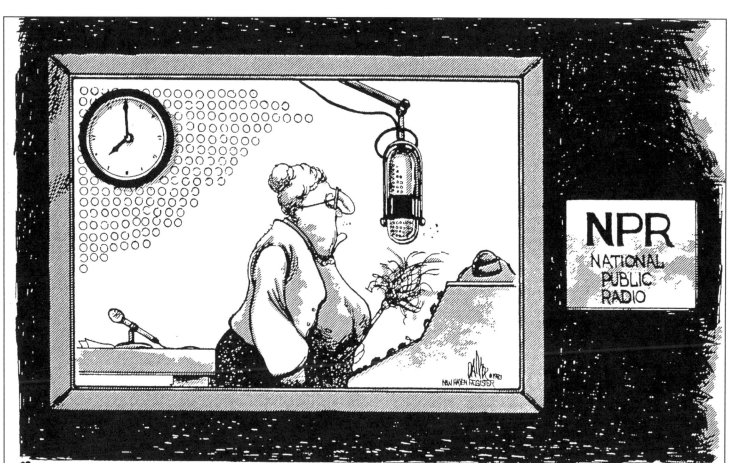

"GOOD EVENING AND WELCOME TO 'ALL THINGS CONSIDERED! BECAUSE OF THE LACK OF ADEQUATE FUNDING, OUR REGULAR STAFF AND UNIQUE PROGRAMMING HAVE BEEN SLIGHTLY ALTERED TONIGHT. I AM THE CLEANING LADY, YOUR HOST. AND WE WILL BE RIGHT BACK WITH OUR FIRST INTERVIEW WITH THE 'TIDY BOWL MAN!'"

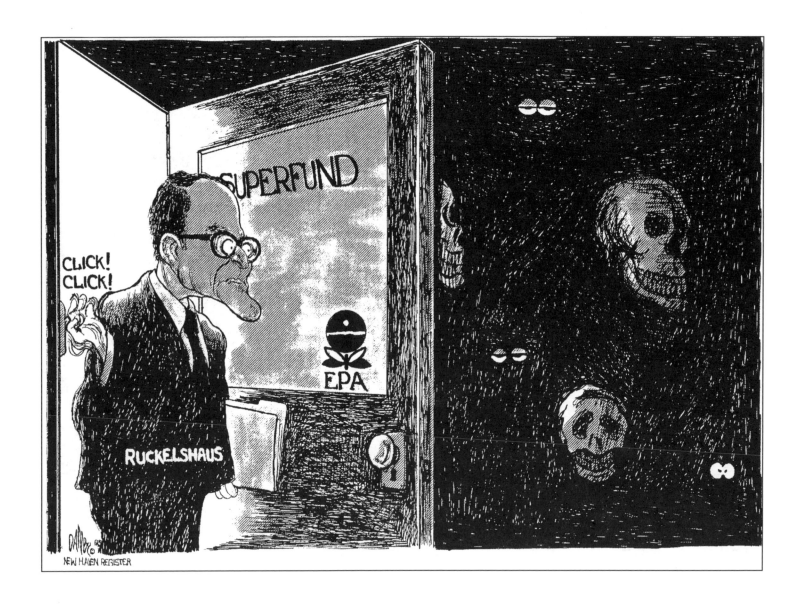

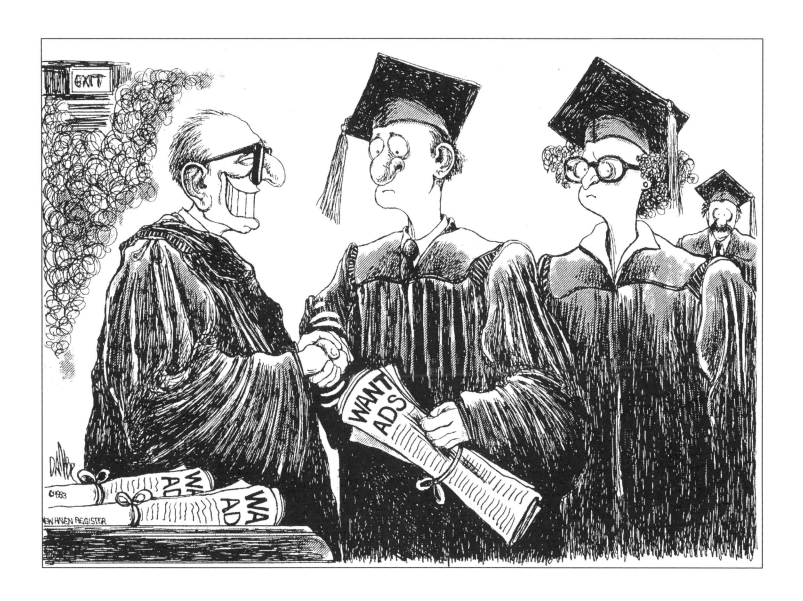

63

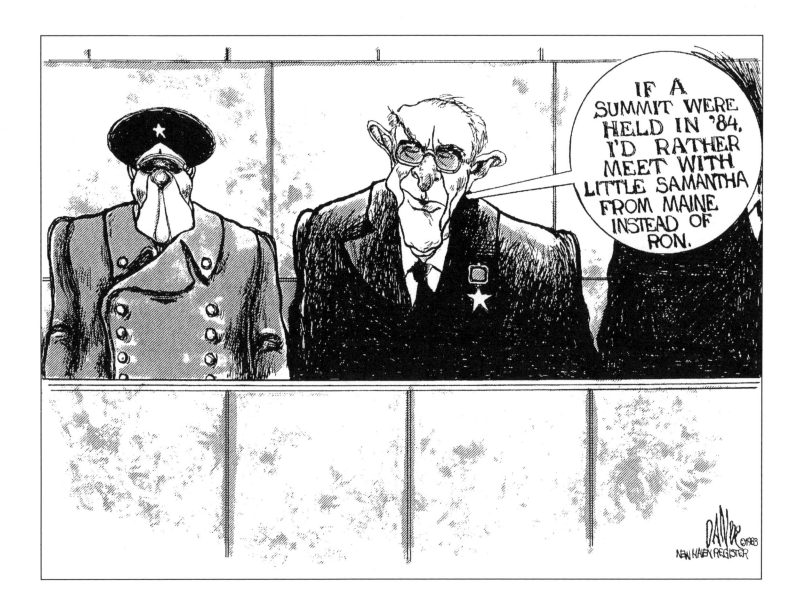

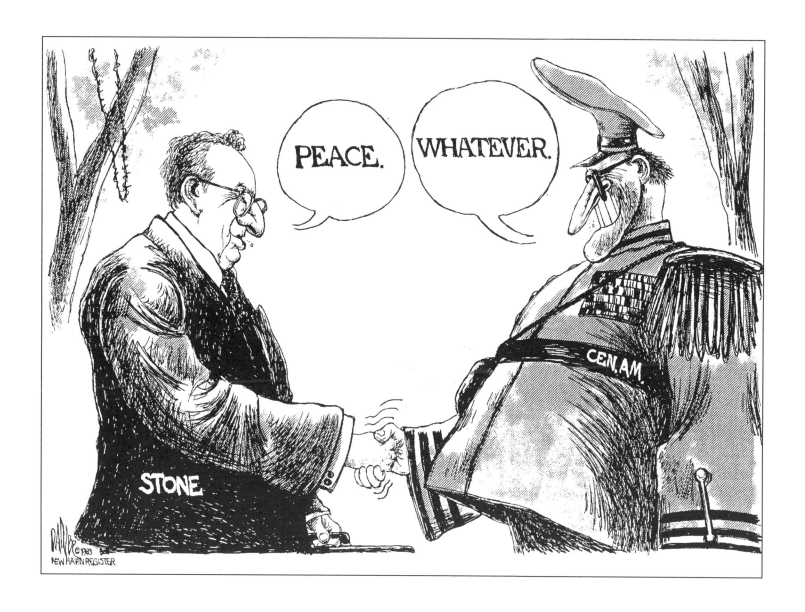

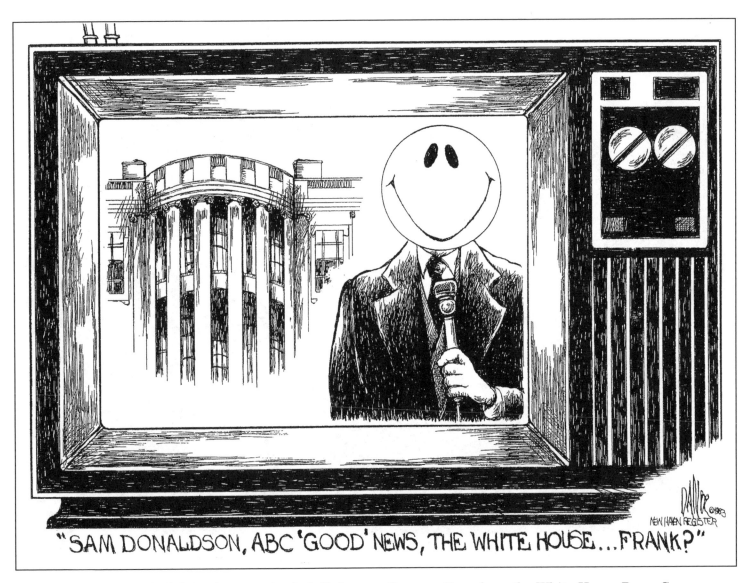

"SAM DONALDSON, ABC 'GOOD' NEWS, THE WHITE HOUSE...FRANK?"

1983 – The Reagan administration was tired of all the negative questions from the White House Press Corps, especially those from media star Sam Donaldson, who had a reputation for being abrasive with his line of questioning. Donaldson called asking for the original cartoon, and suggested that he might start appearing in the White House press room wearing a "happy face" mask!

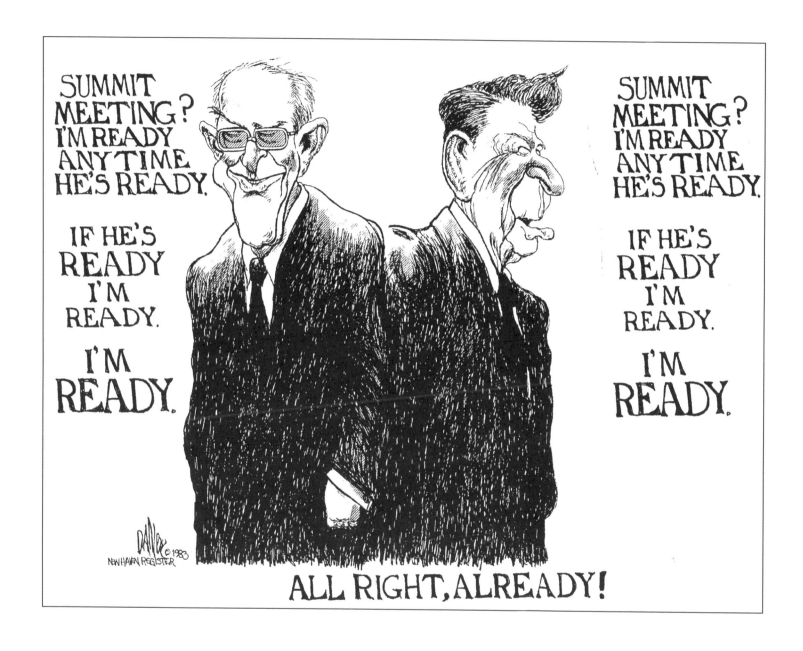

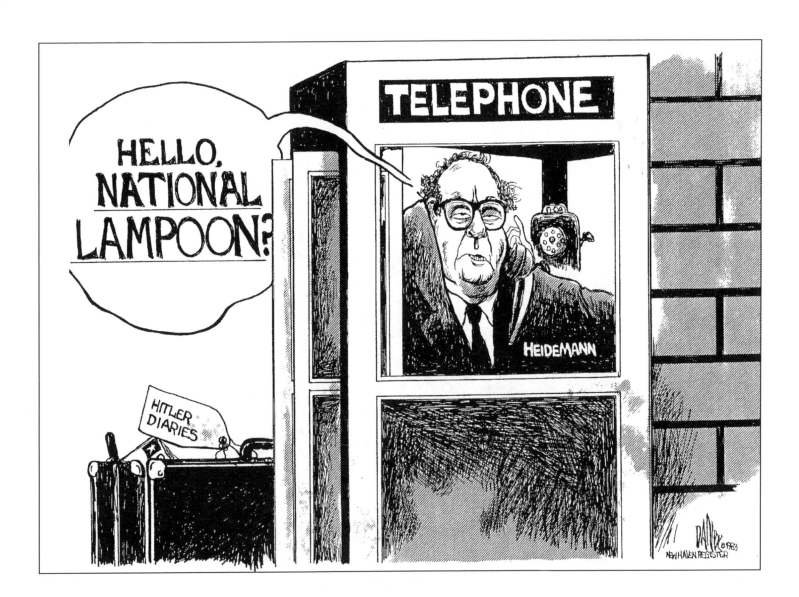

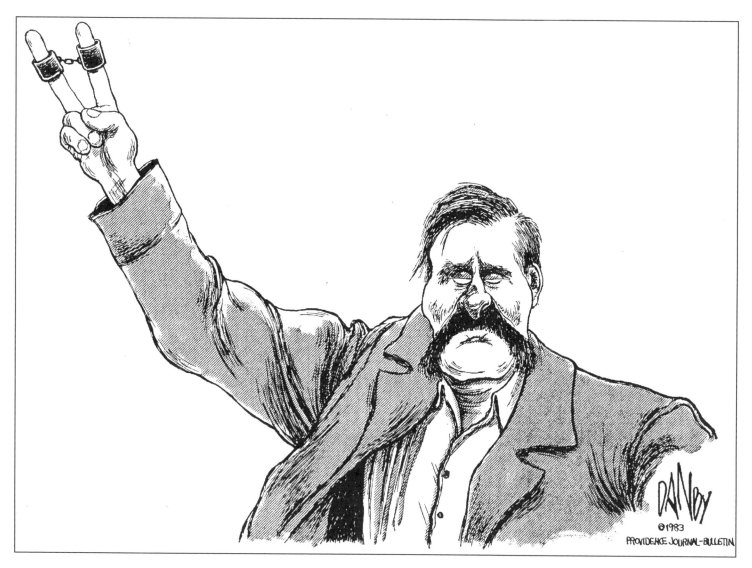

One of my first cartoons to appear in the *Providence Journal-Bulletin*, as staff editorial cartoonist.

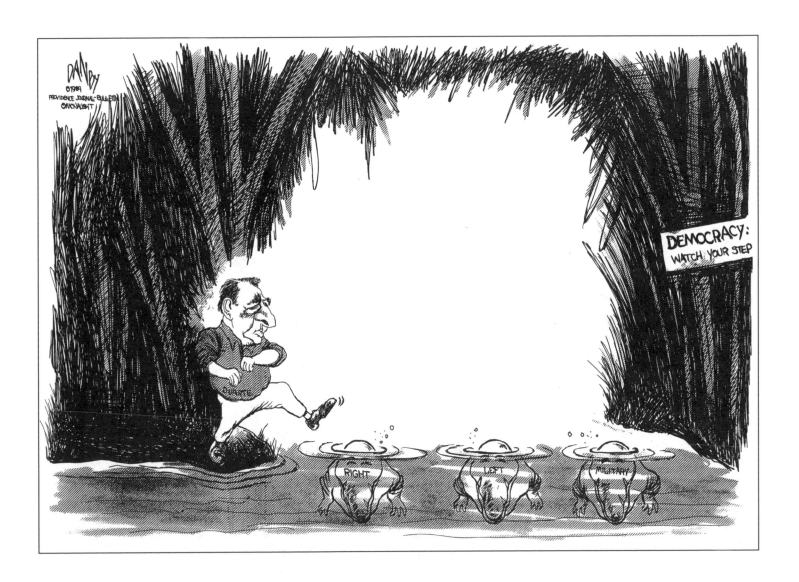

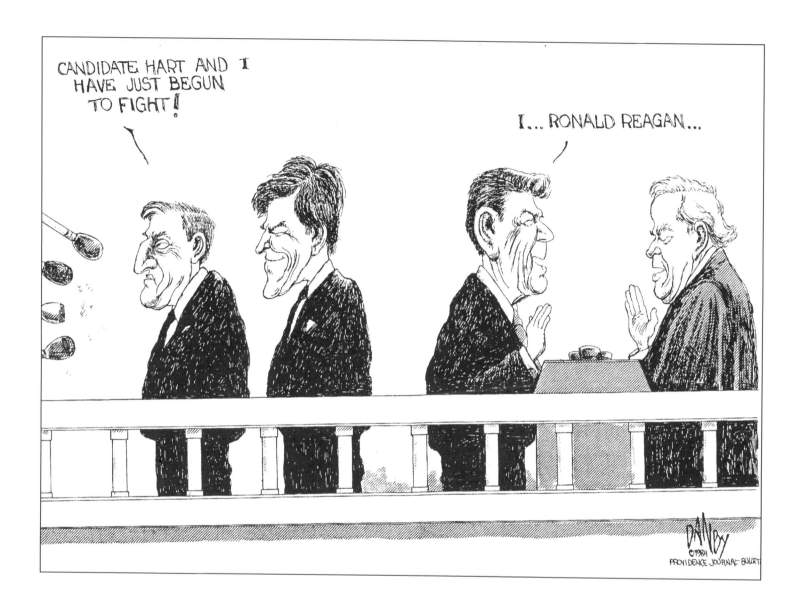

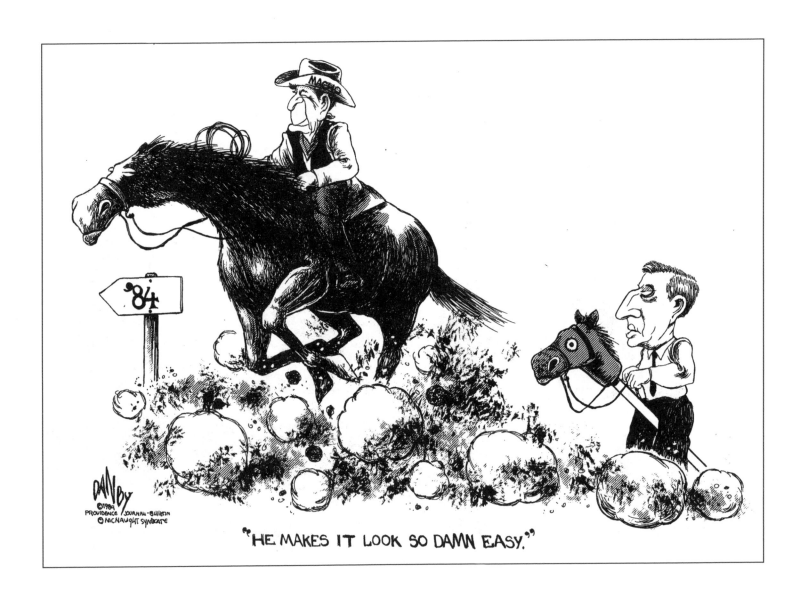

"HE MAKES IT LOOK SO DAMN EASY."

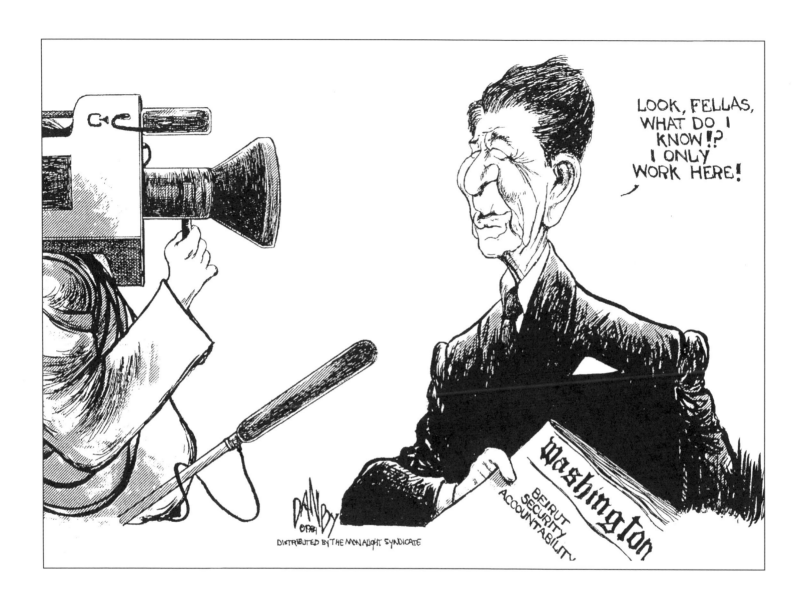

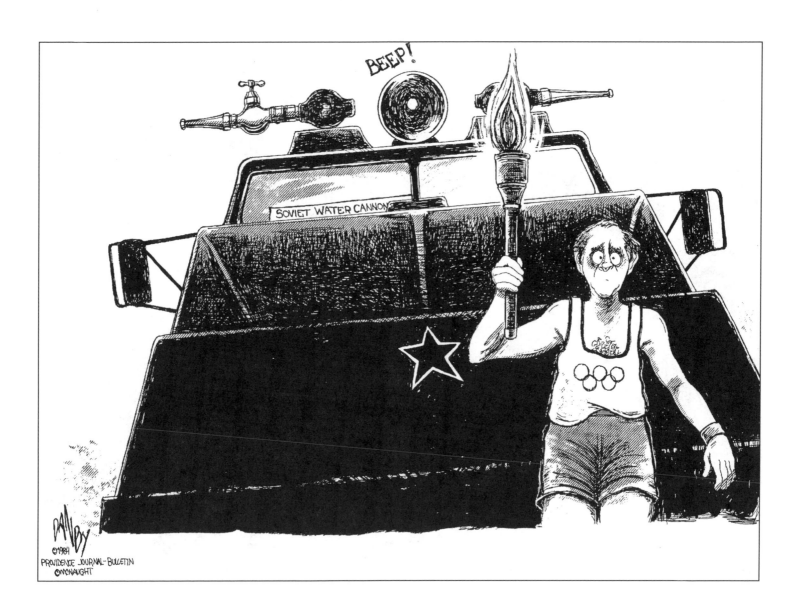

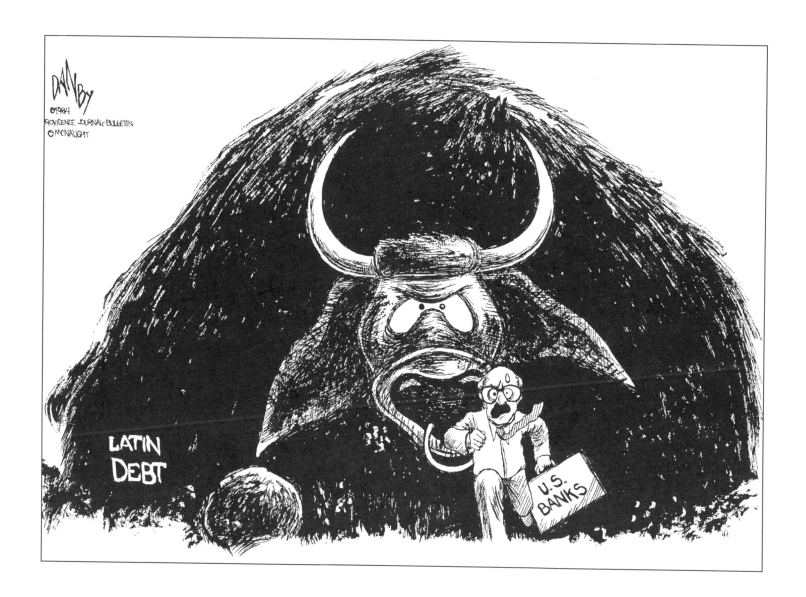

LATIN DEBT

U.S. BANKS

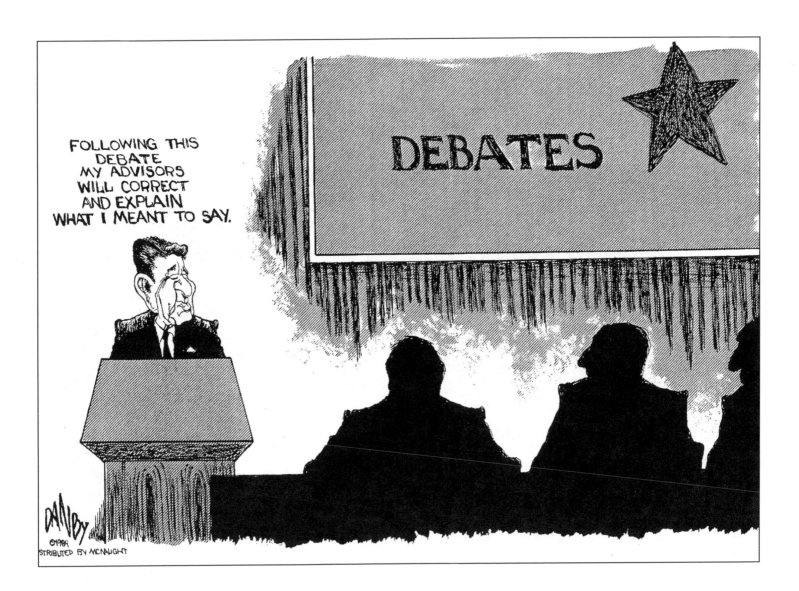

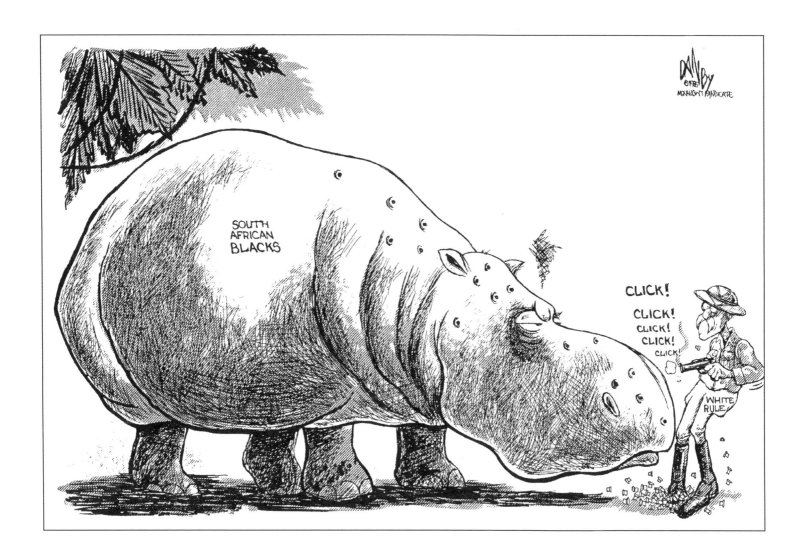

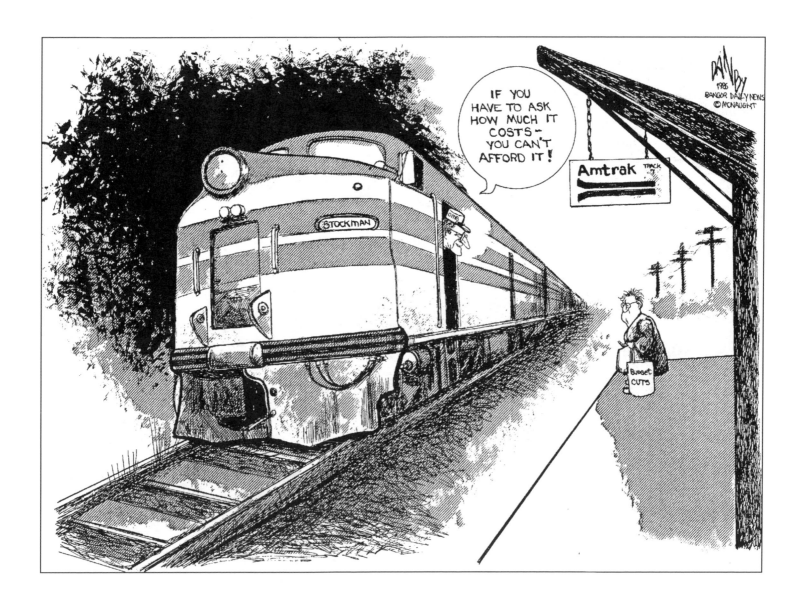

78

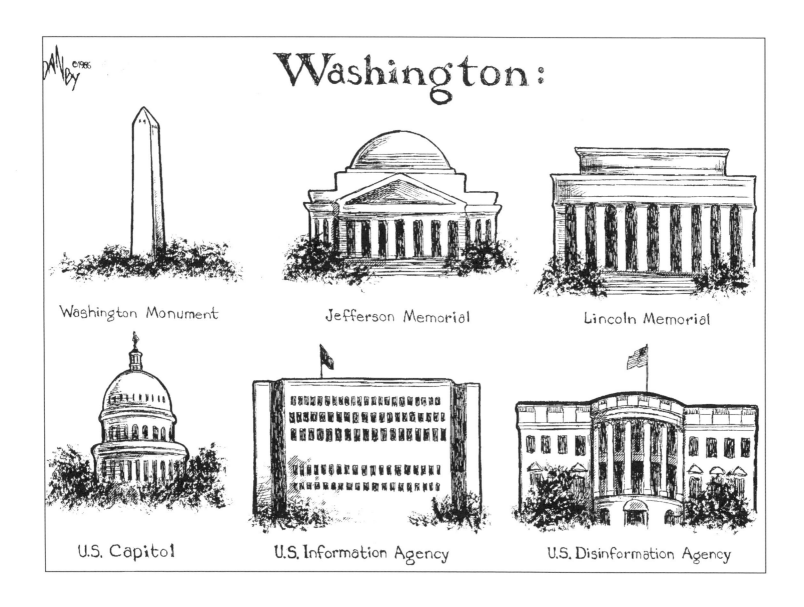

Washington:

Washington Monument

Jefferson Memorial

Lincoln Memorial

U.S. Capitol

U.S. Information Agency

U.S. Disinformation Agency

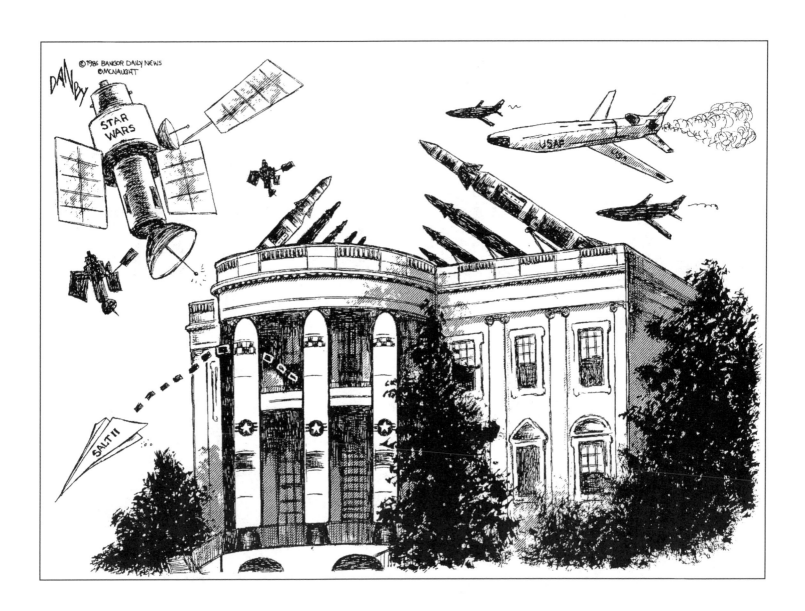

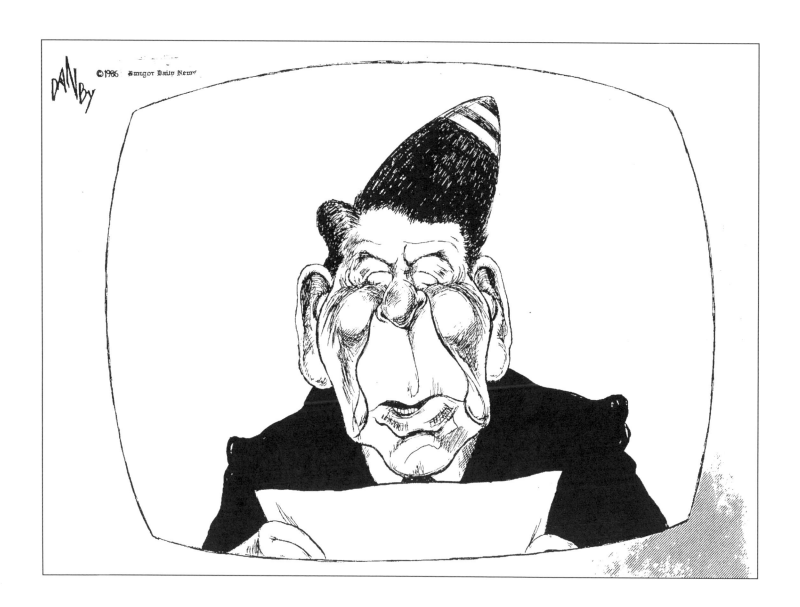

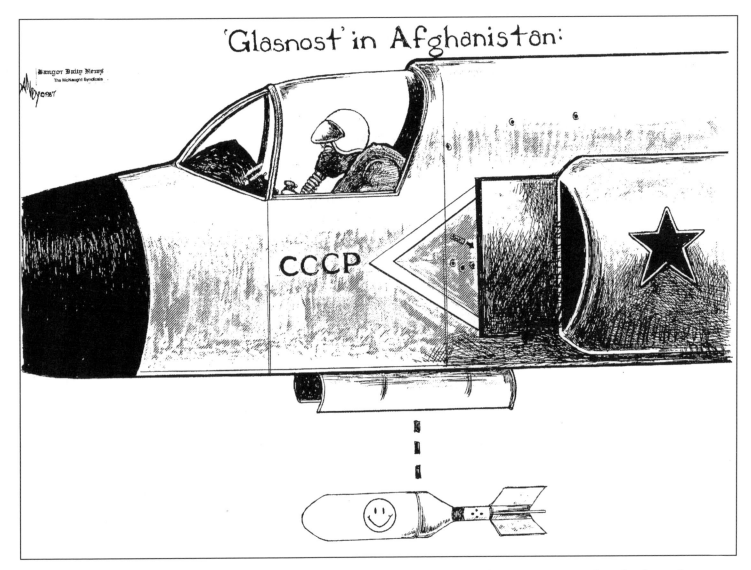

An early cartoon, returning to the *Bangor Daily News* as staff cartoonist. This cartoon was also the first of many drawings that appeared in the *New York Times* over the next fifteen years. One of my favorite accomplishments.

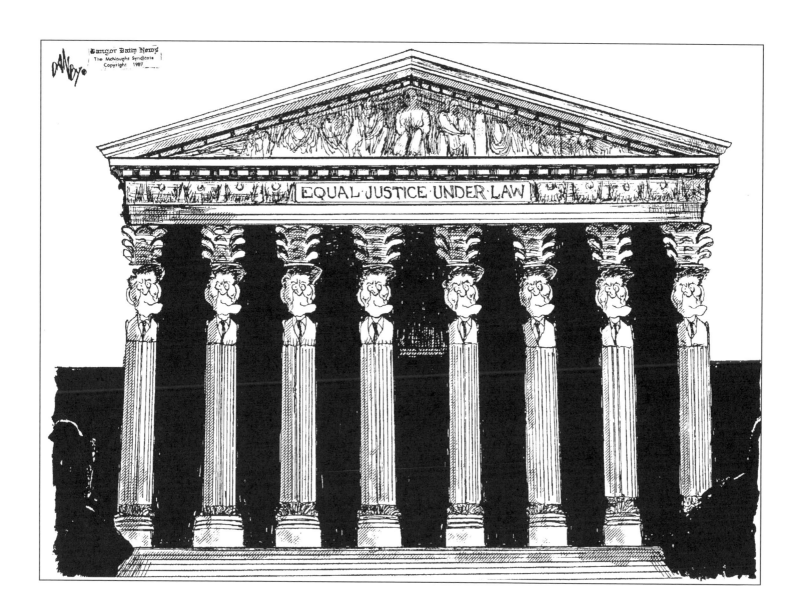

LACK OF MONEY MIGHT HALT TOXIC CLEANUP PROGRAMS. — EPA

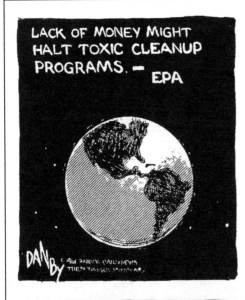

BY MARCH, EPA WOULD BEGIN SHUTTING DOWN CLEANUP PROJECTS...

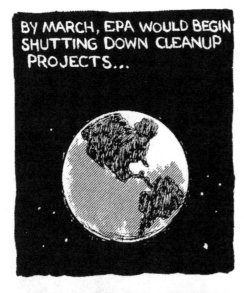

BY APRIL, EPA WOULD REDUCE IT'S RESPONSE TO TOXIC EMERGENCIES...

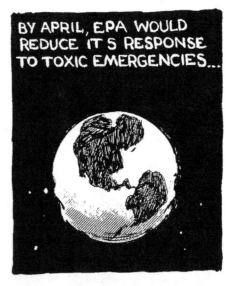

BY JULY, ALL LONG-TERM PROJECTS WOULD SHUT DOWN...

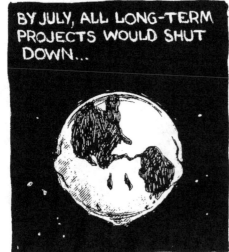

BY SEPTEMBER, EPA WOULD HALT ALL ACTION AGAINST POLLUTERS...

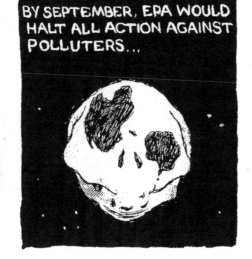

BY DECEMBER...

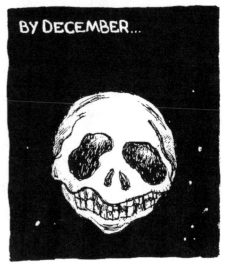

84

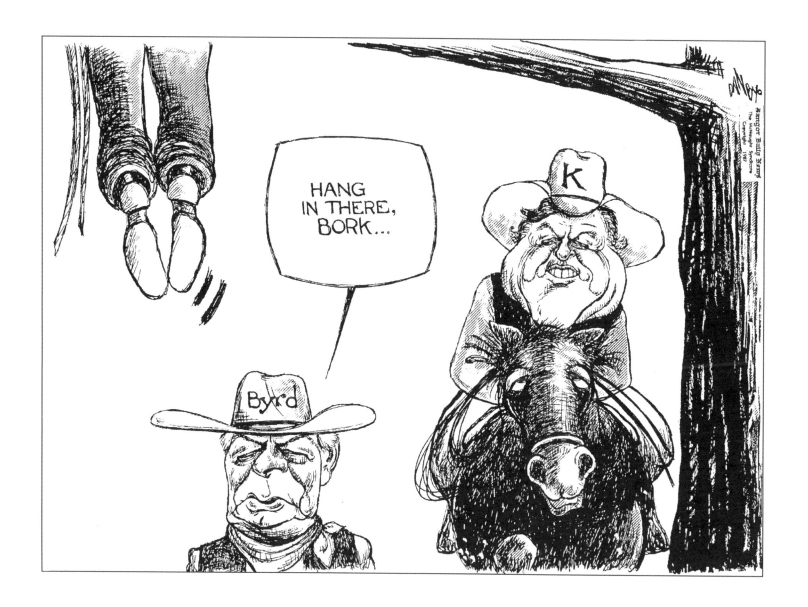

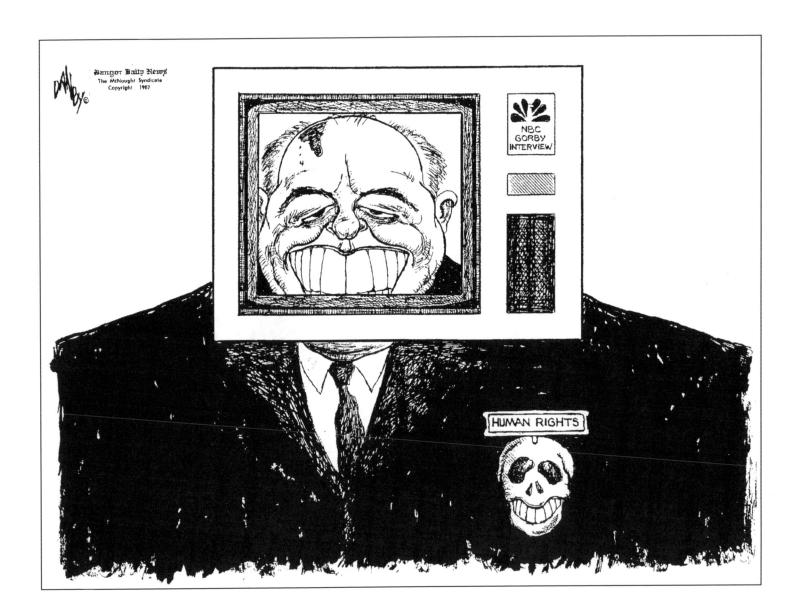

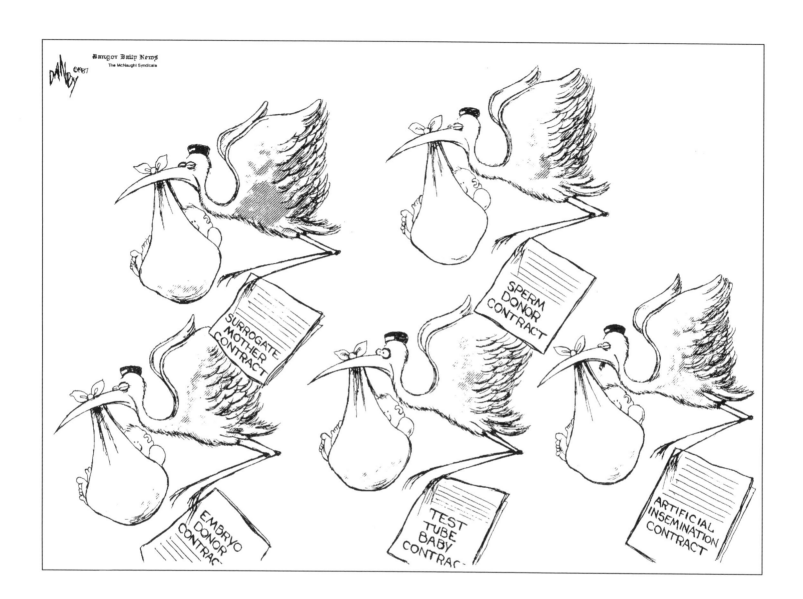

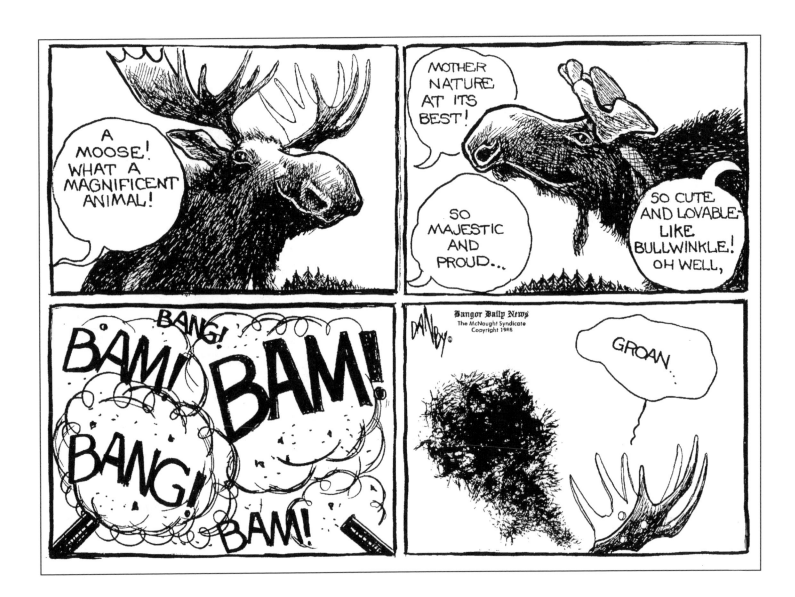

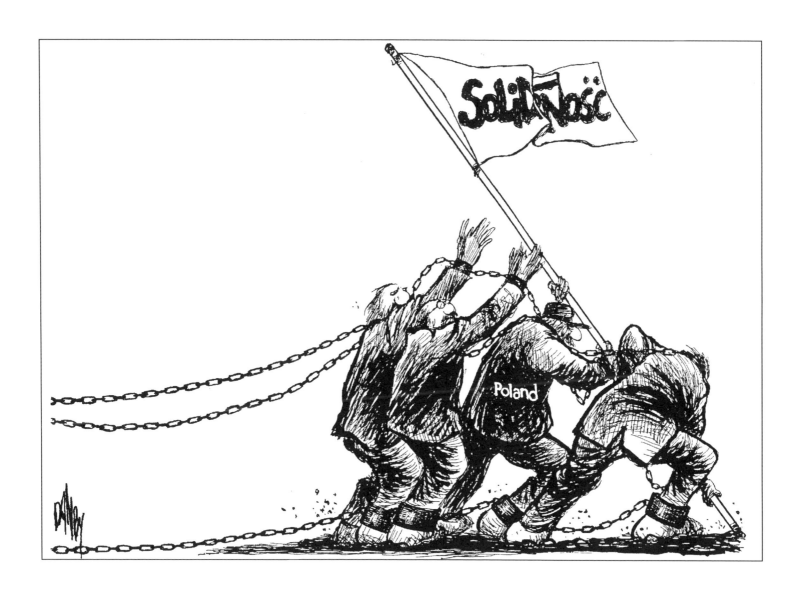

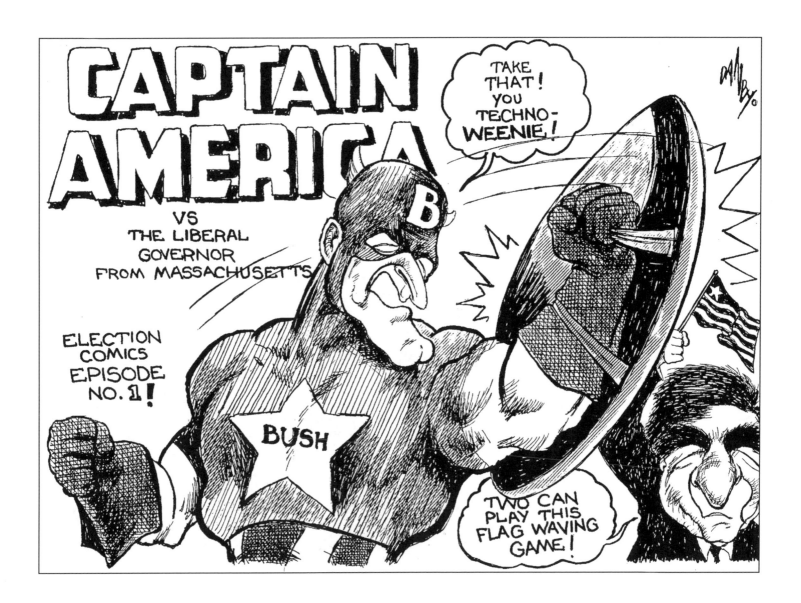

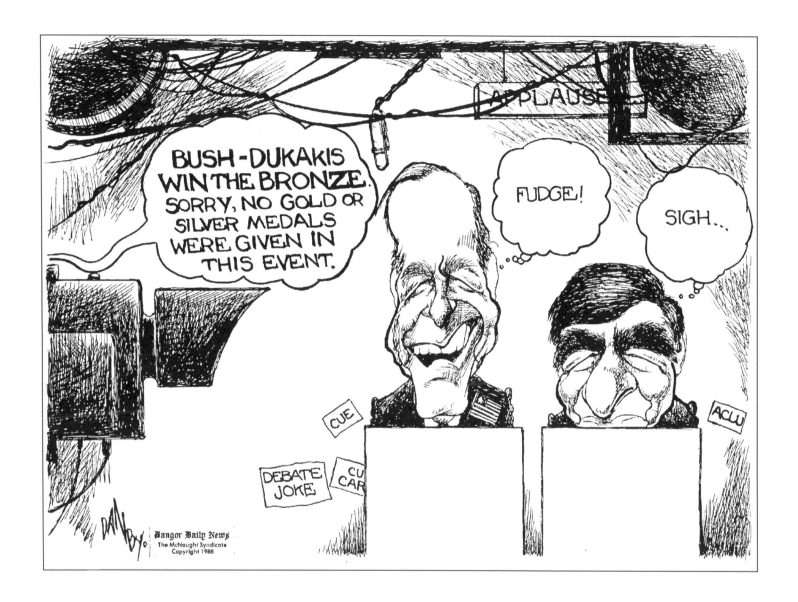

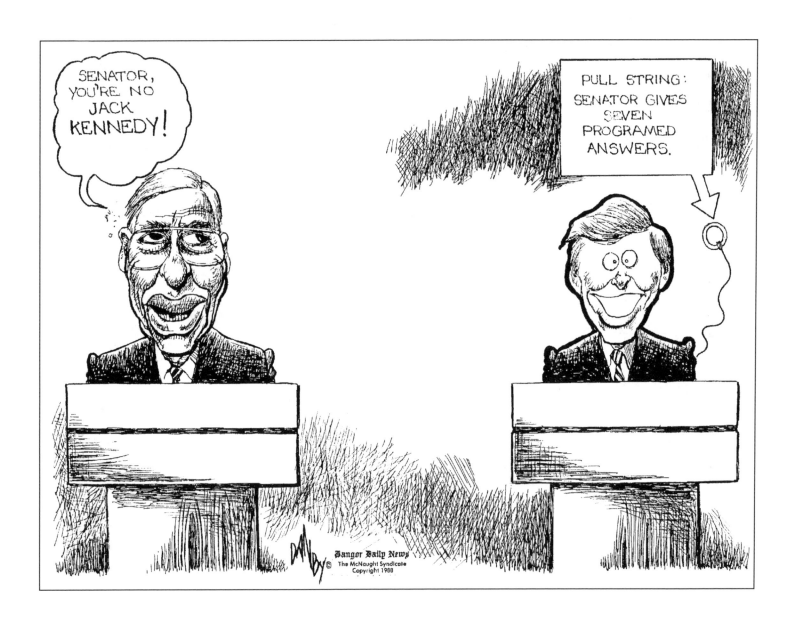

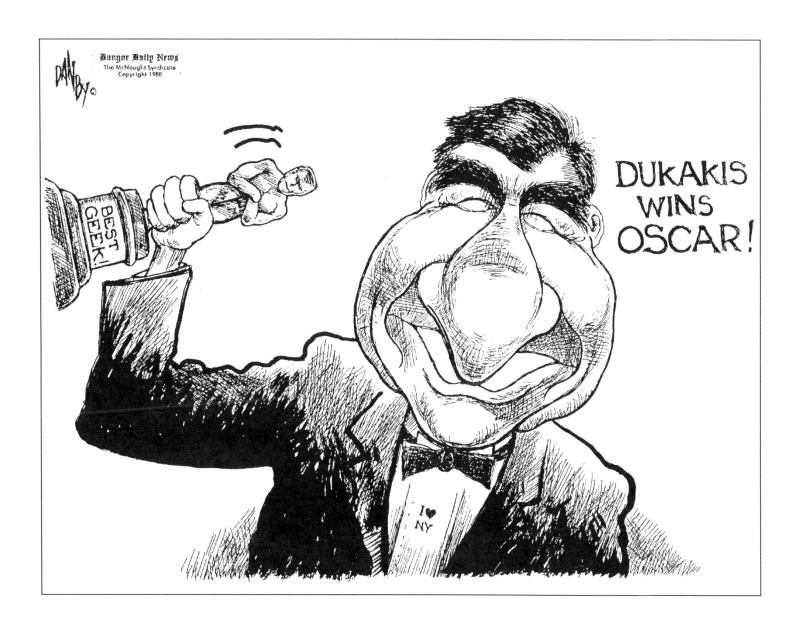

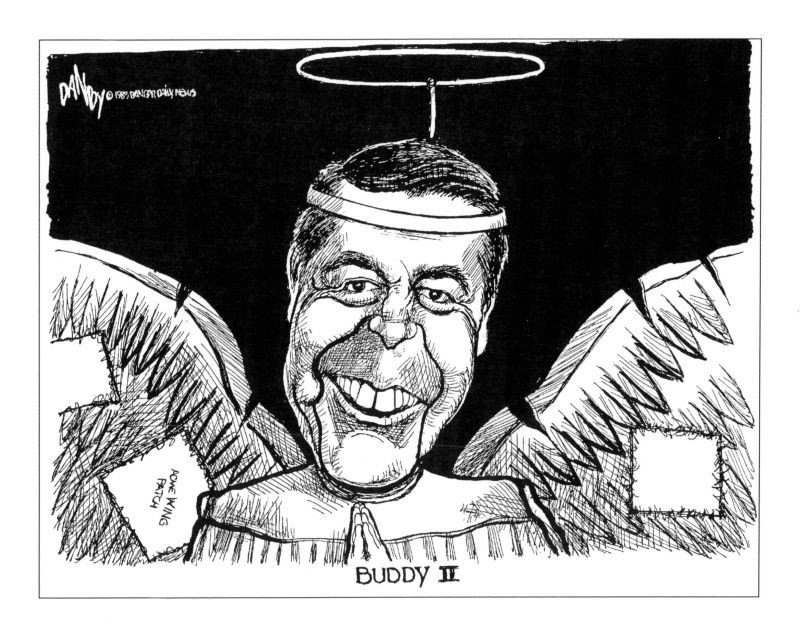

BUDDY II

94

TAXPAYER SURVEY · CLIP & MAIL

STATE GOVERNMENT CONTINUES TO OVERCOLLECT MILLIONS OF DOLLARS FROM MAINE TAXPAYERS WHO HAVE ASKED FOR A WAY TO EXPRESS THEIR OUTRAGE WITH THE PERSONAL INCOME TAX SYSTEM. HERE IS YOUR CHANCE! COMPLETE THIS SURVEY, THEN READ TODAY'S EDITORIAL...

TELL US WHAT YOU THINK ABOUT THE TAX SYSTEM:

☐ WONDERFUL. THE WAY IT IS. PLEASE DON'T TOUCH IT!

☐ A DISASTER. SCRAP IT. GIVE ME SOMETHING REASONABLE.

☐ PARDON ME WHILE I LAUGH...

☐ I'M MAD AS HELL AND I CAN'T TAKE IT ANYMORE.

☐ EXPLETIVE DELETED...

☐ P.S. WHERE IS MY REBATE?

☹ OTHER COMMENTS... _____

CLIP & MAIL TO :
TAXES
BDN P.O. BOX 1329
BANGOR, ME. 04401

DANBY (©1989) BANGOR DAILY NEWS DIST. BY MCNAUGHT SYN.

This "clip and mail" cartoon from 1989 received much attention. Five thousand readers responded. I delivered the contents to then governor John McKernan for his perusal. Taxpayer overcollection was a hot-button issue by the end of the 1980s. The response turned into a front-page photo op, with editorial page editor Mark Woodward and myself dumping the clippings onto the desk of the governor.

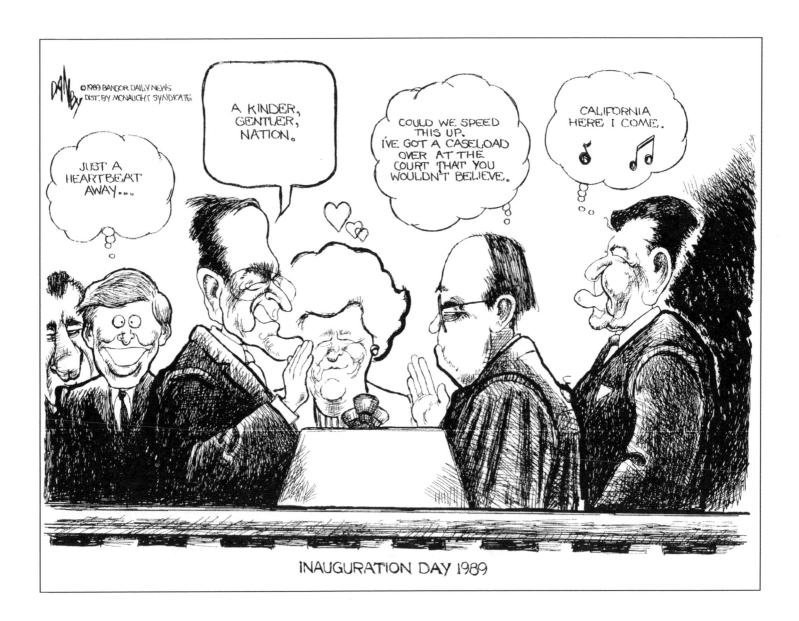

INAUGURATION DAY 1989

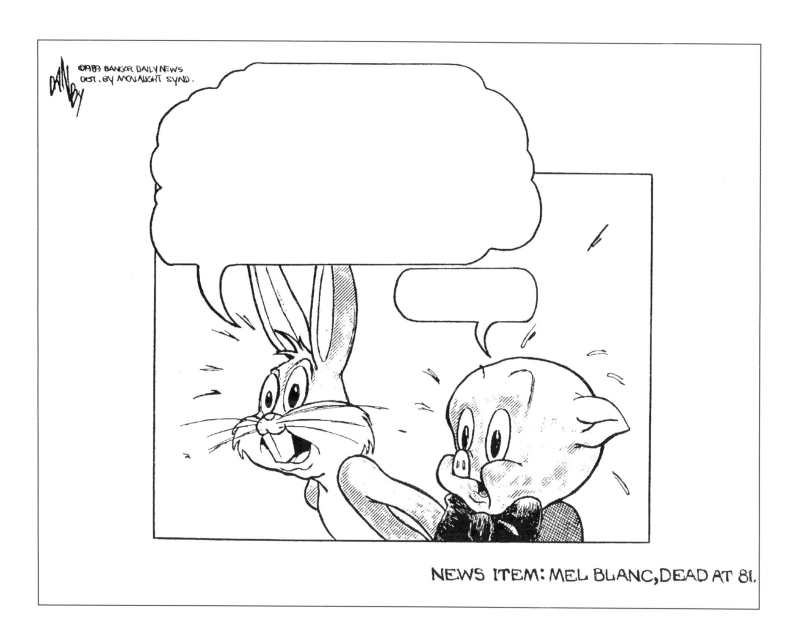

NEWS ITEM: MEL BLANC, DEAD AT 81.

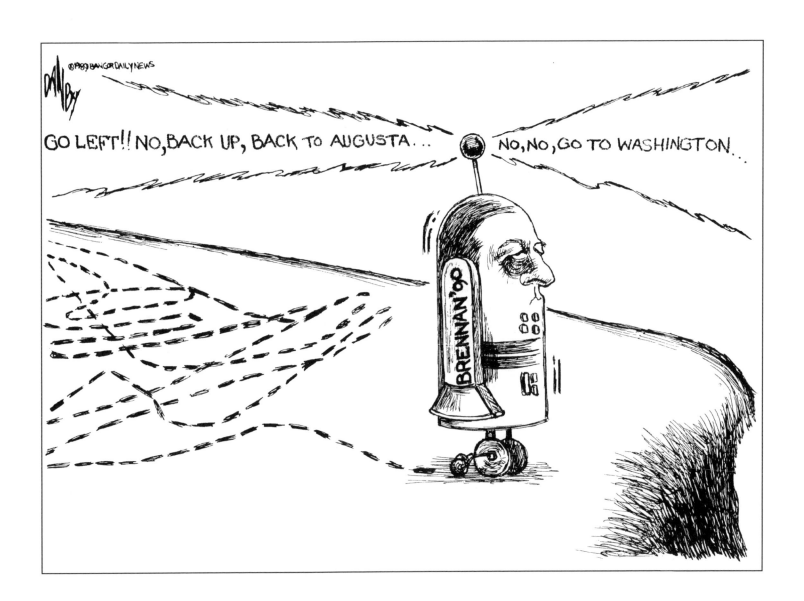

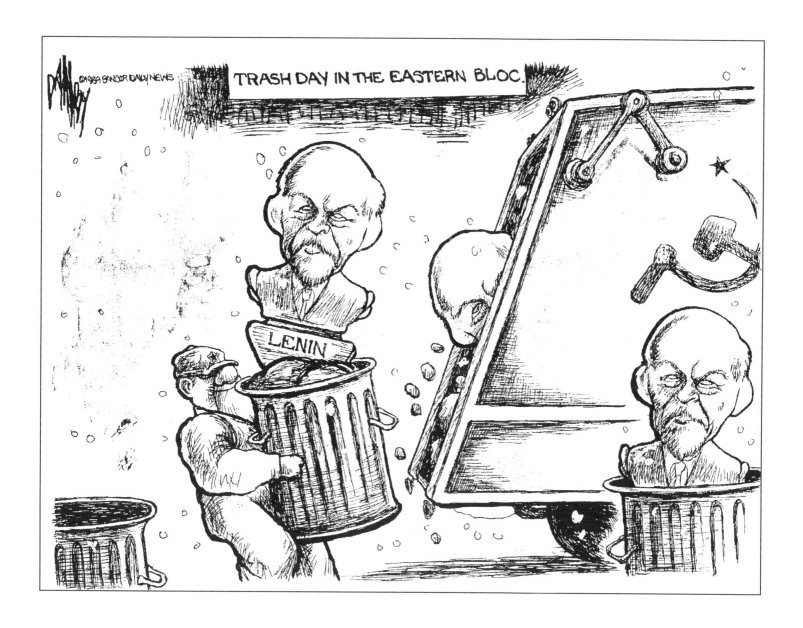

THE
1990s

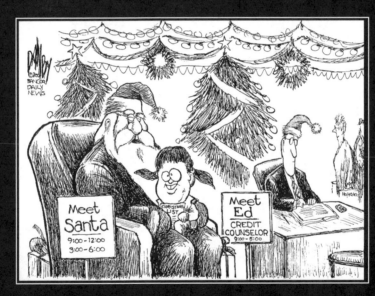

1990s

Reporters junked their typewriters for bulky PCs. Technology was rapidly changing the way a newspaper was produced. Meanwhile, I continued doing my job with ink and paper. Technology was also changing the world. Offices ran on computers; many homes were stocked with at least one PC. Video games were growing sophisticated and Nintendo game consoles were on every kid's Christmas list.

Posters of boy bands plastered every teenager's bedroom walls. People "invested" in Beanie Babies. VHS videotapes and audio cassettes were being phased out by the end of the decade, replaced by DVDs and CDs. The car phone evolved into mobile phones you could carry with you anywhere. If you didn't have a cell phone, you probably had a pager.

My work was gaining national recognition with cartoons in the *New York Times,* the *Washington Post,* and *USA Today*. Even though my career began after the Nixon era, I saw opportunity in sketching the former president for a 1995 cartoon critical of Oliver Stone and his "fictional facts" in the movie based on the former president. That cartoon was published in the *New York Times* and it appears in this chapter.

The 1990s were ripe with news. The early part of the decade saw an oil crisis due to the Gulf War. While the conflict was short, it generated a spike in crude oil prices, from $17 to $36 per barrel. The increase was short-term, but set the stage for further spikes and a steady increase through the first decade of the twenty-first century.

During President Bill Clinton's second term, rumors of personal indiscretions turned into a political nightmare. Allegations that Clinton had had an affair with former White House intern Monica Lewinsky launched an investigation during which Clinton denied any wrongdoing. He became the first sitting president called to testify before a grand jury based on the investigation into his actions.

I drew many caricatures of Clinton during this time. When friend and former colleague Lee Umphrey told me he was to spend an evening with the former president, I asked him to bring a cartoon for Clinton to sign. It appears in this chapter, but the signature came with Clinton's criticism that the sketch looked nothing like him.

The Lewinsky scandal was one of the biggest headline makers of the decade. Other major headlines included the death of Princess Diana and the not-guilty verdict of former football star O. J. Simpson on charges of murdering Nicole Brown and Ronald Goldman.

Maine marked the fiftieth anniversary of the great Maine Lobster Festival held annually in Rockland. Angus King was elected in 1995—the only independent governor in the country. Susan Collins and Joe Brennan battled for a seat on the US Senate floor in 1996—and Brennan suggested my cartoons were the most negative part of the campaign.

Most Mainers who lived through this decade will never forget the ice storm that struck just after New Year's day, 1998. Travel during the storm was impossible, and residents went without electricity for weeks.

The twenty-first century was rung in with fears of Y2K computing disasters or the end of the world.

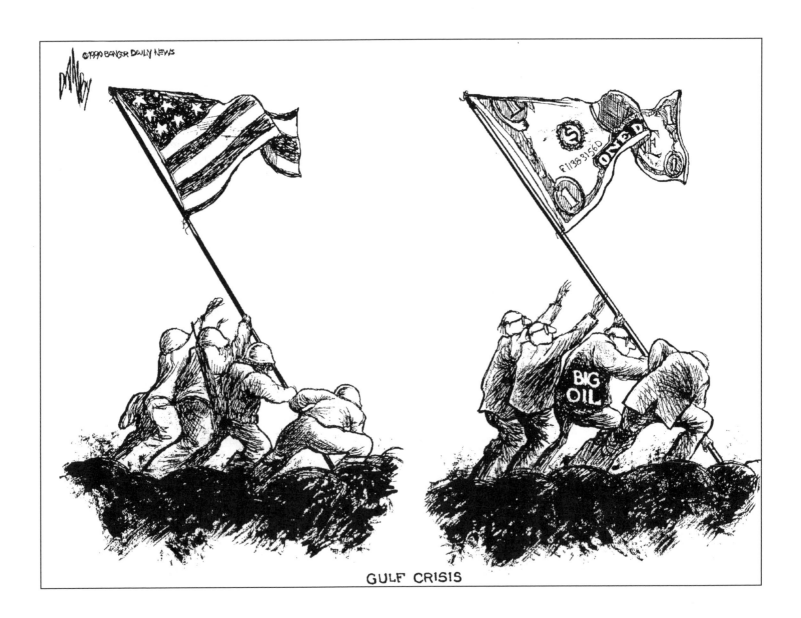

GULF CRISIS

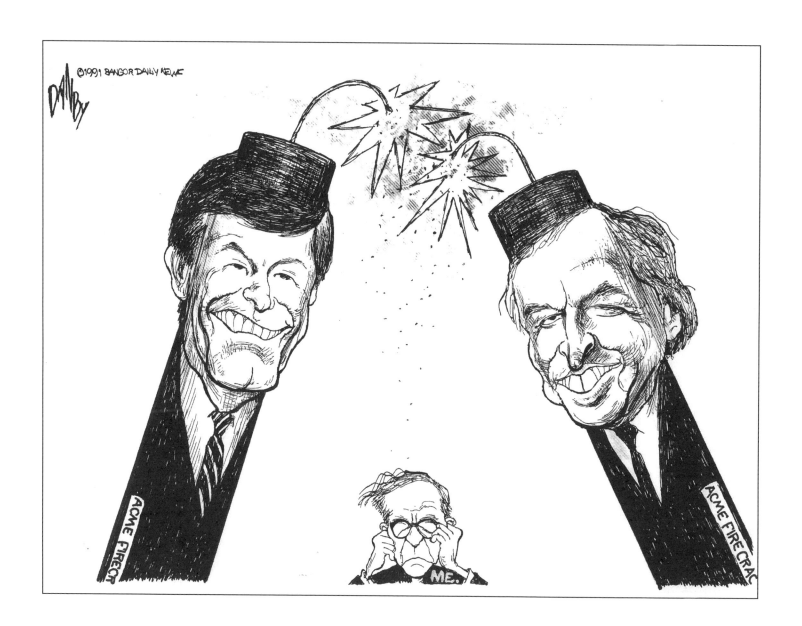

103

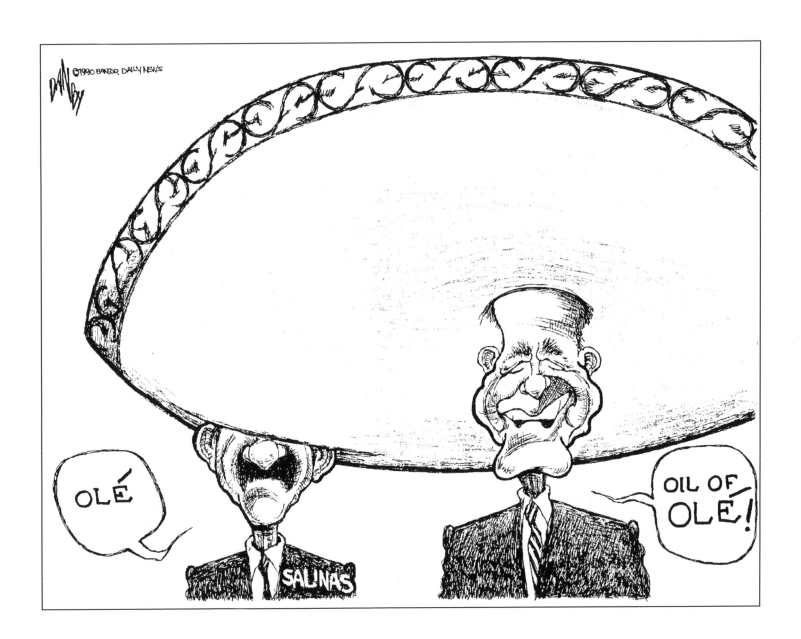

104

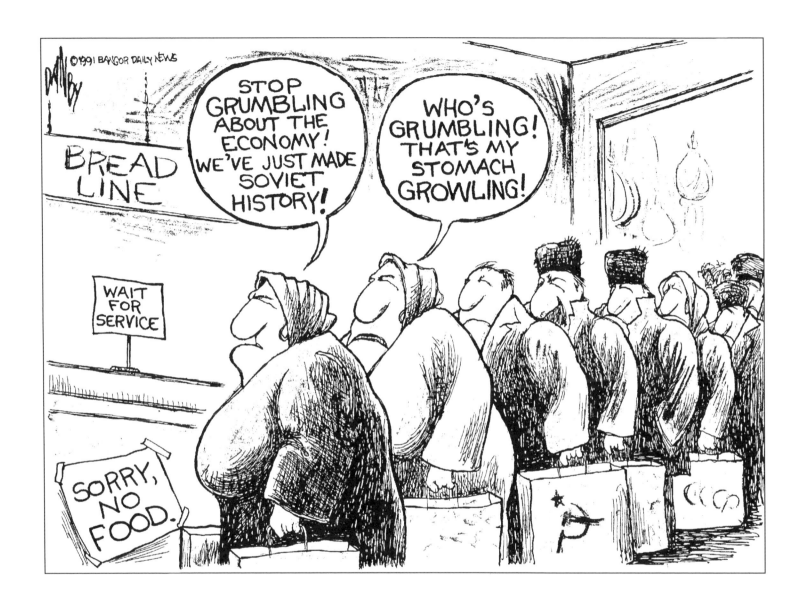

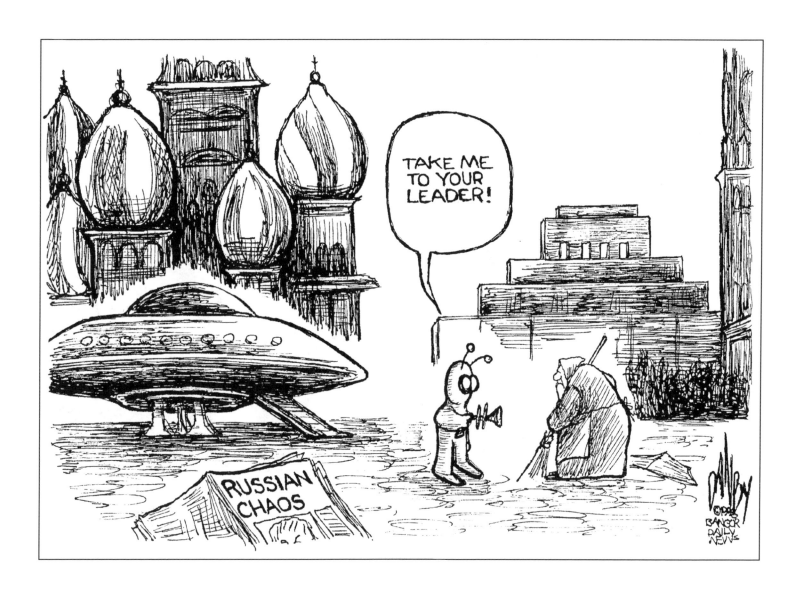

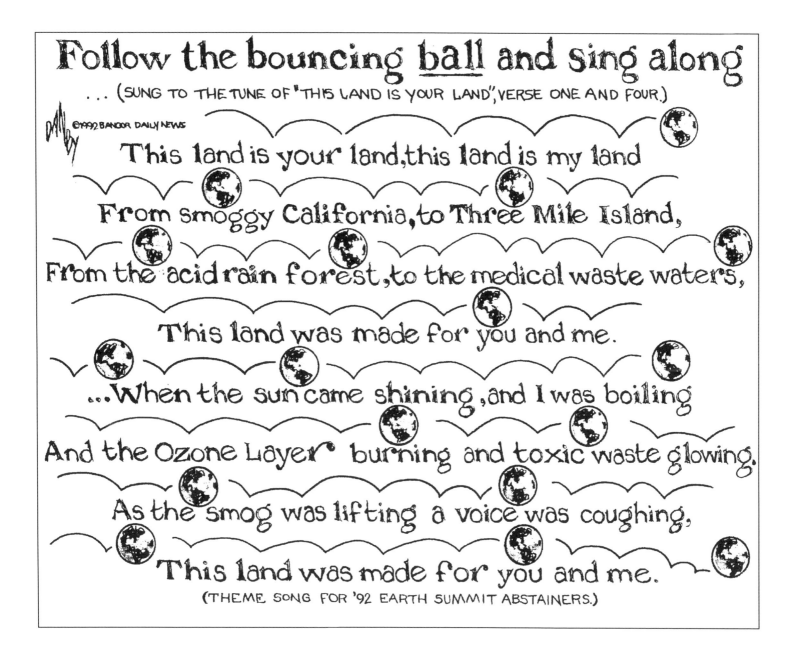

Follow the bouncing <u>ball</u> and sing along

... (SUNG TO THE TUNE OF "THIS LAND IS YOUR LAND", VERSE ONE AND FOUR.)

©1992 BANGOR DAILY NEWS

This land is your land, this land is my land

From smoggy California, to Three Mile Island,

From the acid rain forest, to the medical waste waters,

This land was made for you and me.

...When the sun came shining, and I was boiling

And the Ozone Layer* burning and toxic waste glowing.

As the smog was lifting a voice was coughing,

This land was made for you and me.

(THEME SONG FOR '92 EARTH SUMMIT ABSTAINERS.)

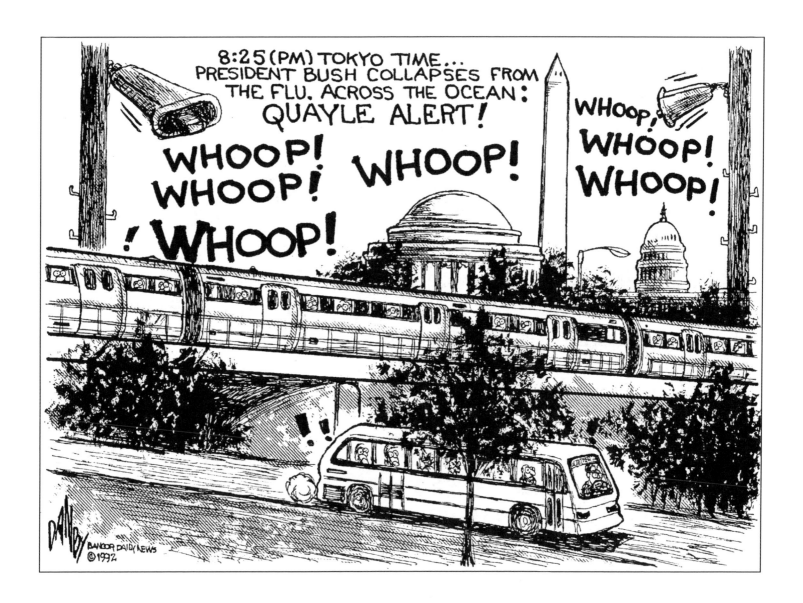

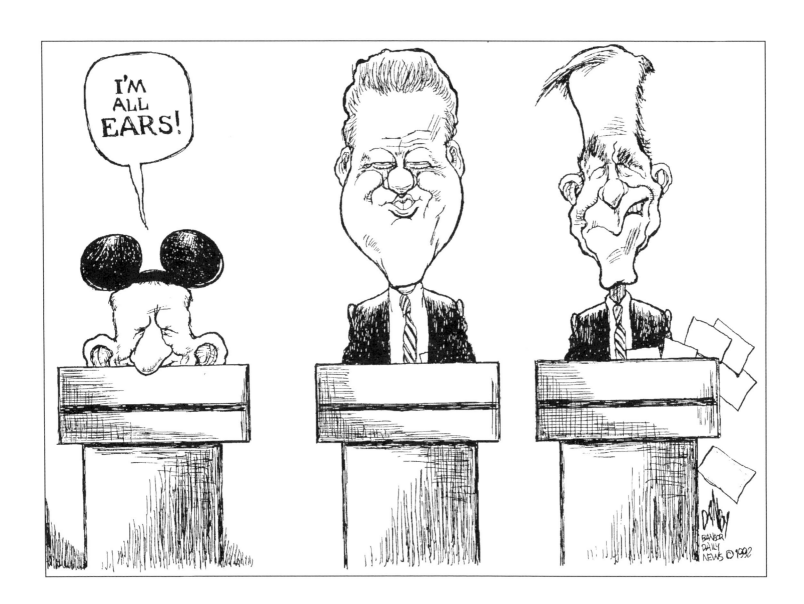

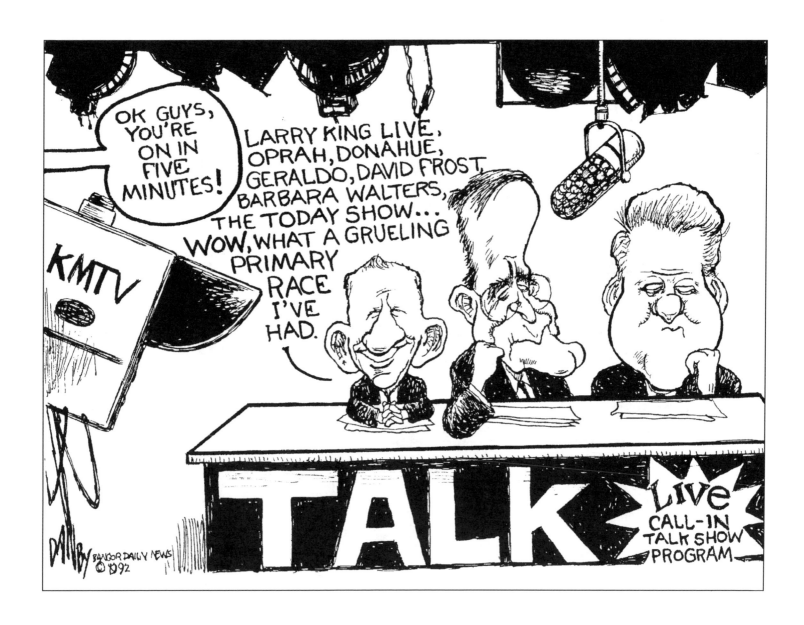

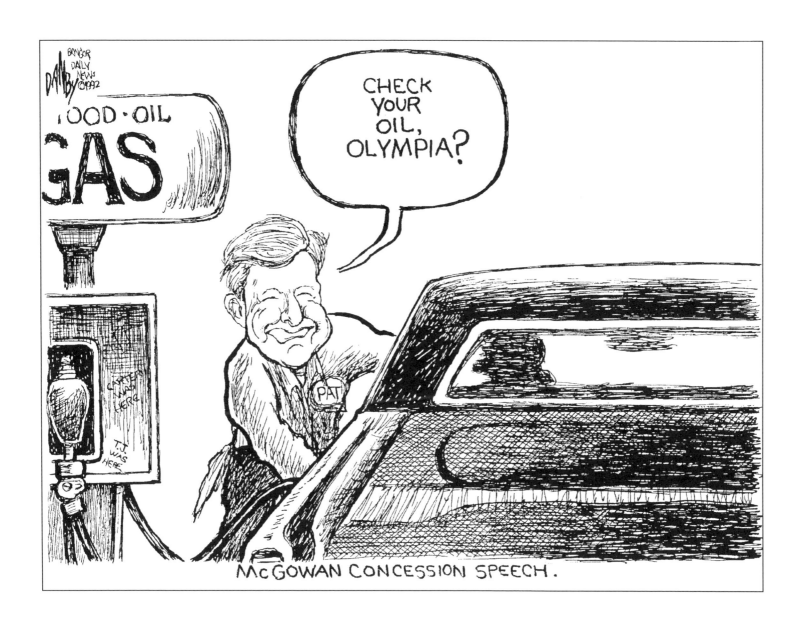

McGOWAN CONCESSION SPEECH.

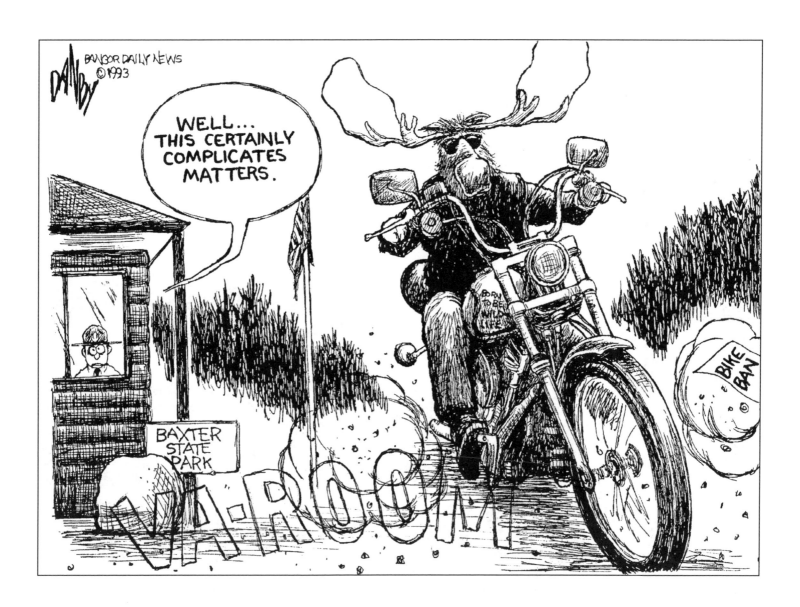

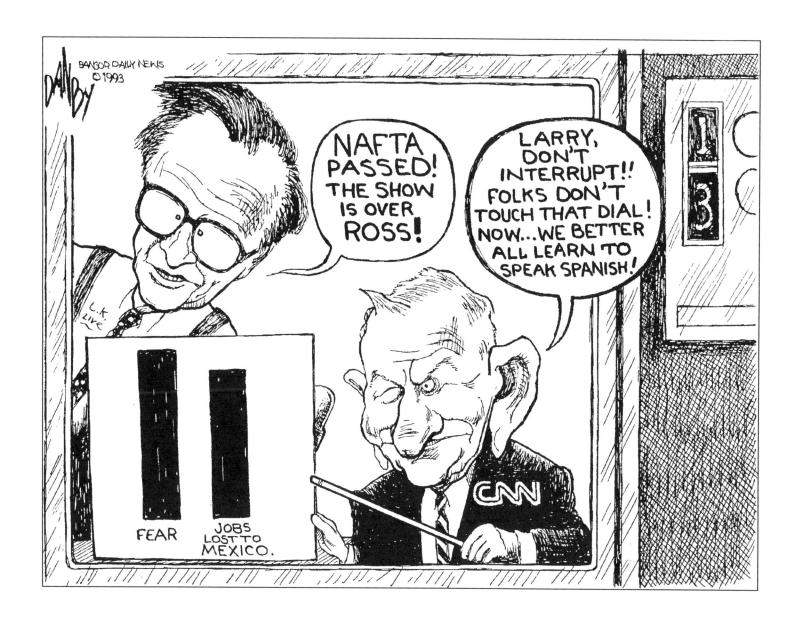

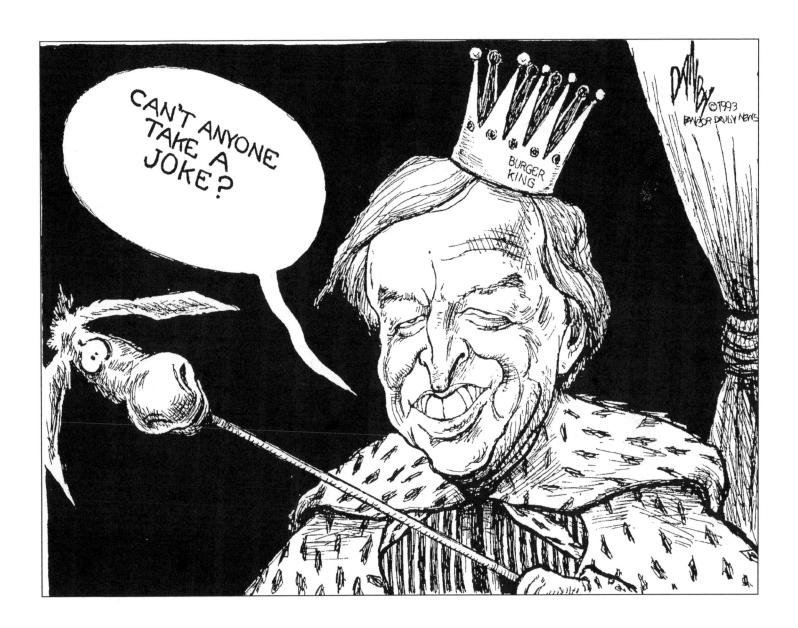

114

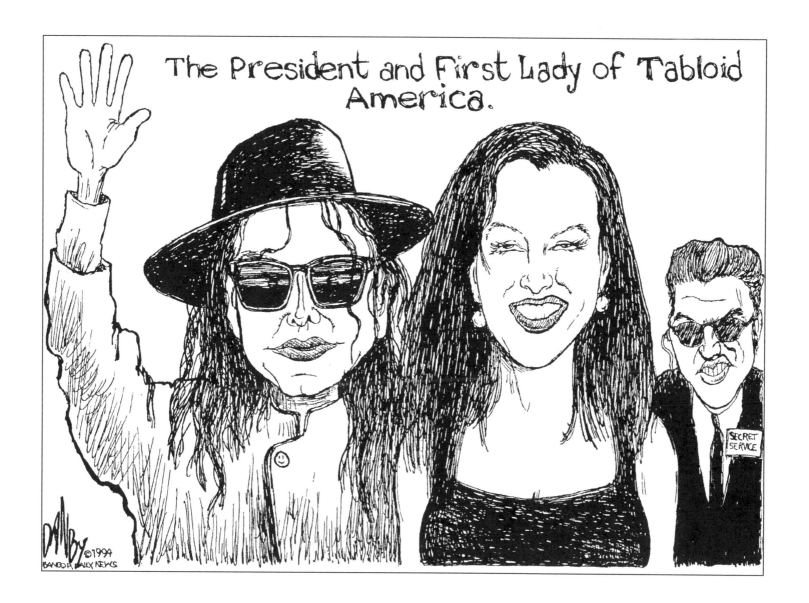

The President and First Lady of Tabloid America.

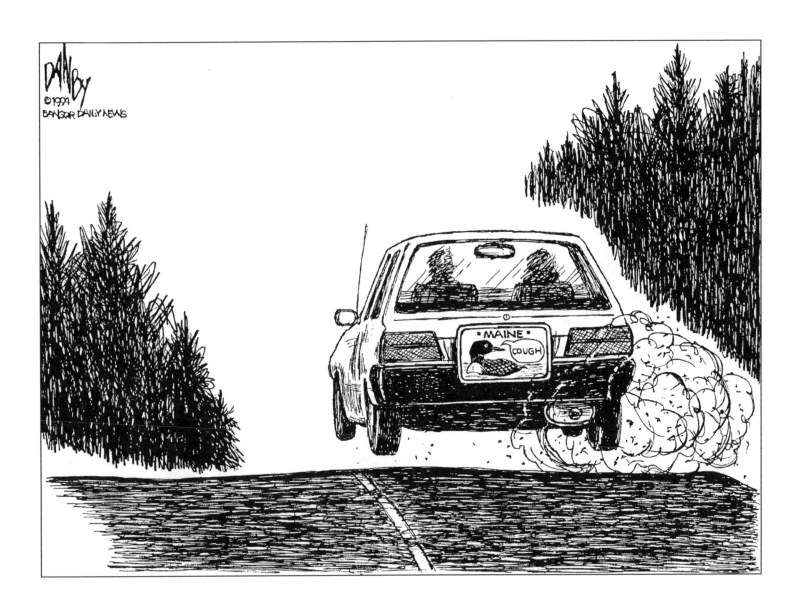

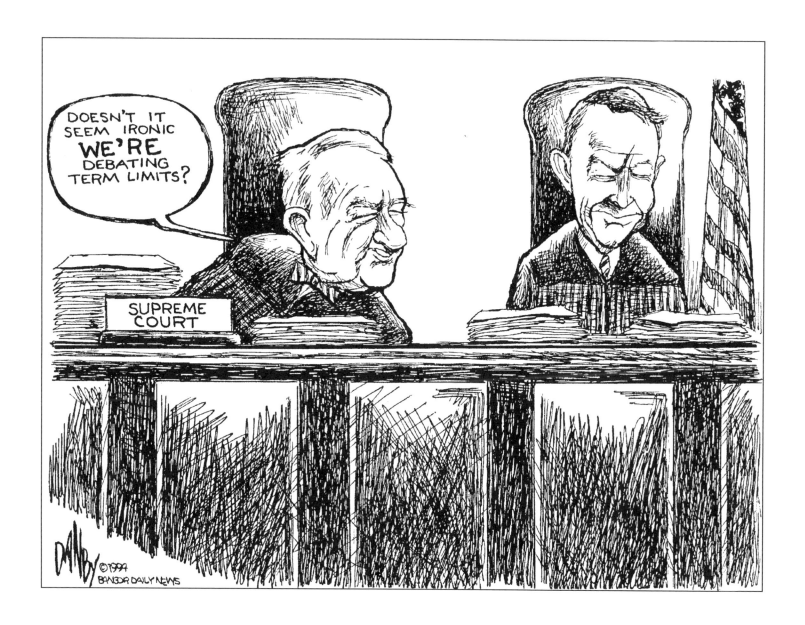

117

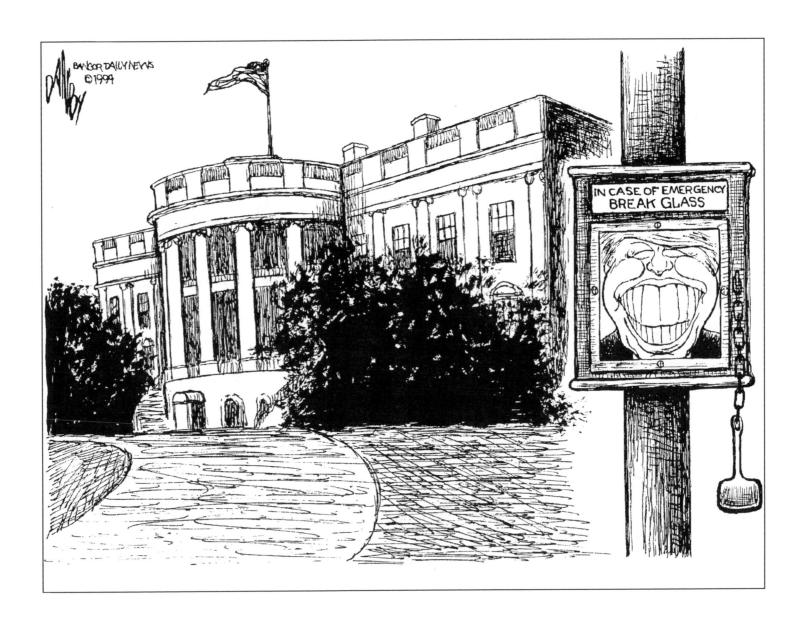

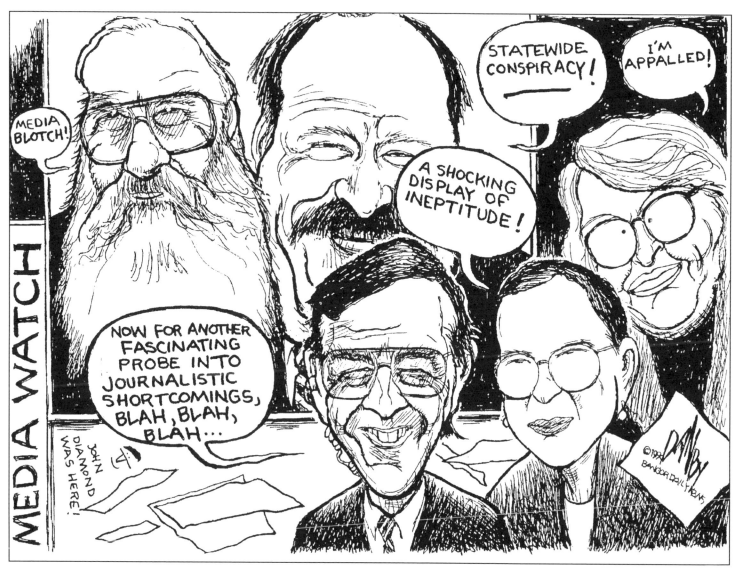

Maine Public Television's *Media Watch,* a weekly opinion show, became fodder for a cartoon. Host John Greenman decided to end the broadcast the week the cartoon appeared this way: "Thanks for watching, blah, blah, blah."

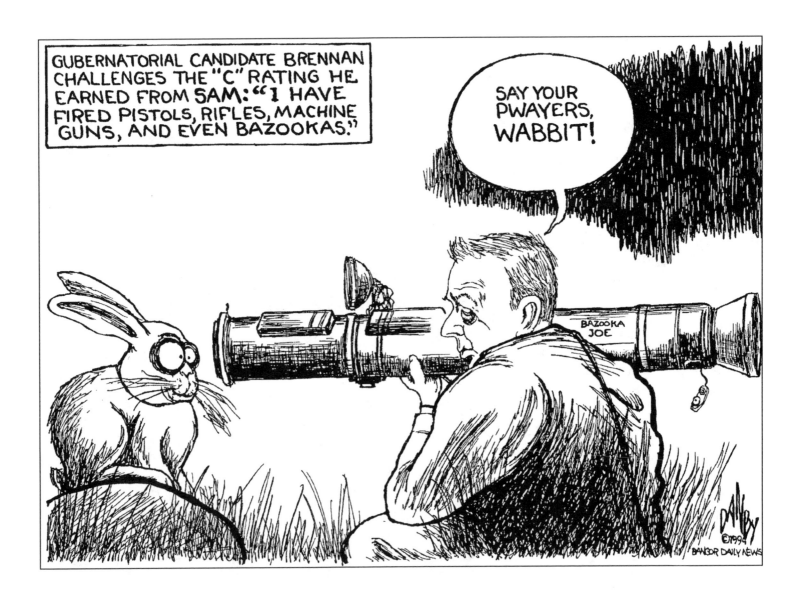

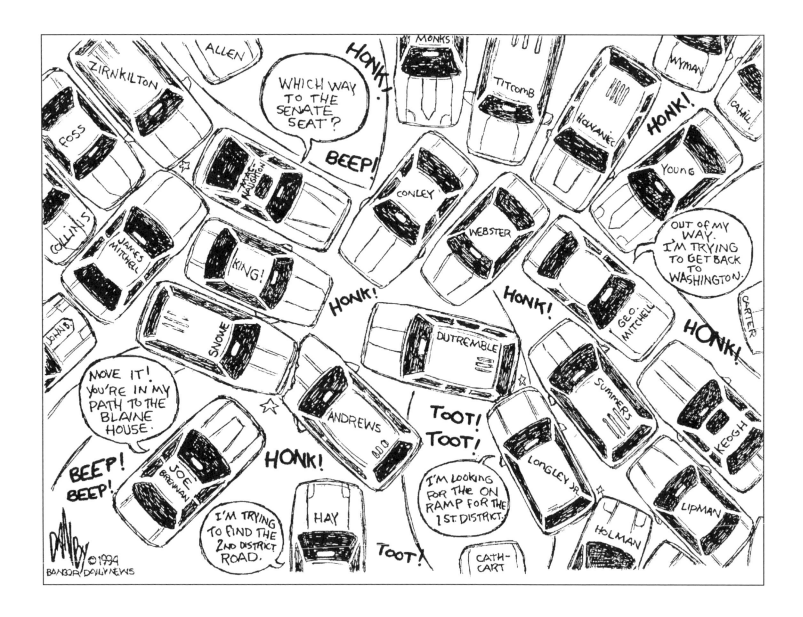

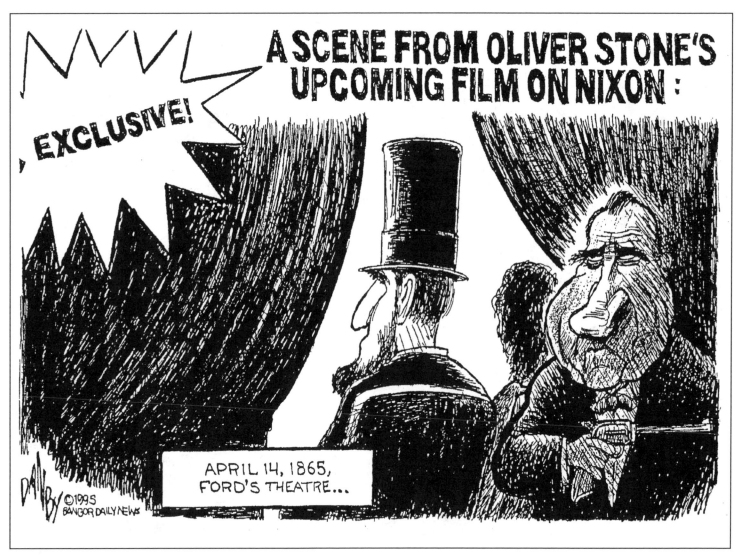

My favorite cartoon, appearing in the *New York Times* in 1995. This was the first published cartoon of former president Nixon that I drew. (When I started getting in print, Nixon had resigned and Gerald Ford was already president.)

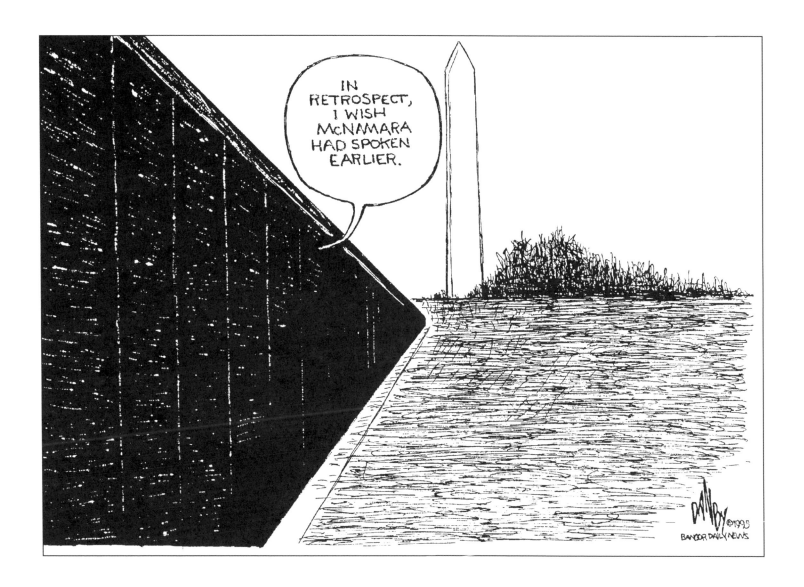

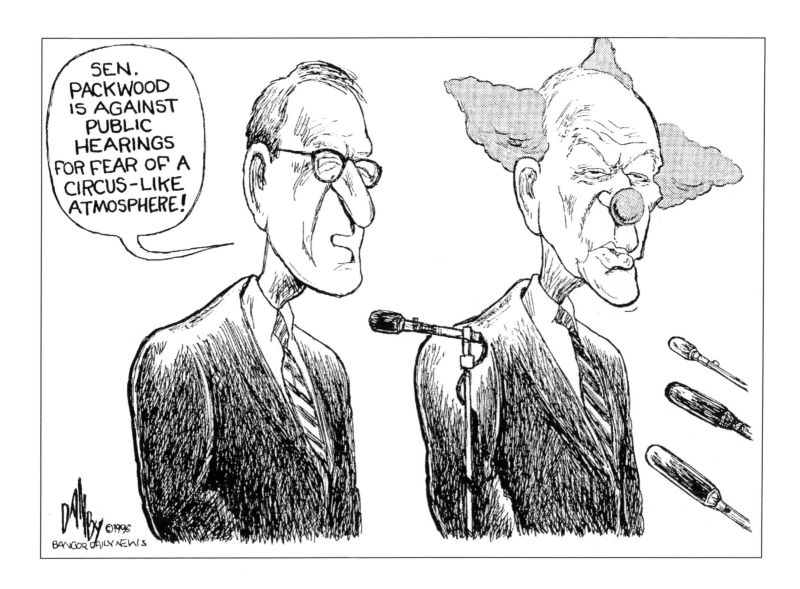

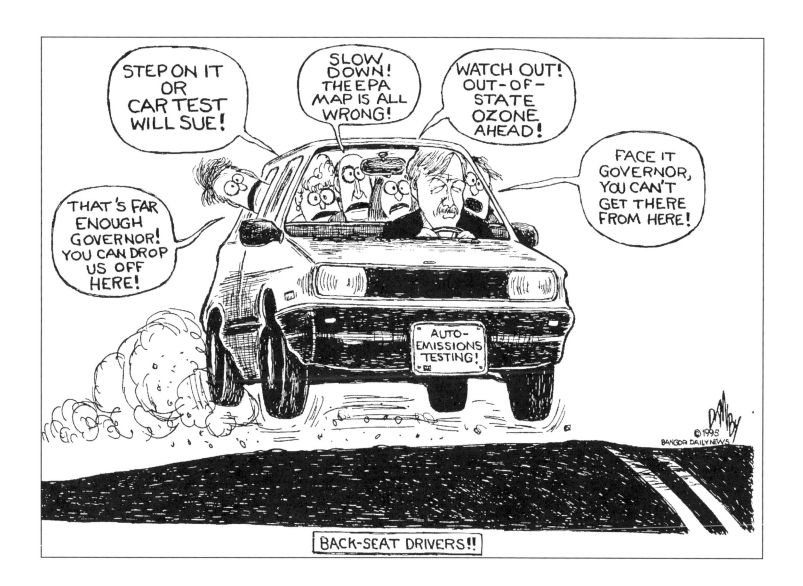

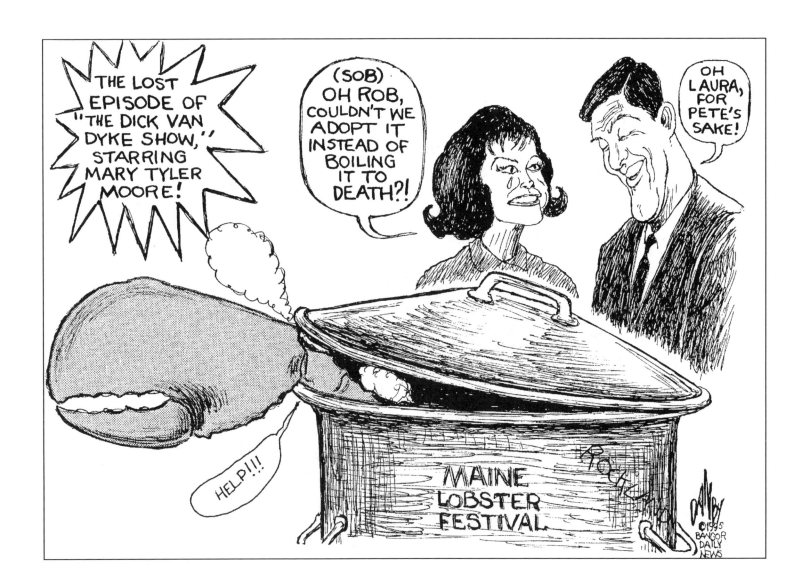

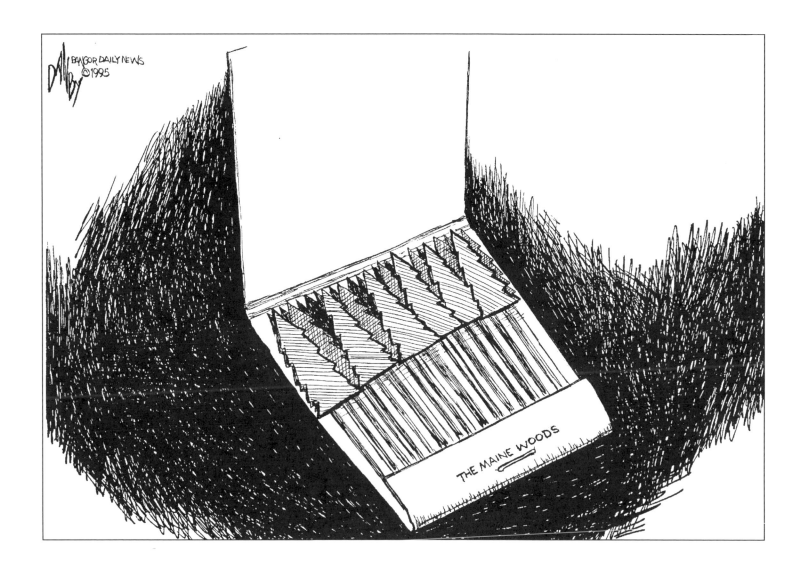

THE MAINE WOODS

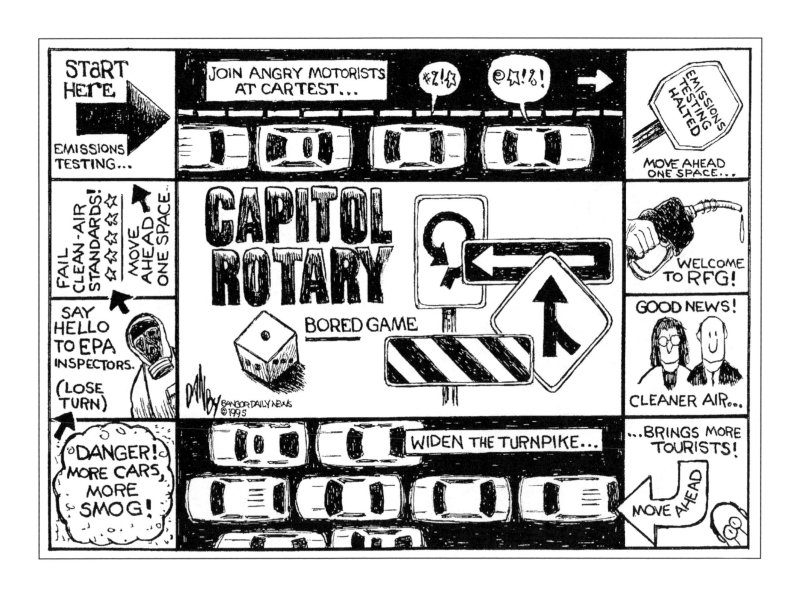

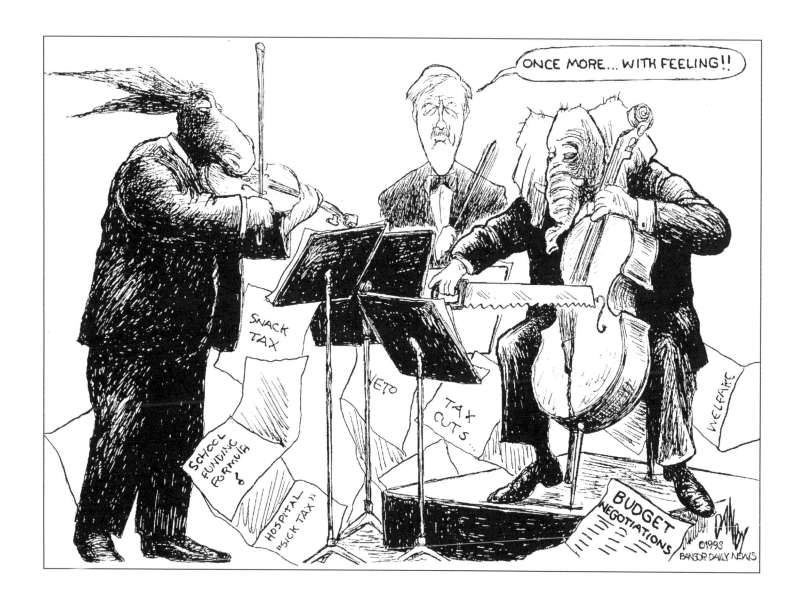

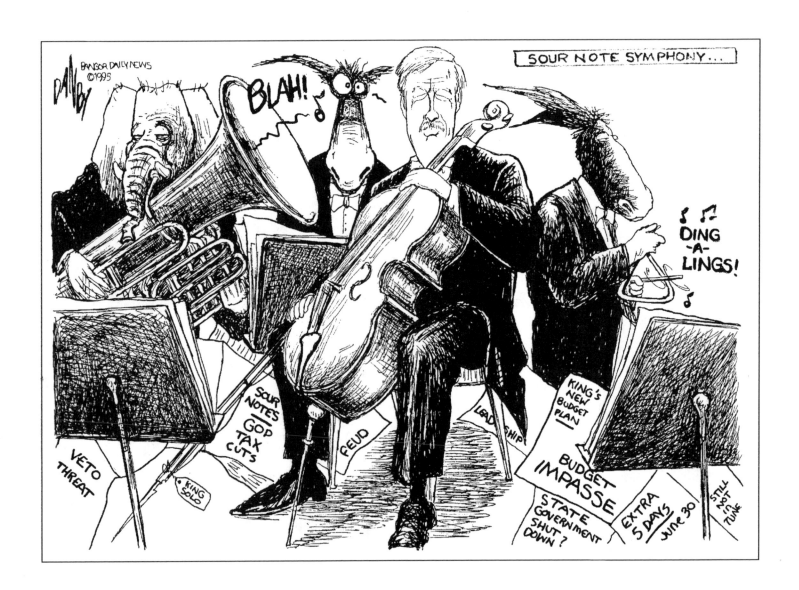

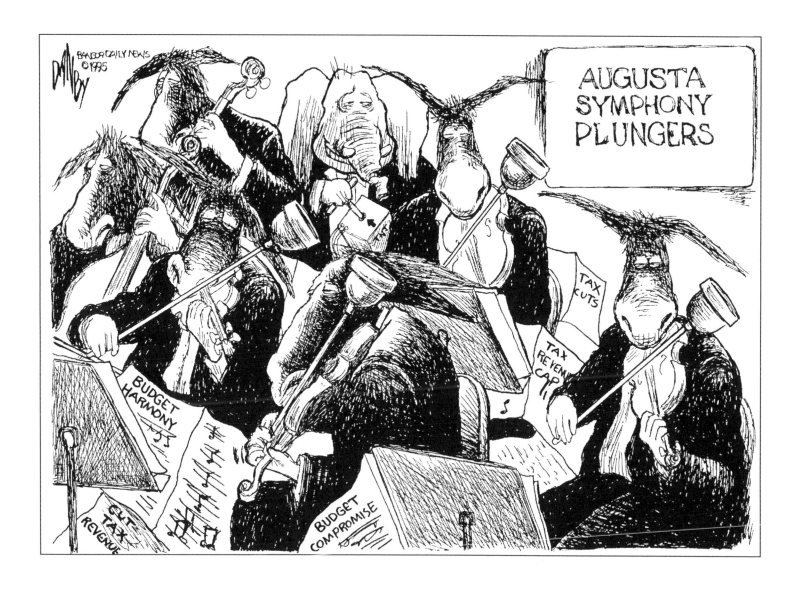

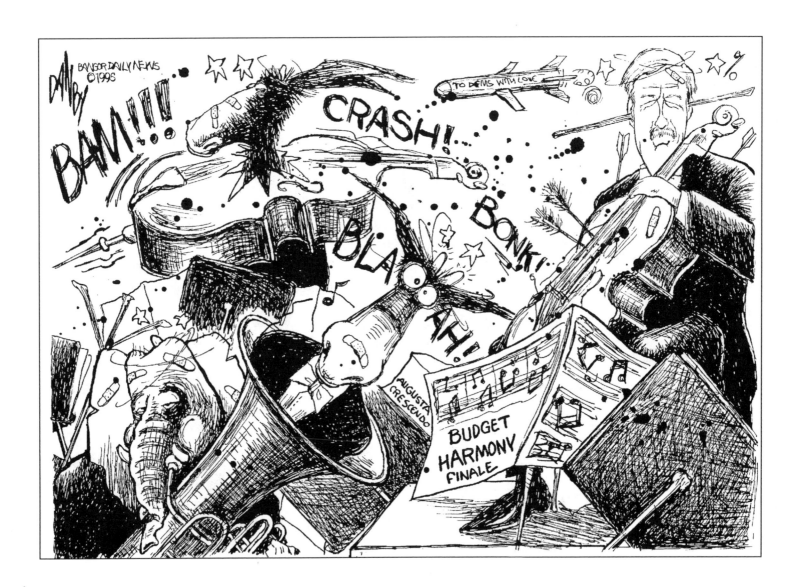

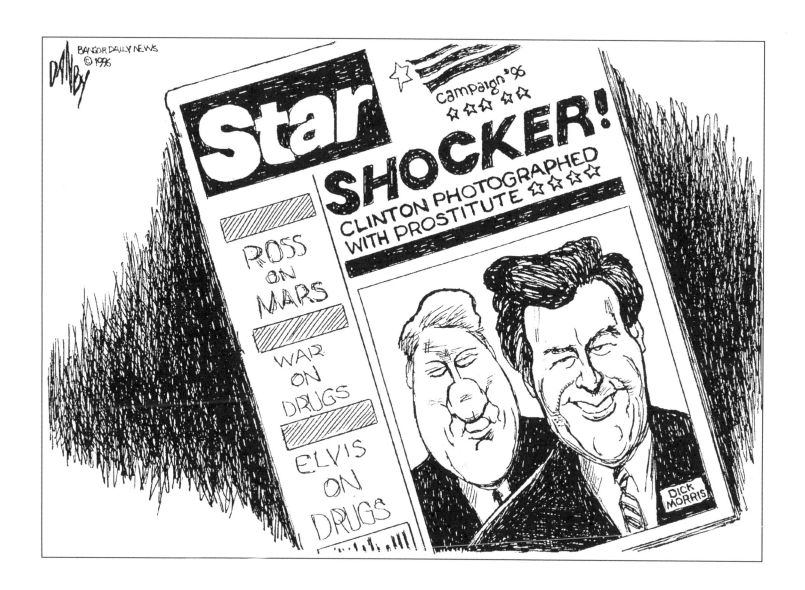

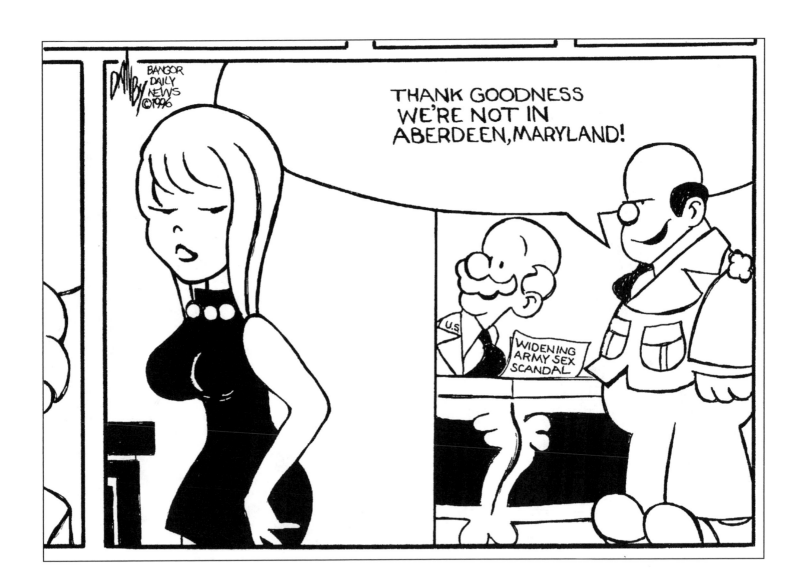

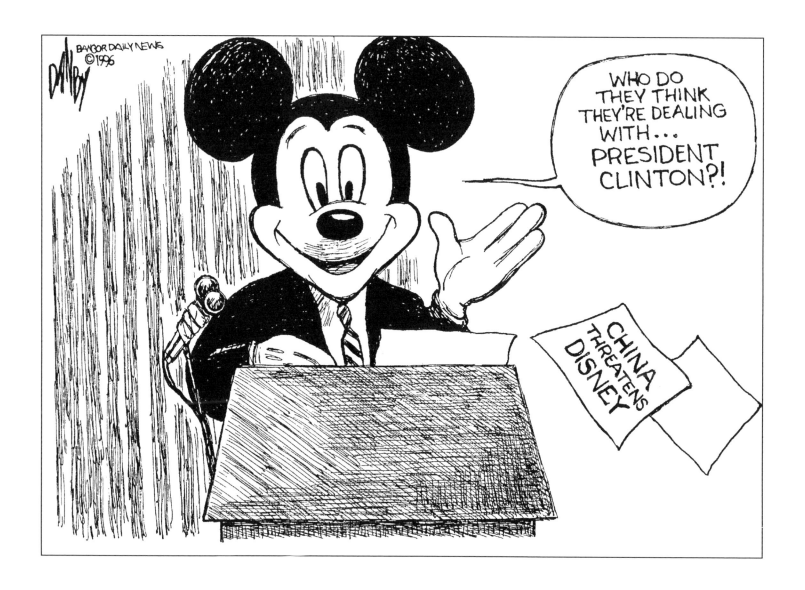

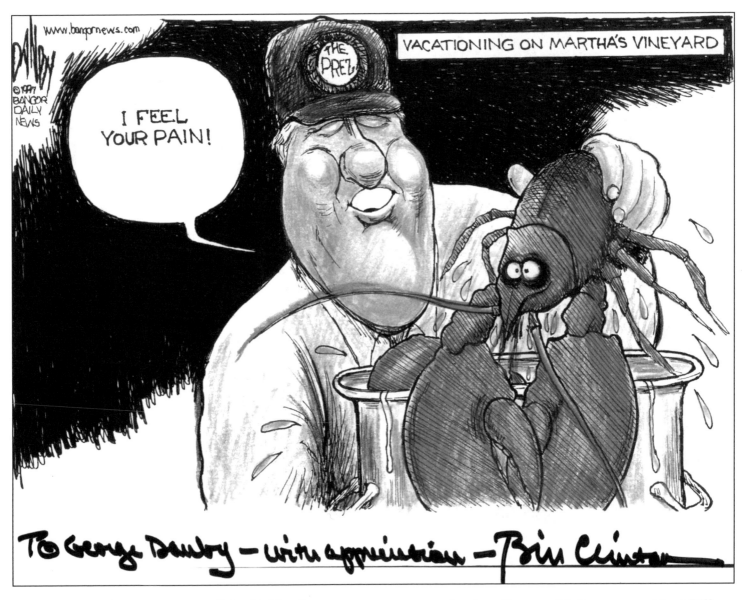

Lee Umphrey, former governor John Baldacci's press secretary, was having dinner with former president Bill Clinton one evening. I sent a cartoon along with Lee in hopes that Clinton would sign it; he did, but only after suggesting that I had drawn a horrible caricature.

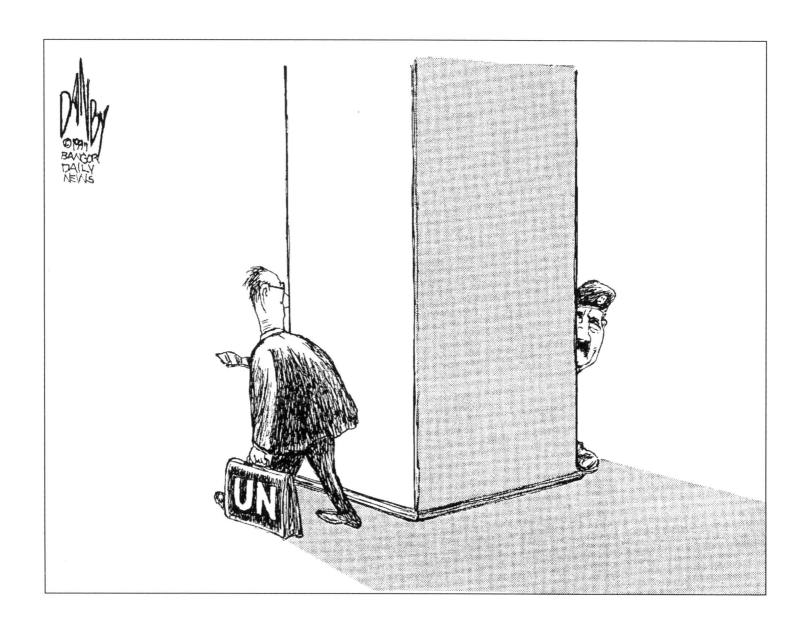

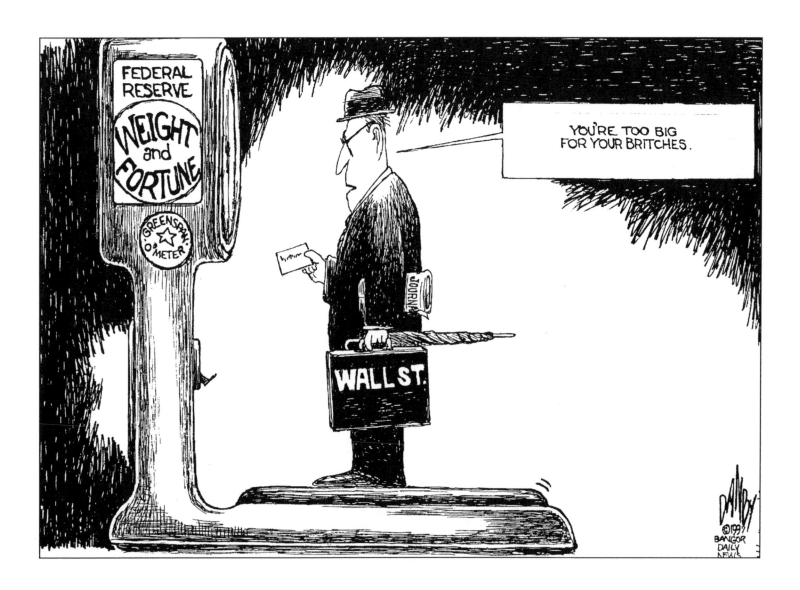

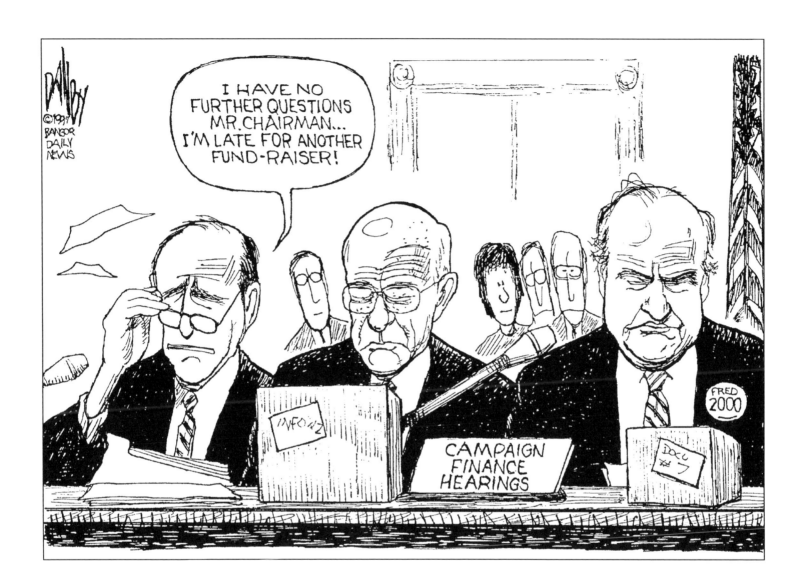

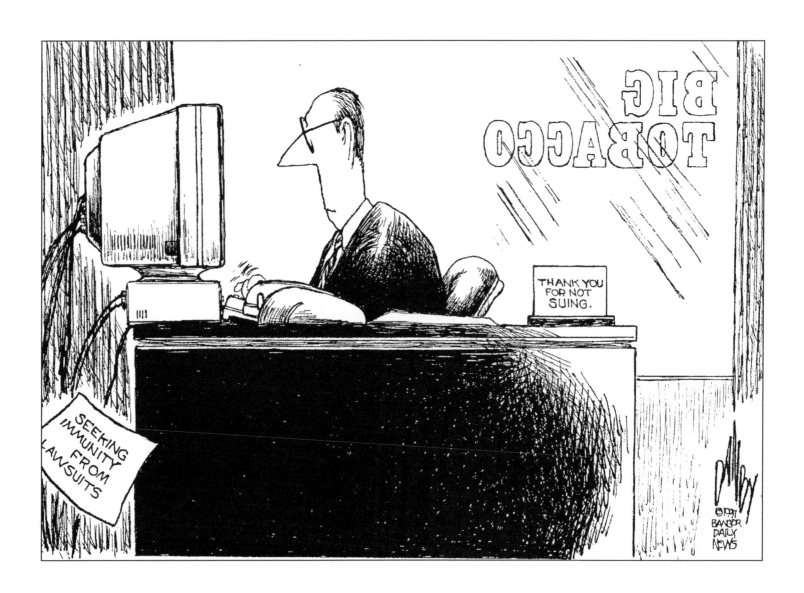

Intown 3 family 3 garages, 3 decks, basement, appli-
ances, storage, new back exits new furnace, new stove on
1st floor, newly painted ~~~~~~~~~~~~~~~~~~~~~ or
~~~~~ BRUNSWICK

Historic 3 story 30x70 building in Downeast Coastal Vil-
lage w/consignment clothing store and building supply
store and movie theater (needs finishing) w/35mm projec-
tor, corner lot across from Pennamaquan River ~~~~~~
72~~~~~~~~~~~~~~~~~~~~~~~~~~~~~~~~~~~~

Historic 30x70 3 story building w/2 stories as movie
theater (not being used) completely renovated, 2 bdrm.
house, new ~x80 garage building on corner lot, river
view, coastal village ~~~~~~~~~~~~~~~~~~ PEM-
BROKE

3 BR ranch w/attached 2 car garage & breezeway, 2
acres, full basement, monitor heat, fireplace, great for
pets, $8~,000, 20 min. from Portland ~~~~~~ W
B~~~ON

Idled nuclear power plant, troubled history,
needs repairs & tests. $257 mil. or best offer.
882-6321 WISCASSET

Belgrade Lakes, Long Pond, Rt 27, just beyond Rome
town line, camp, 2 BR ~~~~~~~~~~~~~~~~~ appli-
ances, screened porch, sandy beach, includes boat/motor,
$49,500, call after ~~~~~~~~~ TOPSHAM

Farmington. 112 acres on SE side of Mtn.. drinkable

land, $39,900 no owner financing. ~
Camp, Plunkett Pond, Benedicta, ~
nace, new roof, elec. phone, insula
mi from 105 ~~~~ close to snowmob
$17,000 ~~~~~~~ E. MILLINOCI

House lot in Robbeborn. Only $11,
(site of org. town meeting house).
foundation, lawn. Construction m
Now ~~~~~~~~~~~~ WALDOBOR

Moosehead Lake camp, NE Carry.
renovated, 150' frontage, long ~
swimming, a very clean camp tha
frontage, asking ~~~~~~~~~ ~

Casco property, corner of Rt. 11 &
cial building w/3bdrm house, Liqu
~~~~ SCARBOROUGH

30x30 Retail Building, B-1 zone, h
sure, parking ~~~~~~ After 5:30
~AND

Damariscotta Lake. 2 3-b~
frontage. Great cond.
DAMARISCOTTA

3 BR single family,
back yard. For sa~
Fairview School
AUBURN

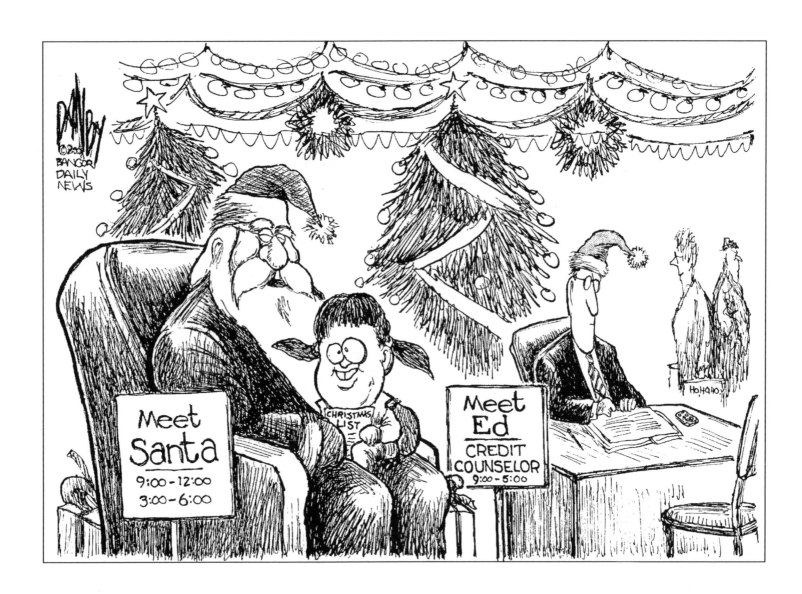

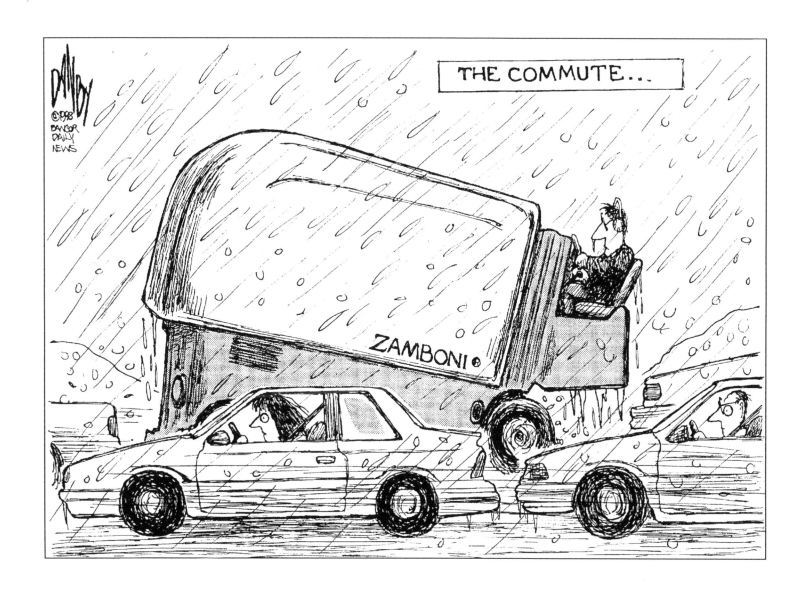

THE COMMUTE...

ZAMBONI ®

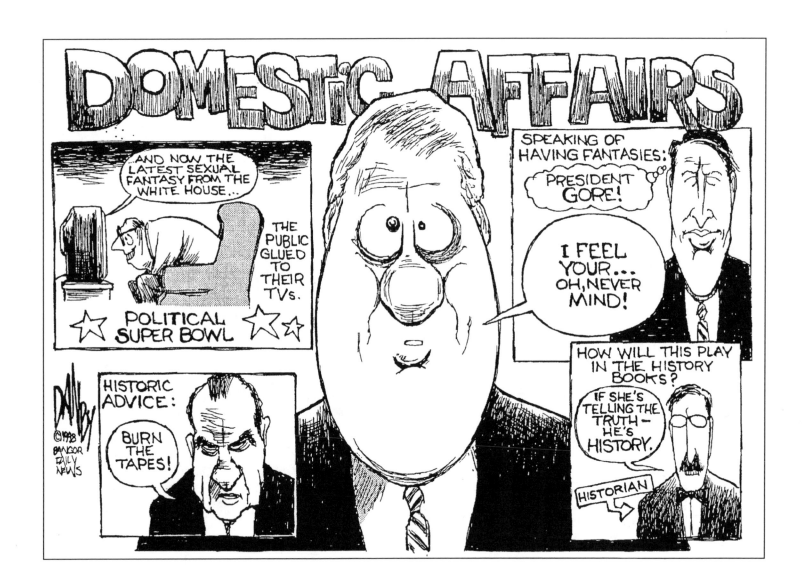

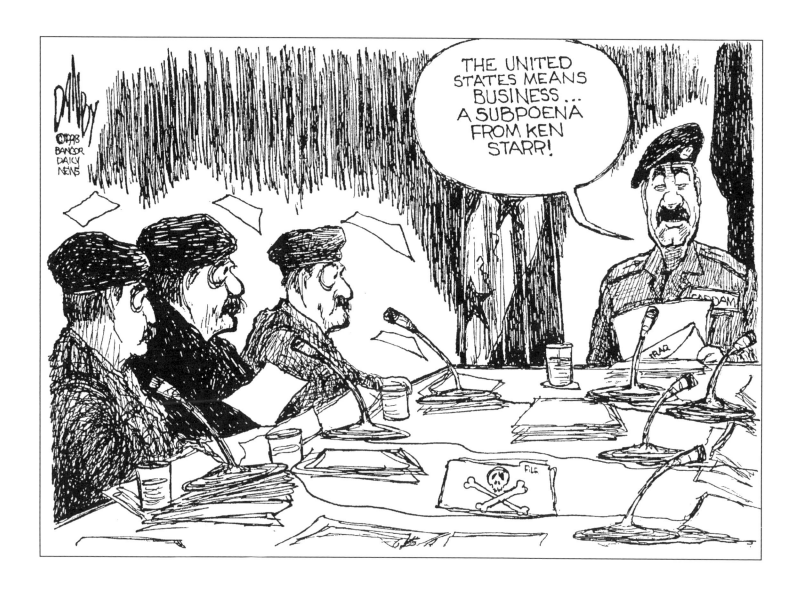

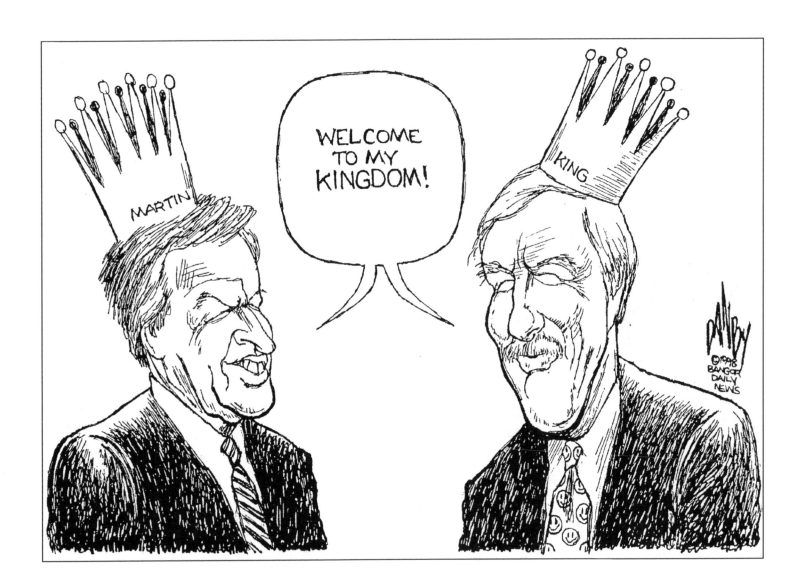

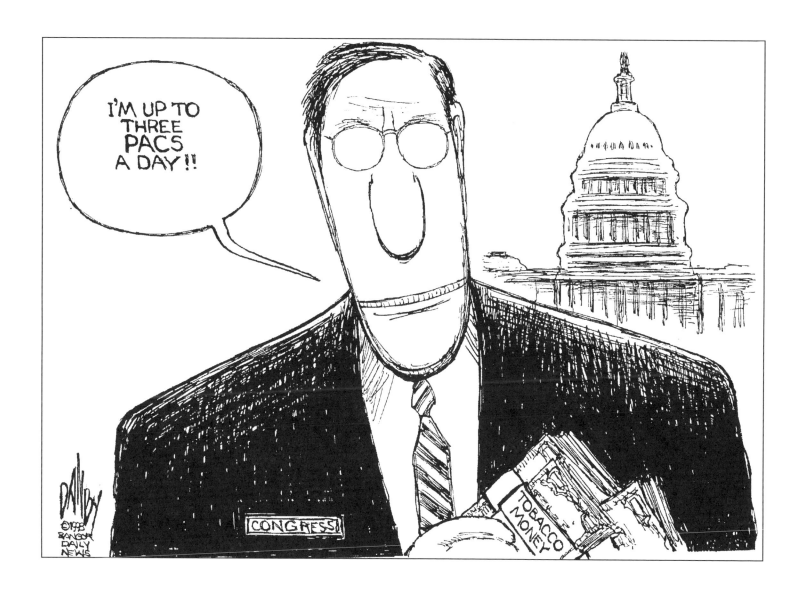

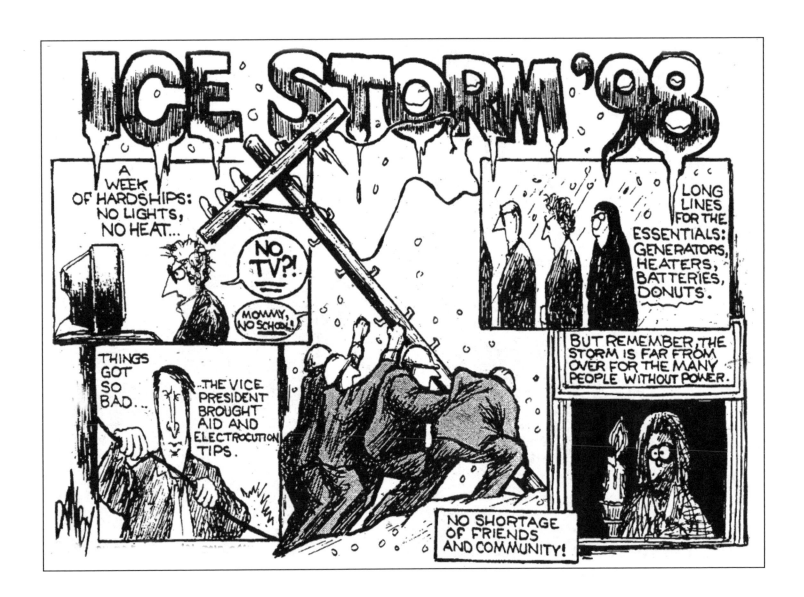

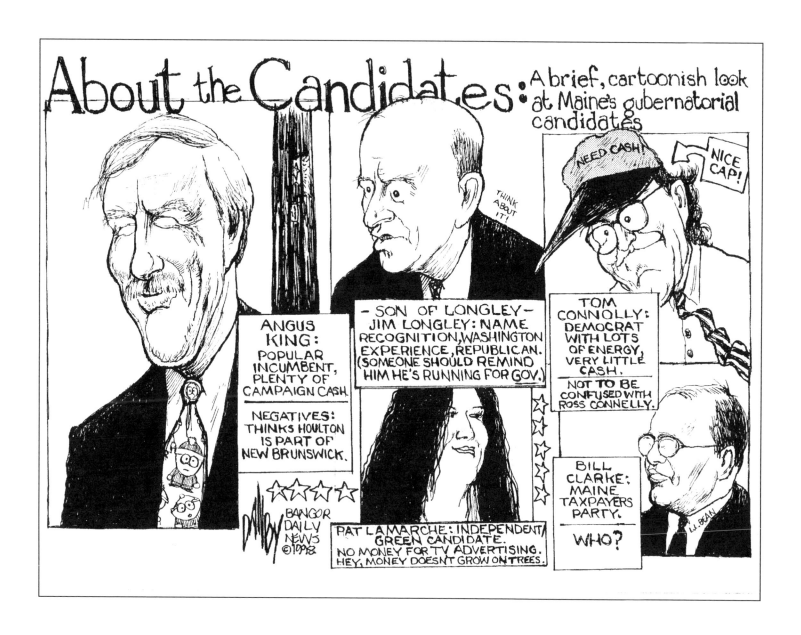

149

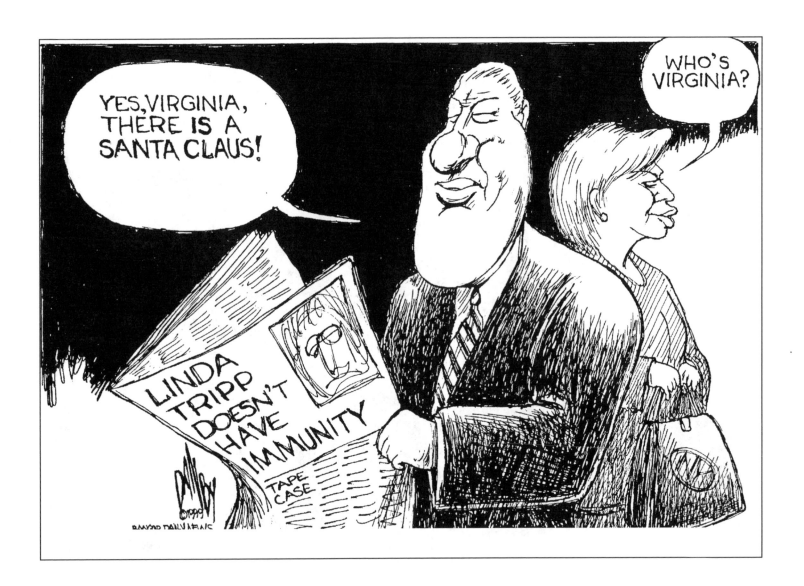

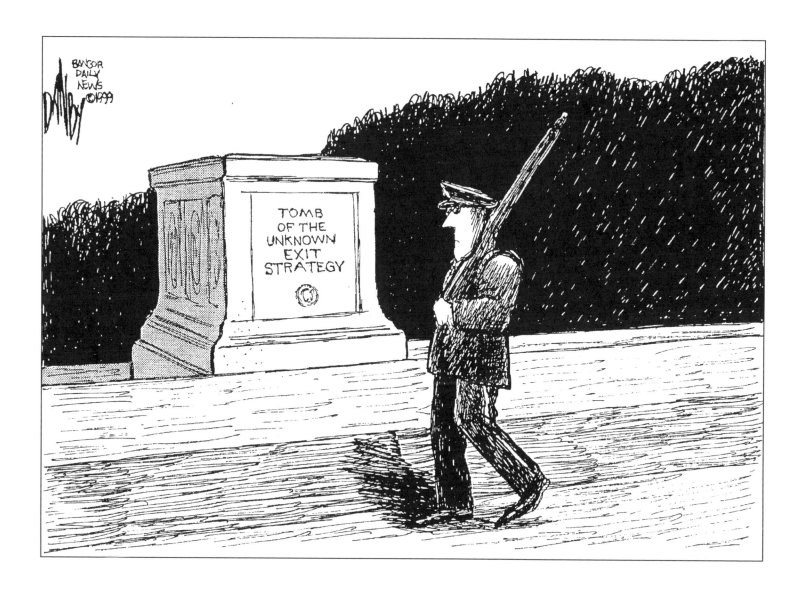

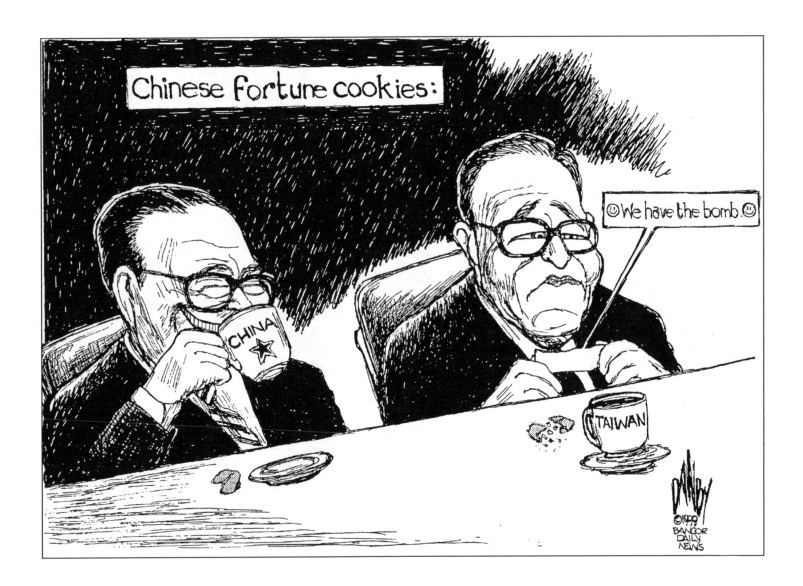

152

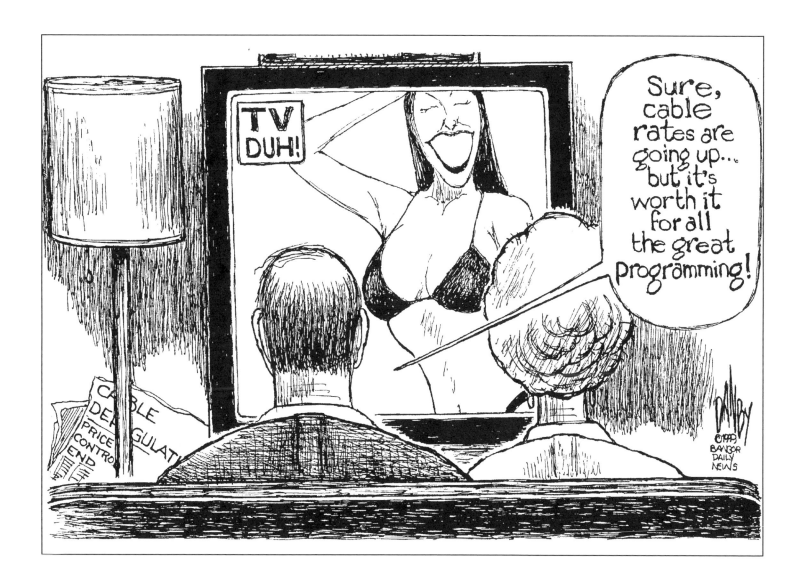

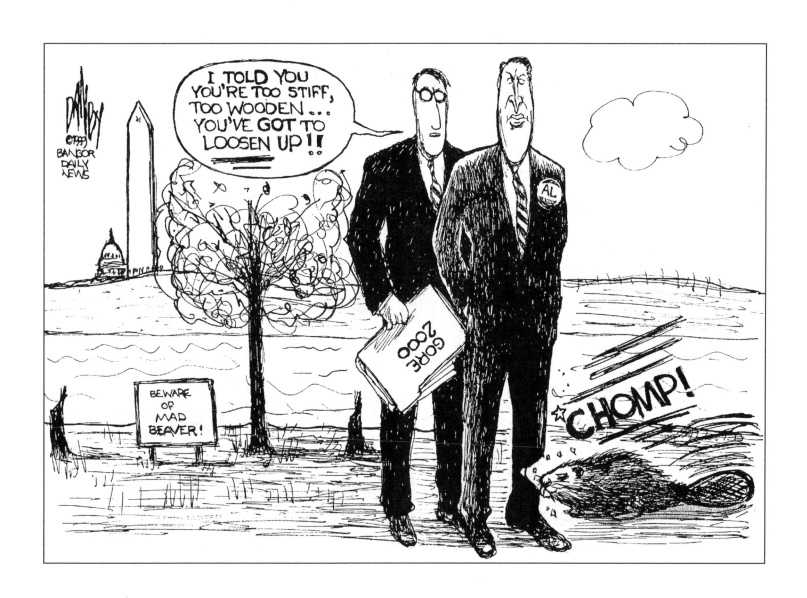

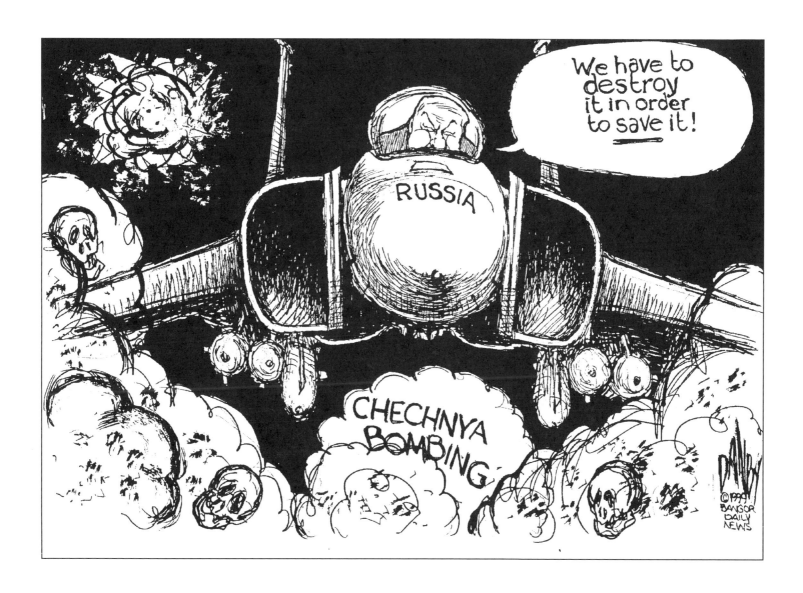

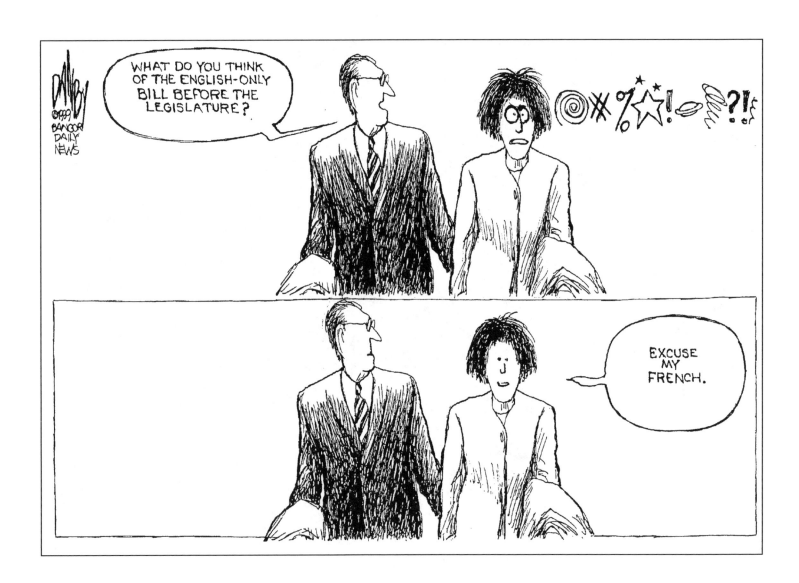

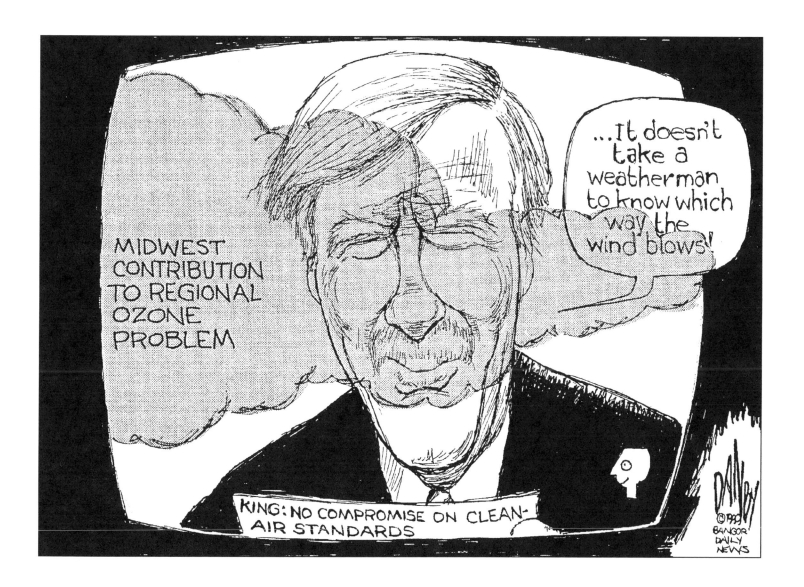

157

THE
2000s

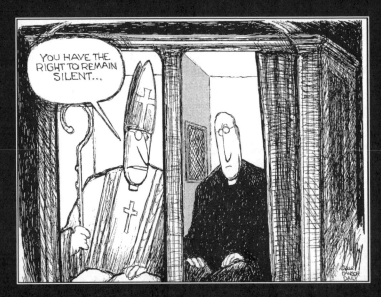

2000s

As you probably know, the turn of the century happened without a hitch. However, technology has its faults. Electronic voting led to a heated standoff between presidential candidates Al Gore and George W. Bush during the 2000 election. Gore's refusal to concede led me to draw one of my favorite cartoons: a bird's-eye view of the White House, with Bush moving vans at the North Portico and Gore moving vans at the South Portico.

Ultimately, Bush was named president, winning the electoral count 271 to 266. His first year as president was rocked by the terrorist attacks on September 11, 2001. Two planes hit each tower of the World Trade Center in Manhattan, while a third clipped a corner of the Pentagon in Washington, D.C., and a fourth managed to be diverted, crashing in a Pennsylvania field. Nearly 3,000 people died in the wake of these attacks.

The platforms Bush touted during his campaign were set aside to address homeland security and deploy troops to Iraq to target al-Qaeda, the extremists believed to be behind the terrorist attacks. Troops invaded Iraq to overtake the country's president, Saddam Hussein, and also to find al-Qaeda founder Osama bin Laden. Both men were killed by American troops, who continue to have a presence in Iraq and Afghanistan.

Meanwhile, I had fun sketching the president and was thankful for his selection of vice president. Bush and Vice President Dick Cheney made for eight years of caricature fun.

By the time Bush was leaving office and America was electing the country's first African-American president, Barack Obama, an economic crisis was brewing. Workers were laid off in droves, financial institutions crashed, companies filed bankruptcy, and the stock market took a steep dive.

Maine was not isolated from the economic downturn. Jobless rates were high, but the entrepreneurial spirit of most Mainers took over to compensate for the struggling economy. Since the 1970s, tourism numbers rose from about 10 million annual to 45 million visitors in 2004. Even Obama brought his family on vacation in Maine.

In the latter part of the decade, the movement to legalize same-sex marriage made its way to Maine. Governor John Baldacci signed a 2009 bill into law ending discrimination against same-sex couples. Six months after he signed the bill, 53 percent of Maine voters chose to repeal the measure. There were many headlines that led me to sketch Baldacci, but he was never comfortable being caricatured. He called frequently to complain, mostly to point out that I drew him with less hair than he really had.

By this point in my career, my cartoons had a distinct style and an illegible scribble for a signature. I was known nationally and applauded for my critical eye toward many subjects. However, some headlines require a somber and respectful tone. The obituary cartoons marking the passing of *Peanuts* creator Charles Schulz, pop king Michael Jackson, and news king Walter Cronkite received national attention. The simplistic cartoon of the CBS logo shedding a tear for Cronkite's passing produced the most mail I have ever received.

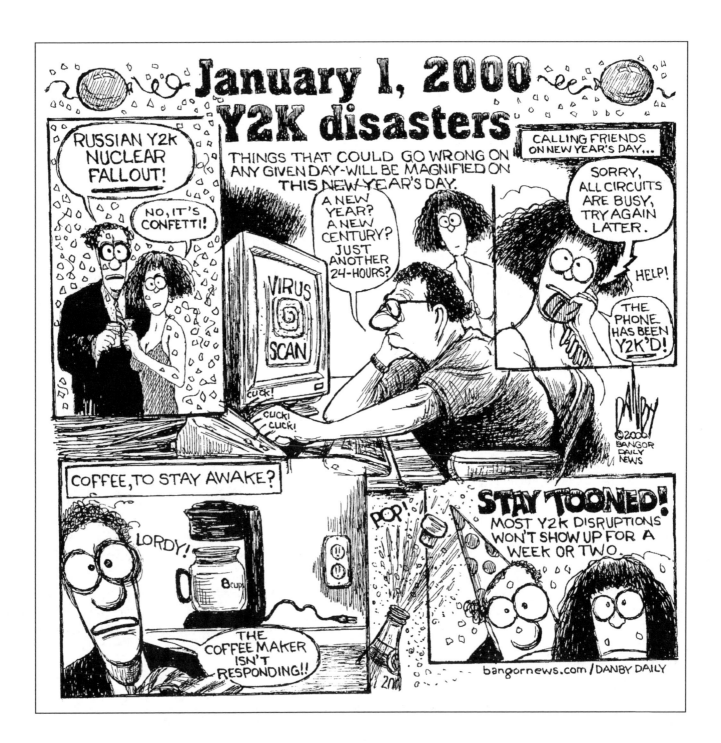

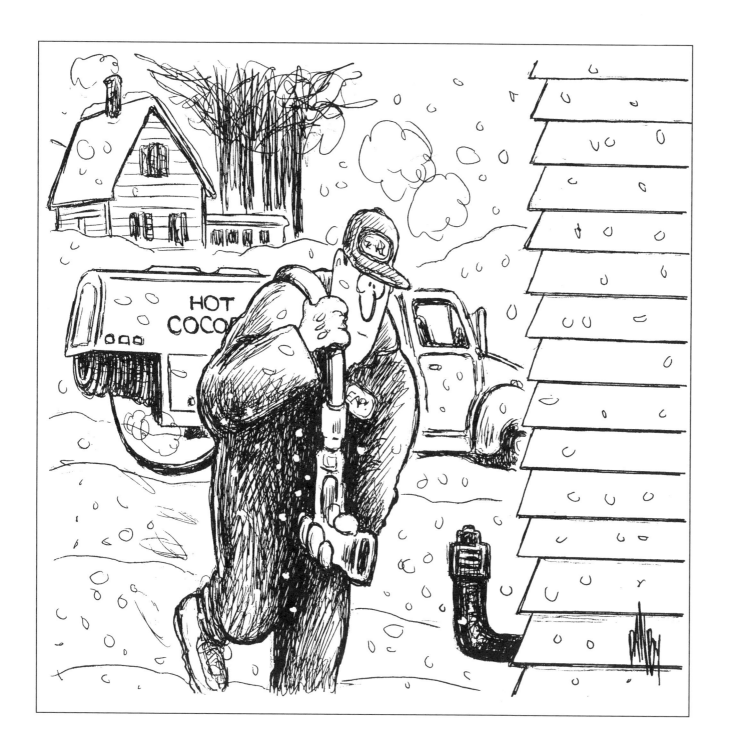

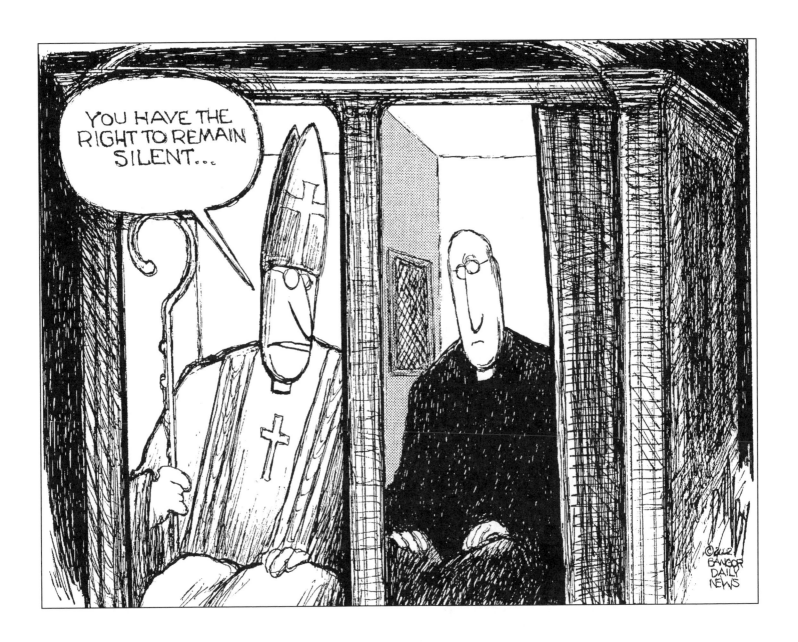

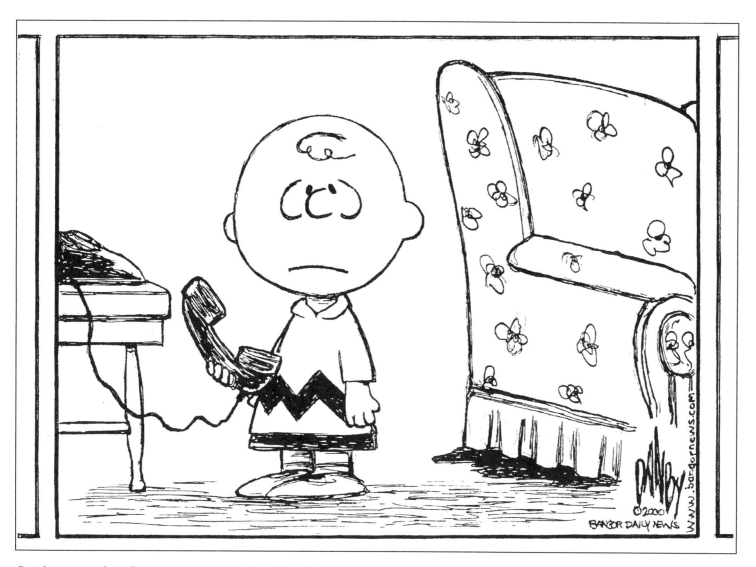

On the news that *Peanuts* creator Charles Schulz had died.

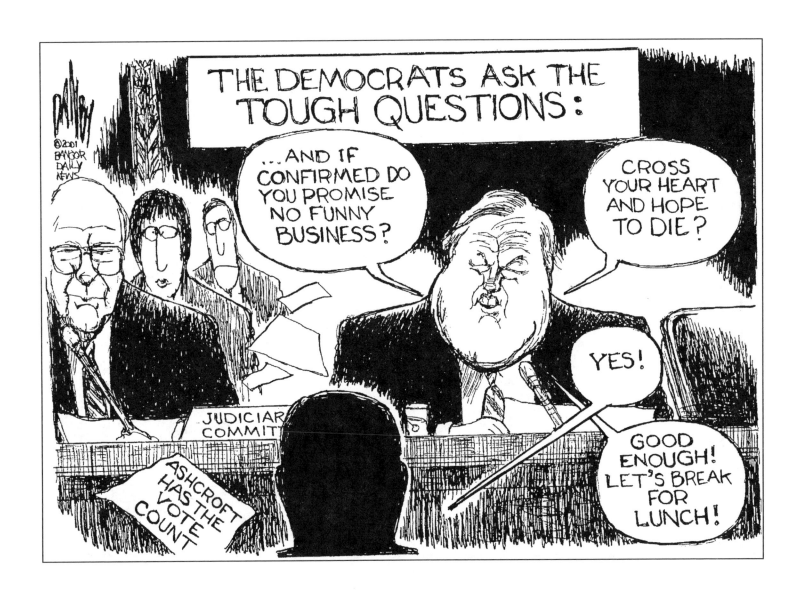

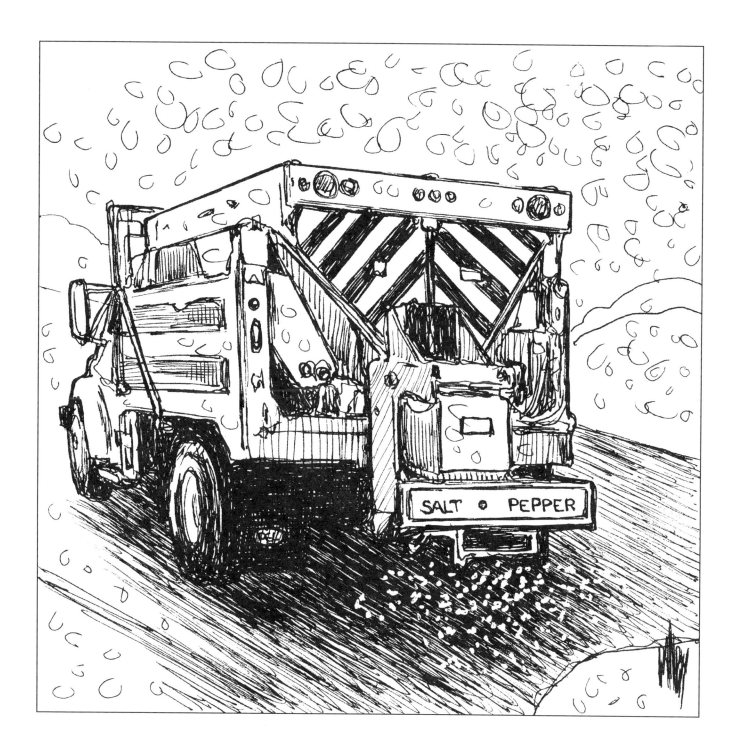

New York SHOCK Exchange... Standard & Poorhouse... Up & Down Jones Industrial Average... Nasdrek........

Market Update

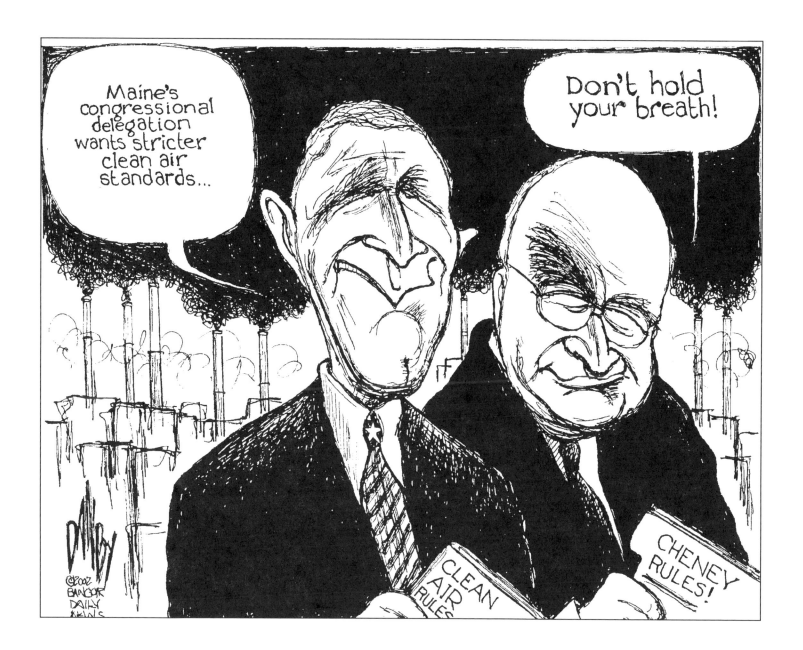

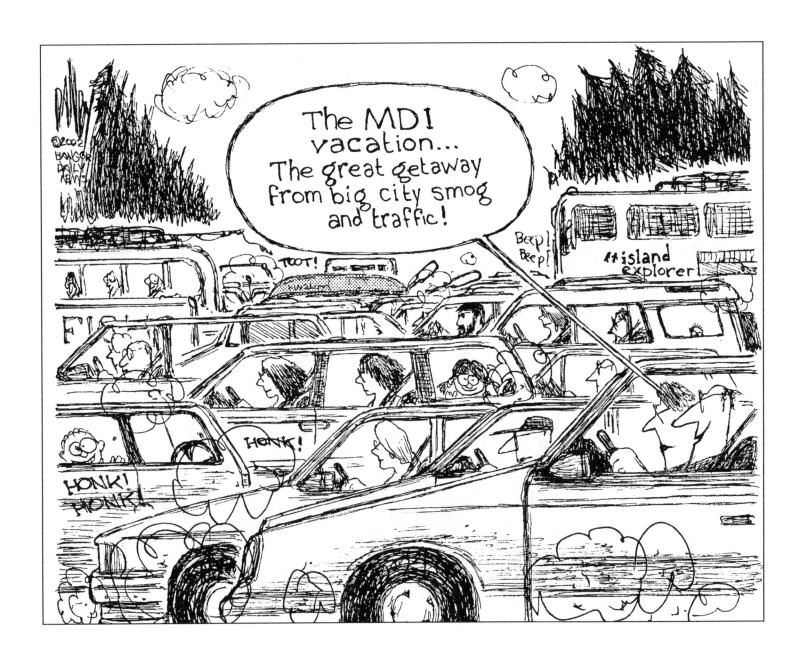

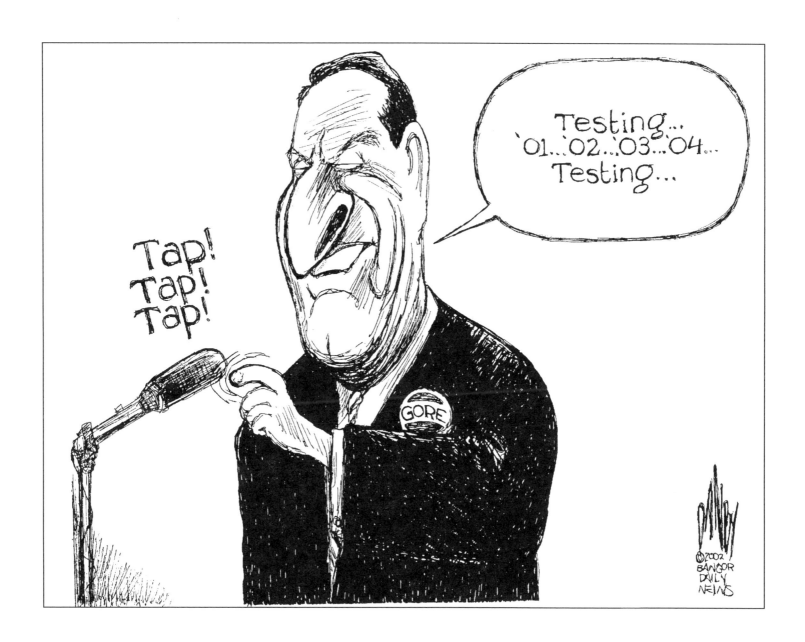

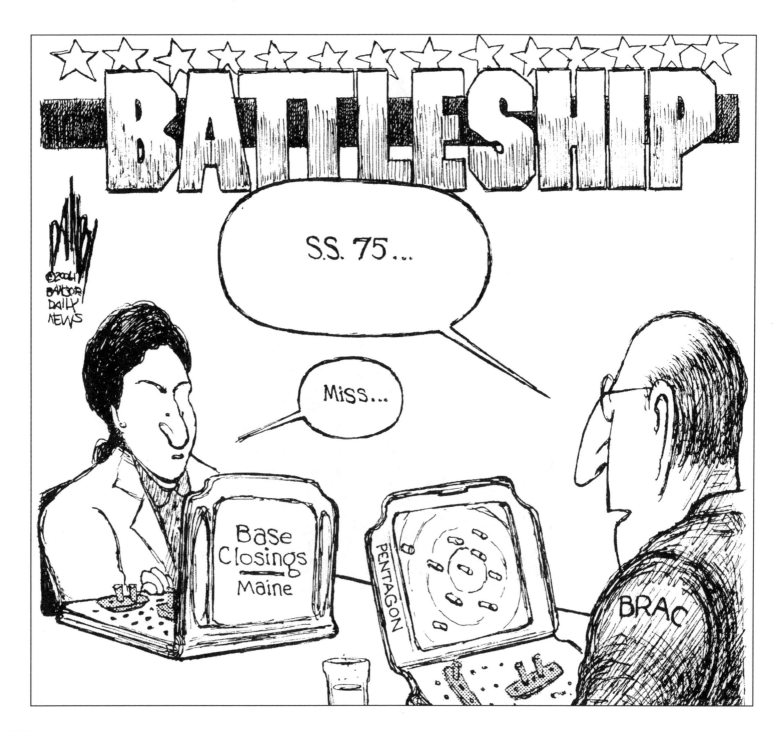

170

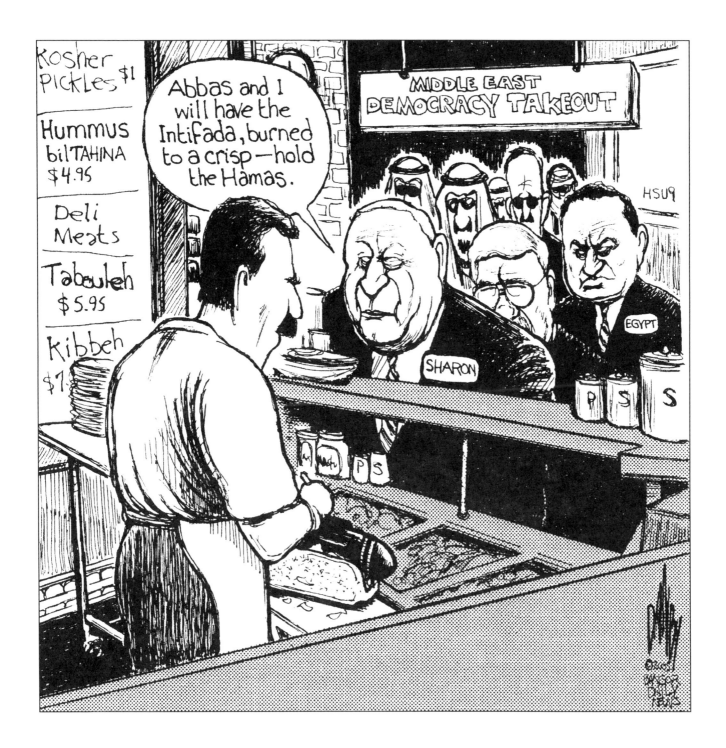

171

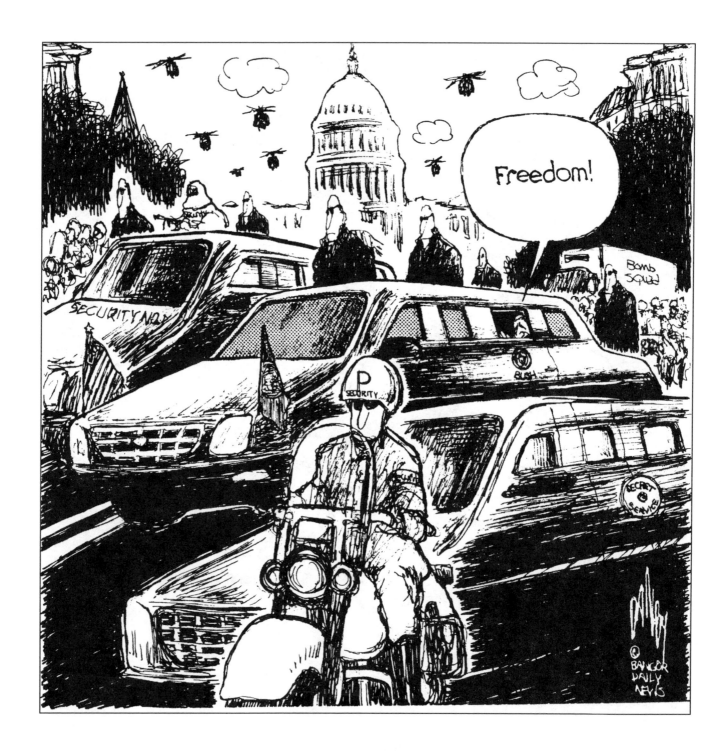

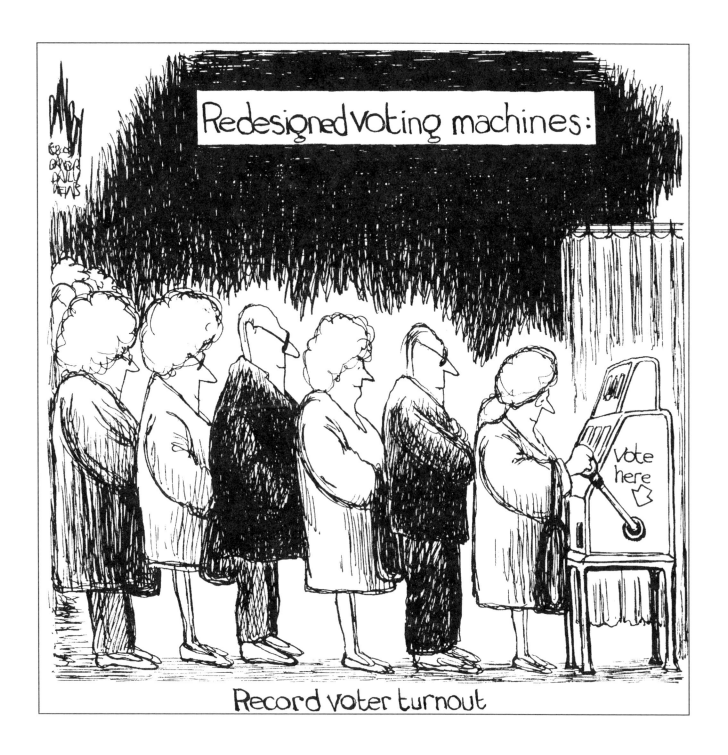

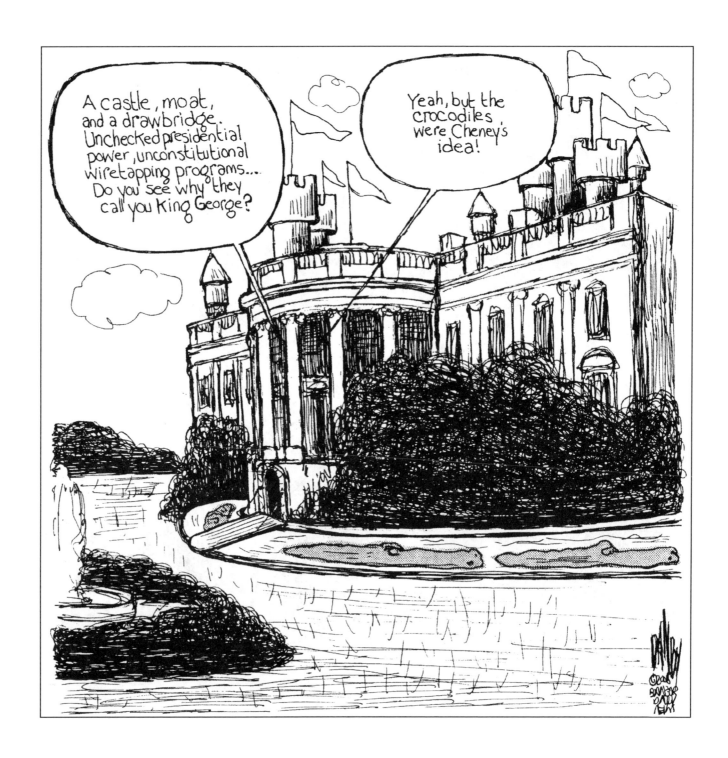

174

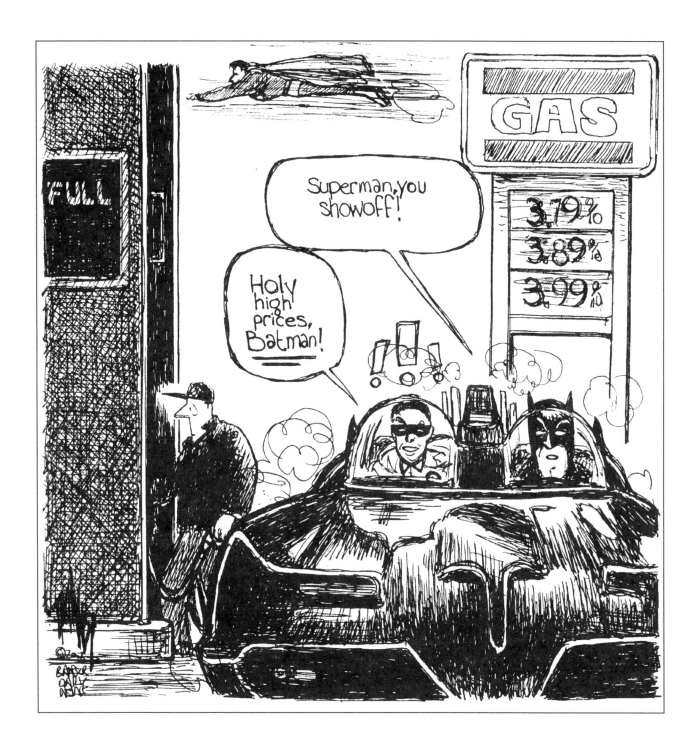

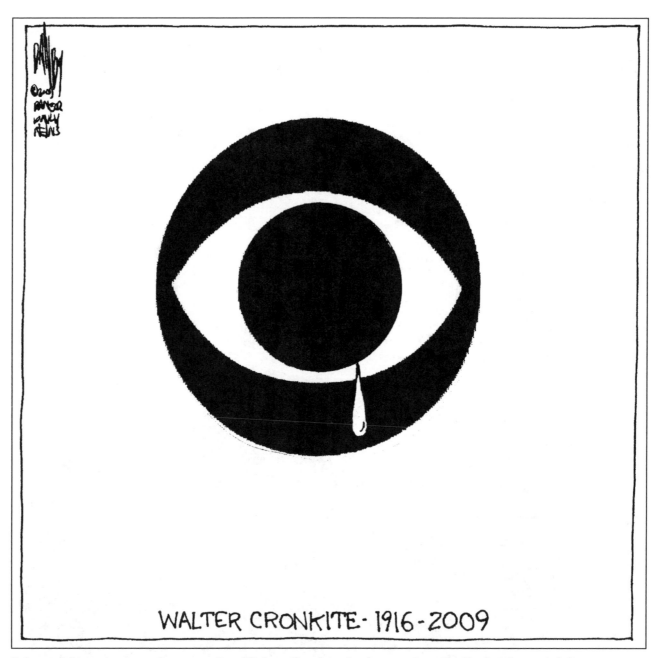

WALTER CRONKITE · 1916 - 2009

I drew this cartoon on the news that Walter Cronkite had passed away. Probably one of the—
if not *the*—most popular cartoon that I drew.

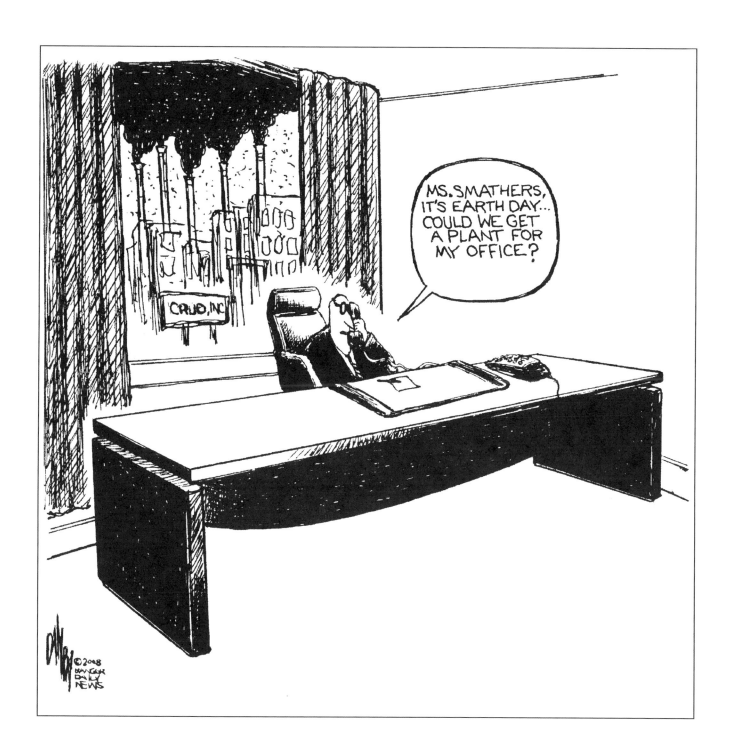

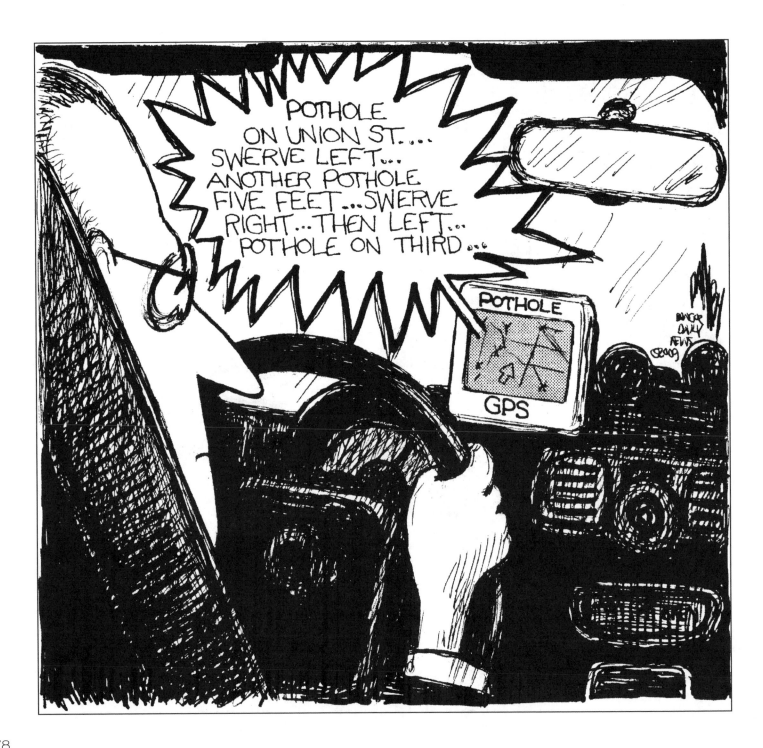

178

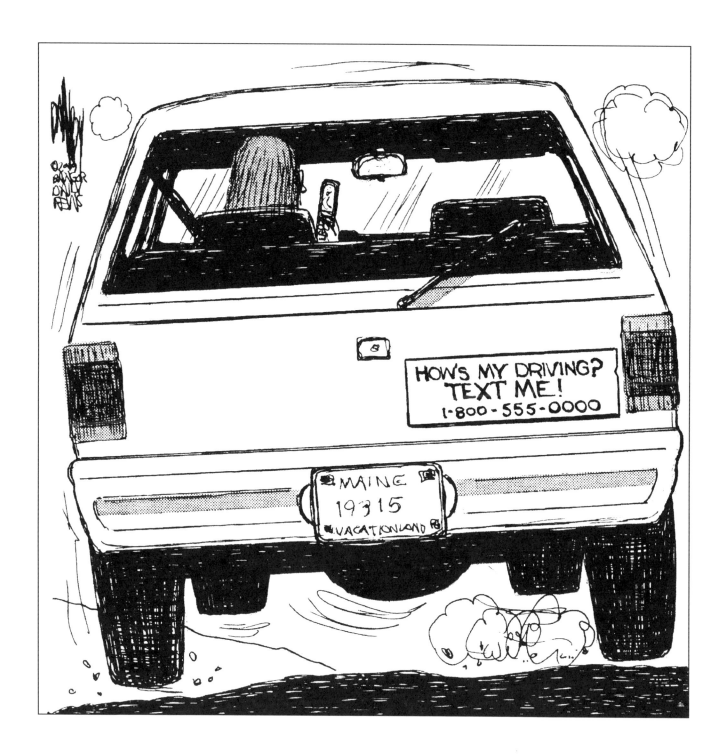

179

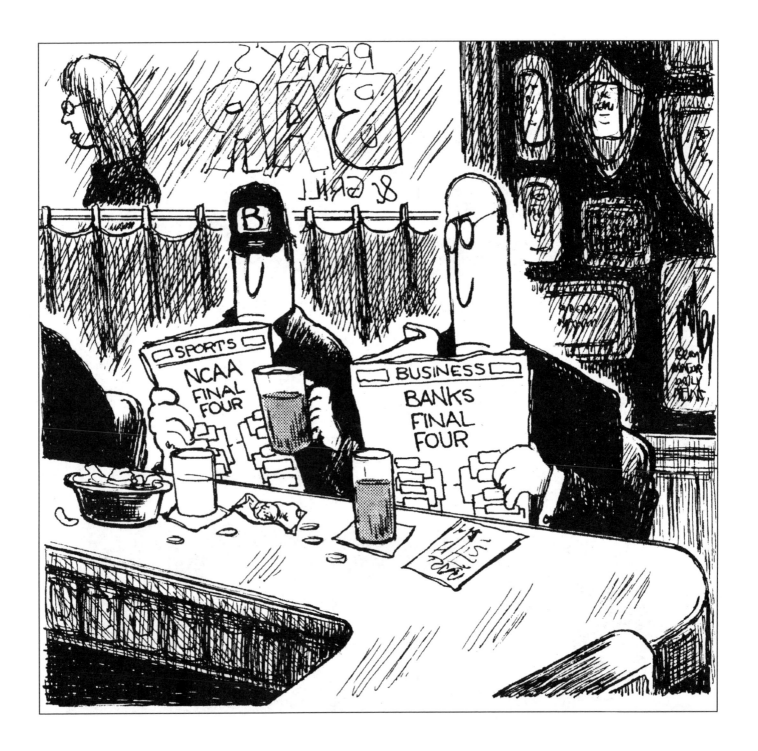

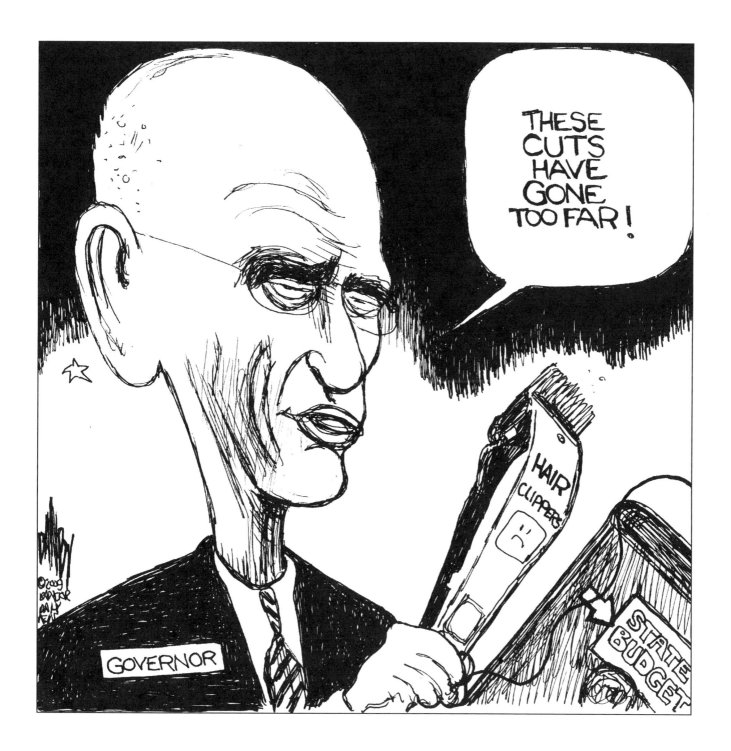

181

THE
2010s

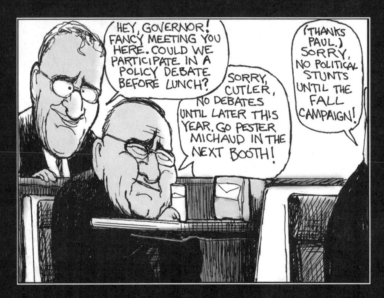

2010s

Paul LePage's run for governor in Maine and subsequent win during the 2010 gubernatorial election made daily deadlines very interesting. Some of my most creative cartoons in recent years were inspired by LePage's daily tirades. He made national headlines for telling the NAACP to "kiss my butt" and for threatening to tell President Obama to "go to hell." He also expressed his angst with news coverage, including the time he said he wanted to punch a news reporter, and when he suggested blowing up the *Portland Press Herald*. I've sketched LePage in many different cartoons, but the images in which he plays the crotchety Scrooge are a few of my favorites.

President Obama won his bid for reelection in 2012. During his second term, he enacted an affordable health-care law that has been dubbed Obamacare and set in place a plan to withdraw troops from Afghanistan by 2016. The economy made a slow recovery from the crash during 2007 and 2008. Gas prices hover at a hefty $4 per gallon (compared to the average around $1.80 back in 2008).

We communicate electronically these days. Facebook, a social network once unique to colleges, is now a place for people of all ages to connect. There are endless options for social media, including Twitter and Instagram, LinkedIn and Pinterest. You no longer meet the love of your life through your best friend; dating is now done online.

While the entire process of creating a daily newspaper has moved to digital formatting, my process of creating a cartoon has not changed. Of course my work has improved, but I continue to struggle with the limits of a daily deadline. There is very little time to rethink or re-draw a cartoon. I have to be just as observant as any reporter, except that my beat isn't just one segment of the news industry. I have to follow politics, local and national news, social trends and entertainment highlights. I keep a notebook with topics of interest to help generate ideas.

From ideas in the notebook, I start my daily cartoon by sketching small thumbnails—not unlike a writer typing notes and a first draft. Once I settle on the idea, I draw a 6.5-inch square on Bristol board and pencil in the sketch. I use a pen nib filled with India ink to go over the details and define the image. It takes me between one to three hours once I start using ink to complete the cartoon, depending on the composition and detail of the drawing. Once my work is done, I scan the drawing and send it to the layout crew to include in the printed paper and online.

When I draw an editorial cartoon, it is a commentary on one moment in time. However, the immediacy of the art form becomes woven into the context of history. This book, in its small way, is a celebration of an American art form and a commentary on the past forty years. Editorial cartoons are an American tradition. With all the changes over the years in technology and how information is communicated, the process of creating an editorial cartoon has remained the same.

This chapter contains some of my best daily cartoons. I hope you recognize the progression of my work over the years and enjoy the entire collection.

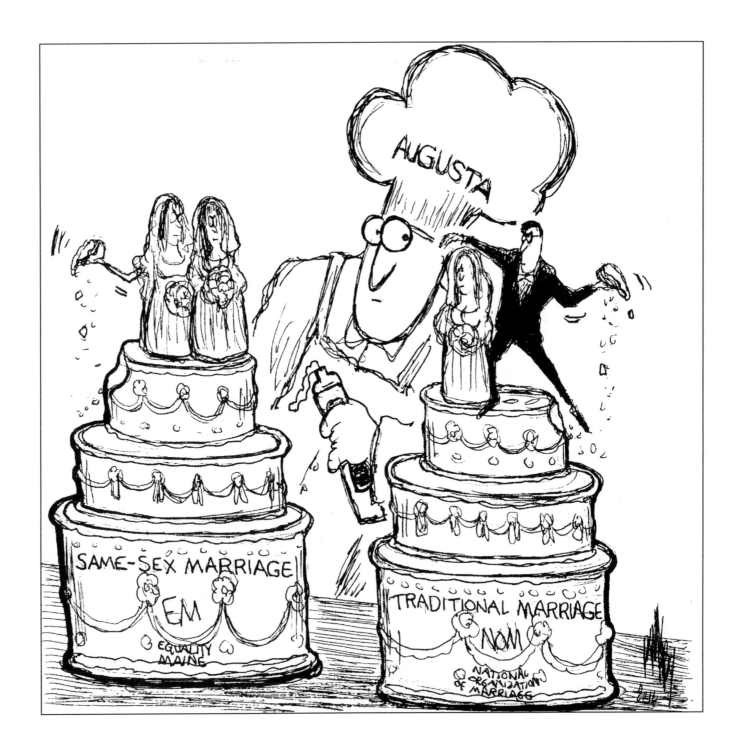

184

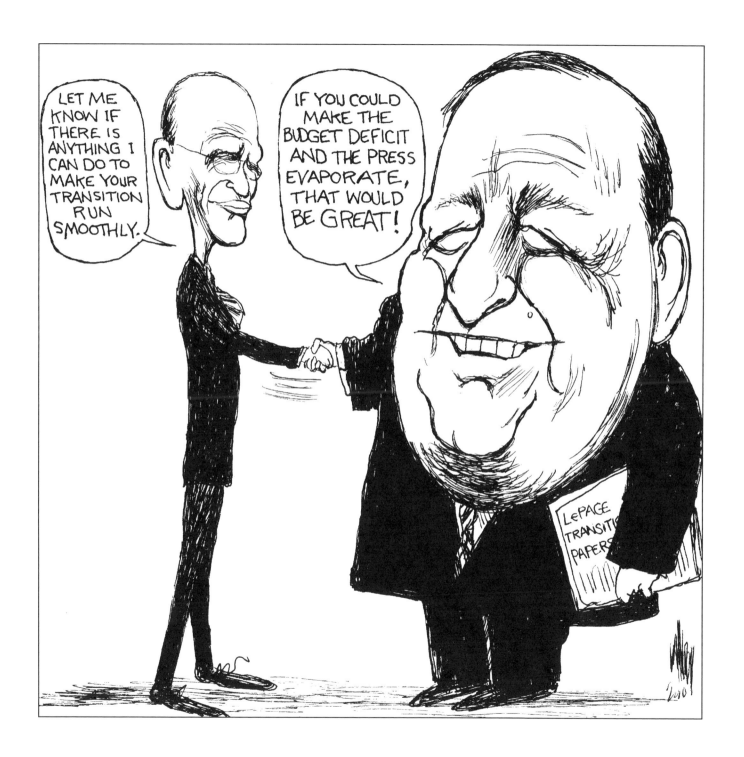

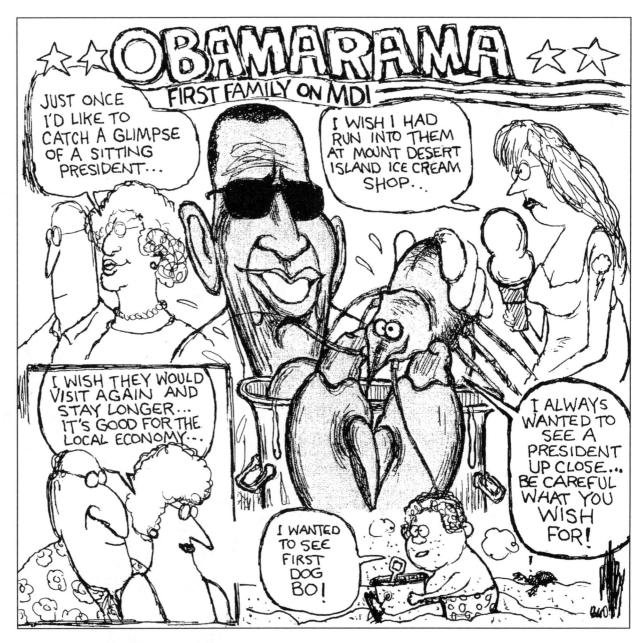

While on vacation, on MDI, the president decided to have ice cream at Mount Desert Ice Cream Shop. The original cartoon hangs on the wall in the shop; check it out when you visit Bar Harbor.

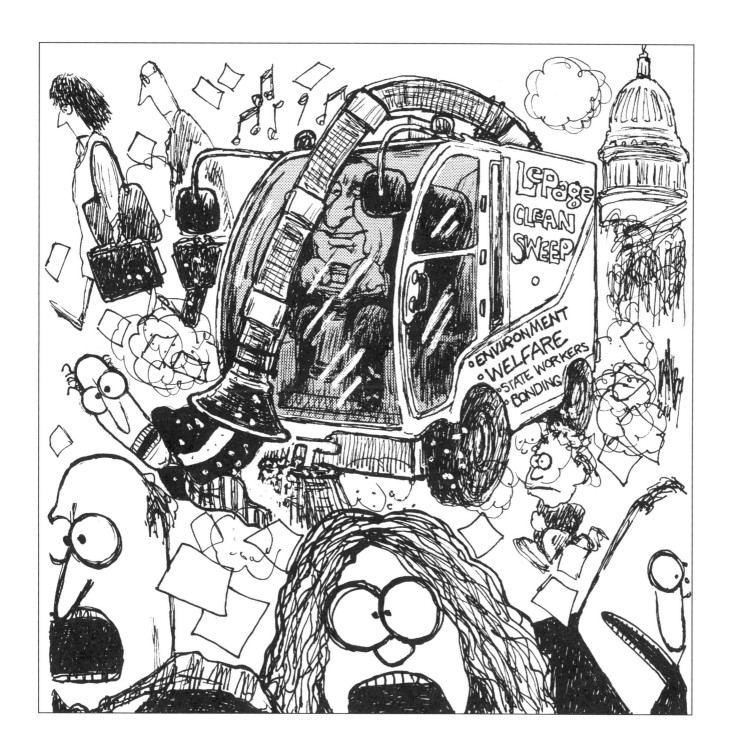

187

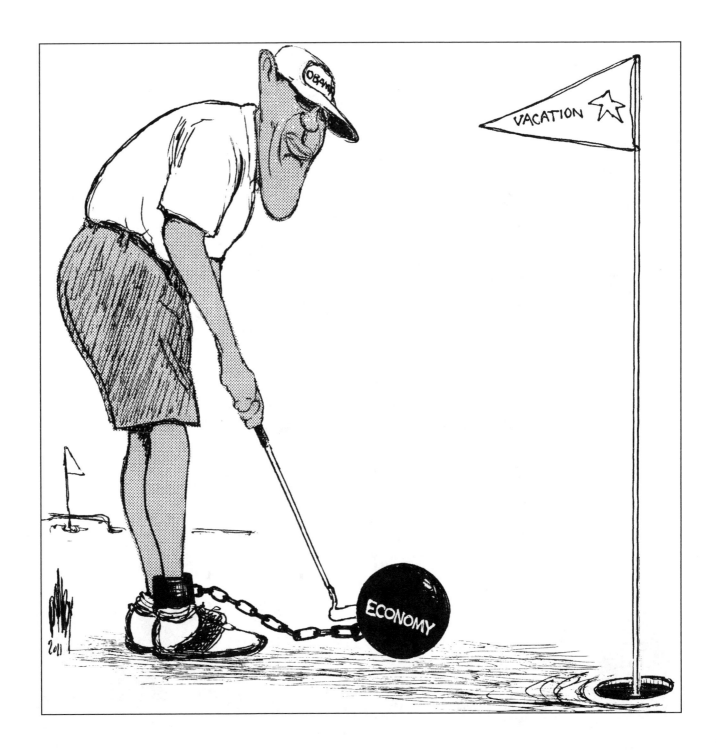

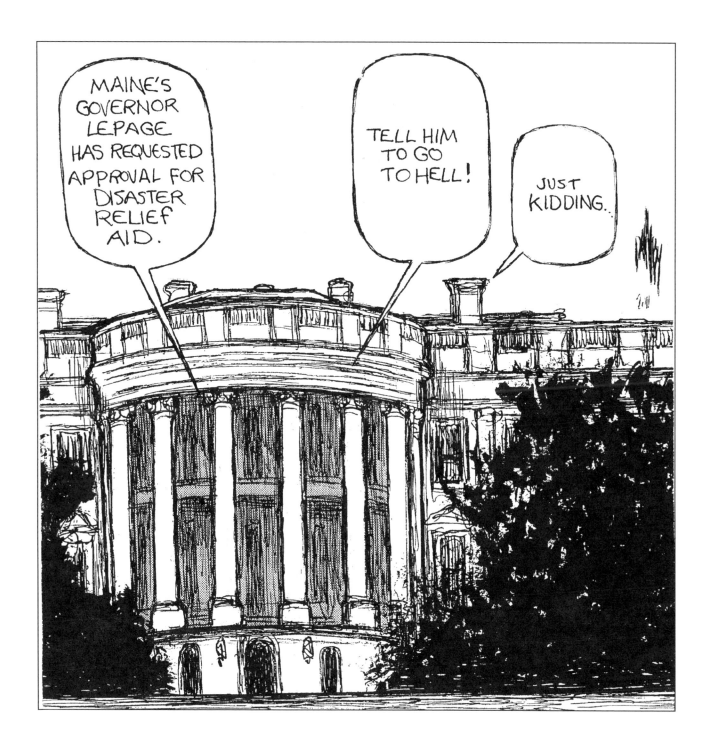

189

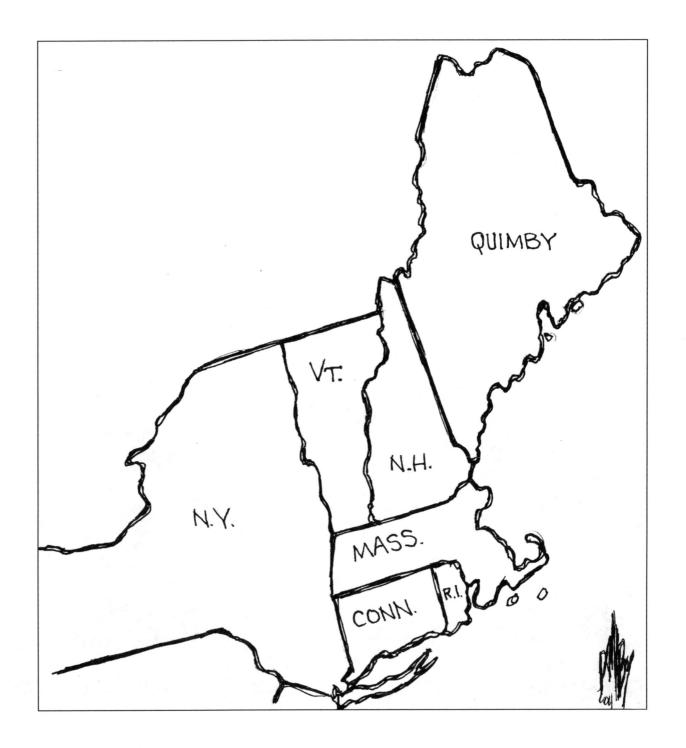

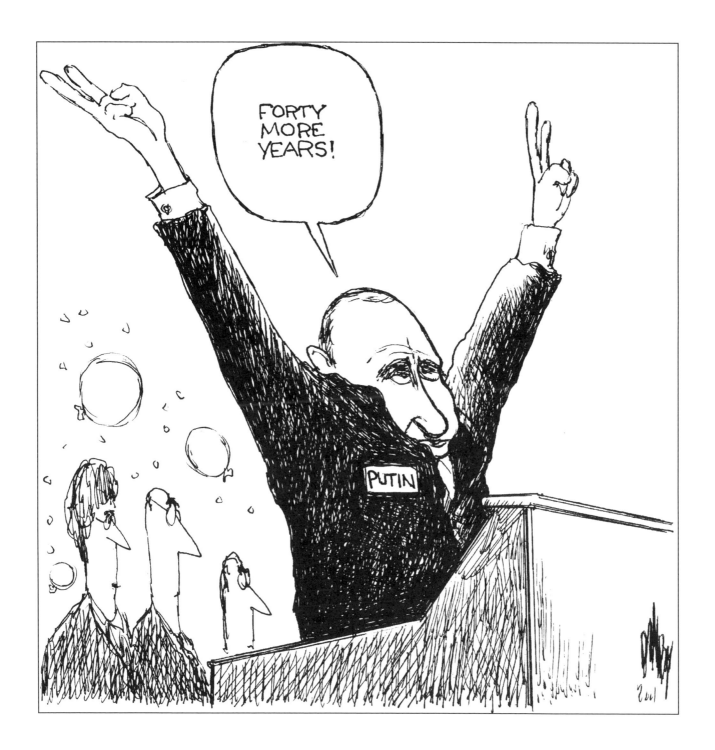

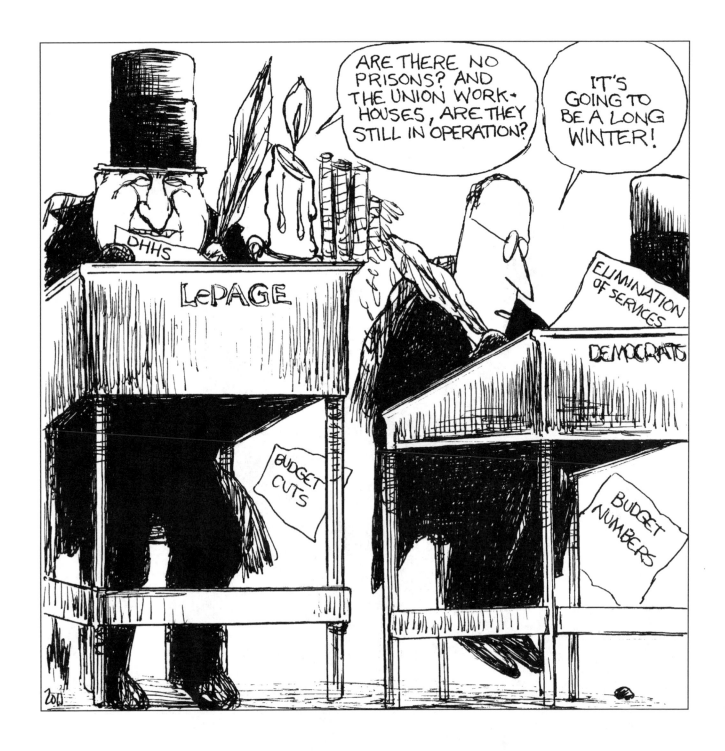

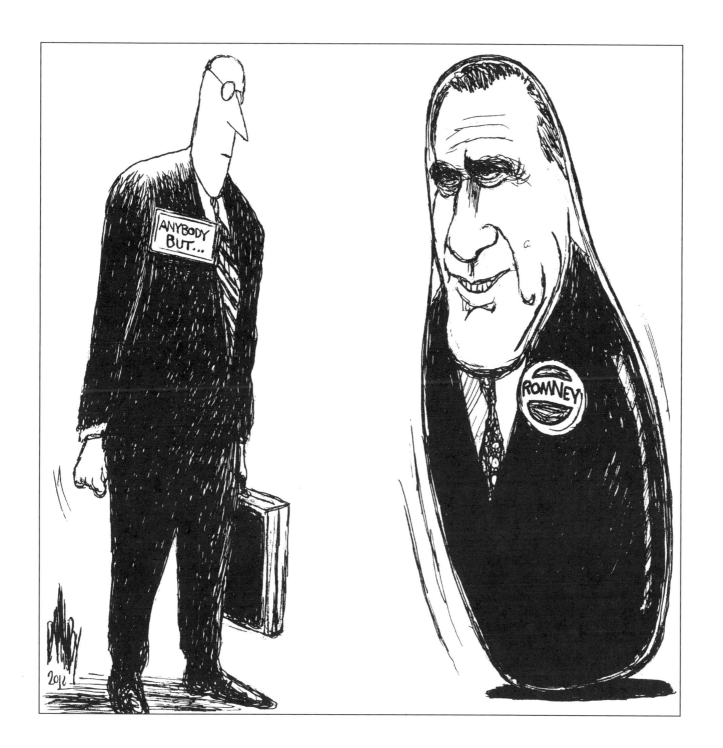

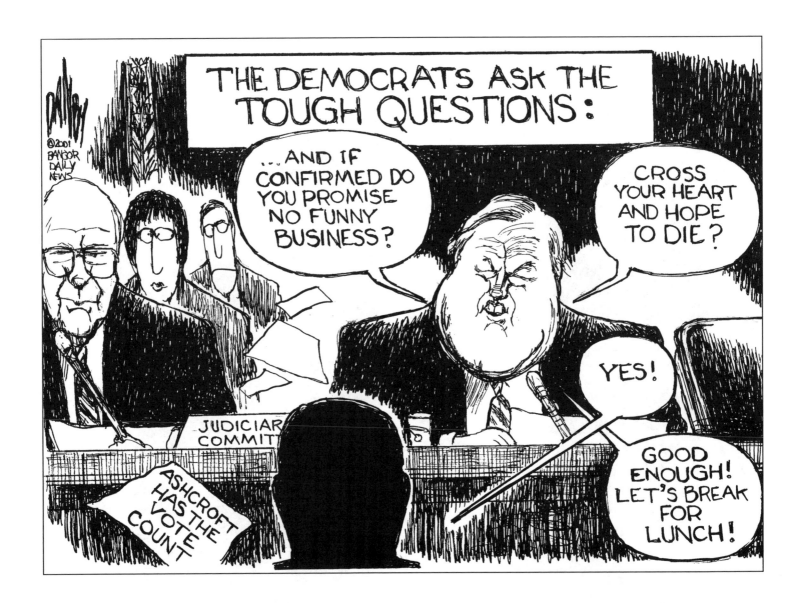

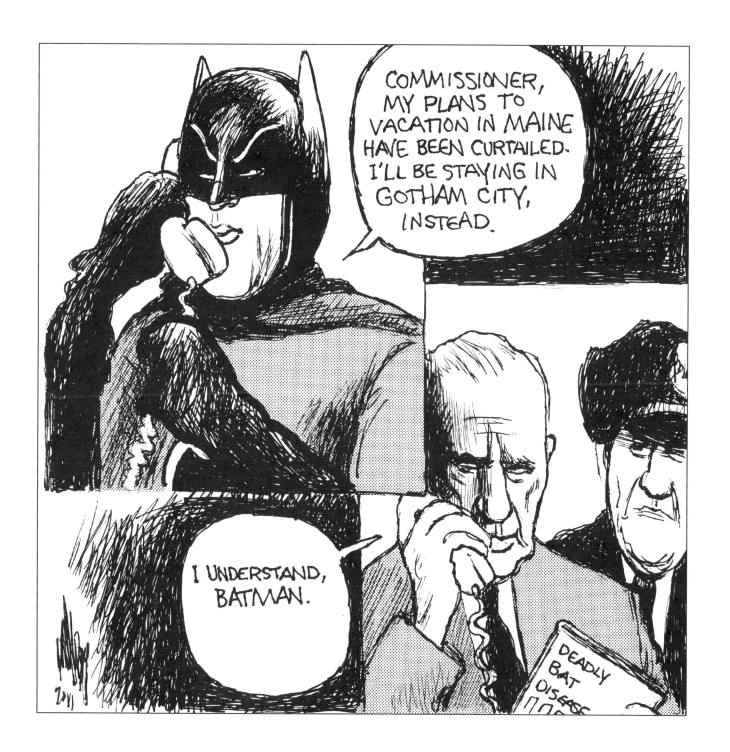

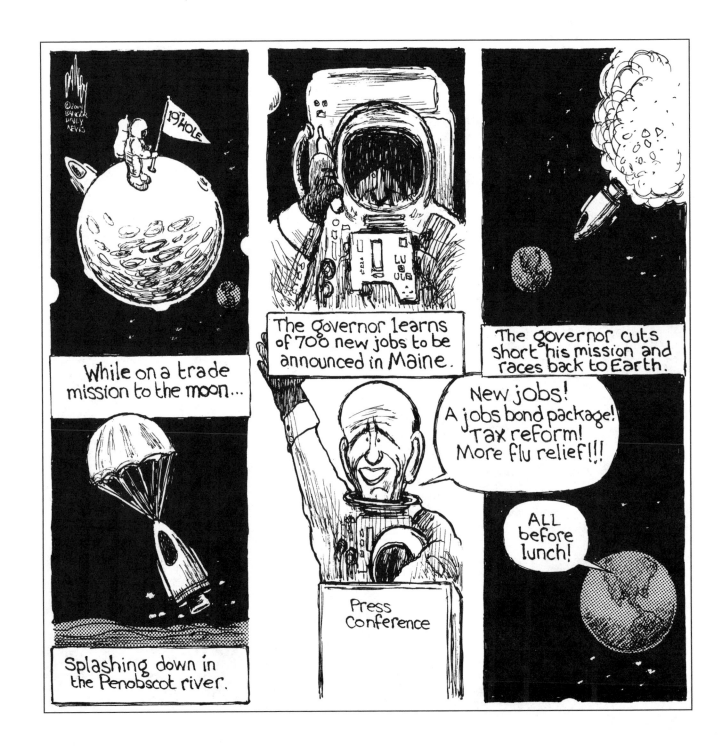

Bangor Daily News

Statewide edition

bangordailynews.com

Tuesday, April 1, 2014

Lawmakers, governor agree on revenue shortfall plan

Release bonds

LePage Signs Medicaid expansion bill

Weather: Sunny, Humid High 91

BDN PHOTO BY ROBAG ERGED

Gov. Paul LePage

April Fools

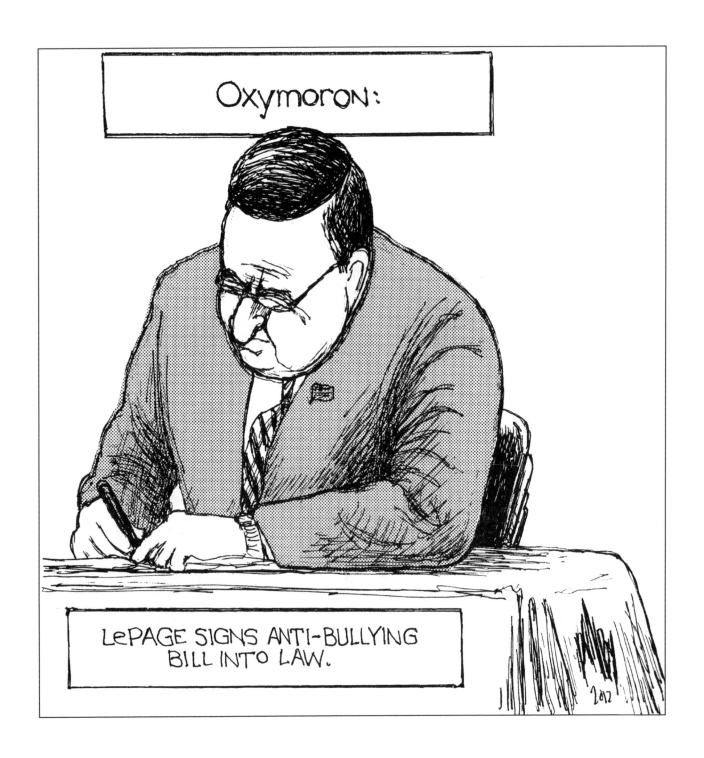

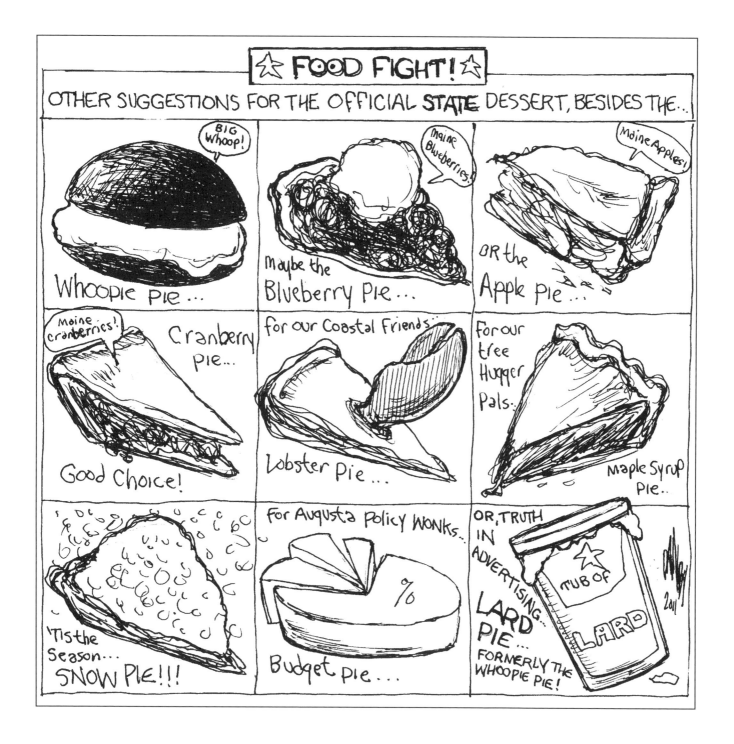

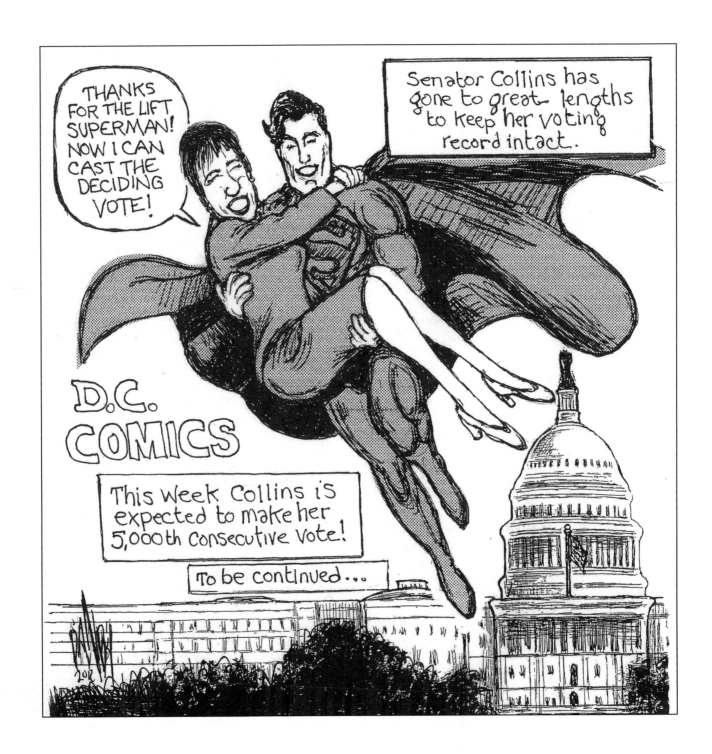

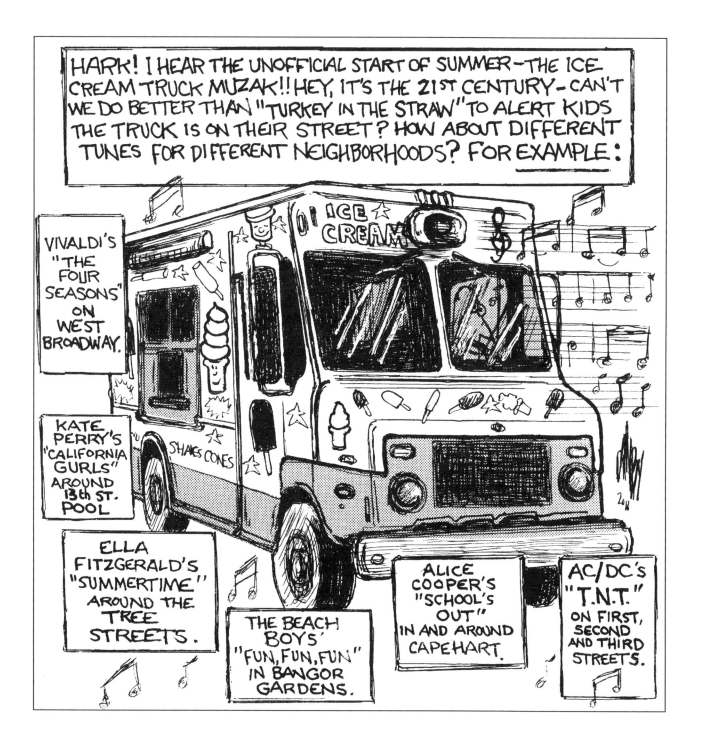

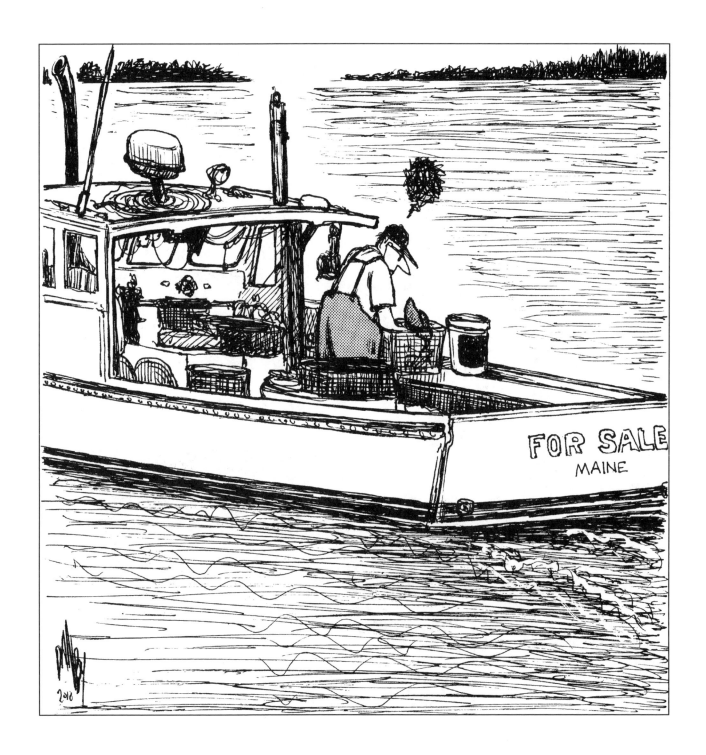

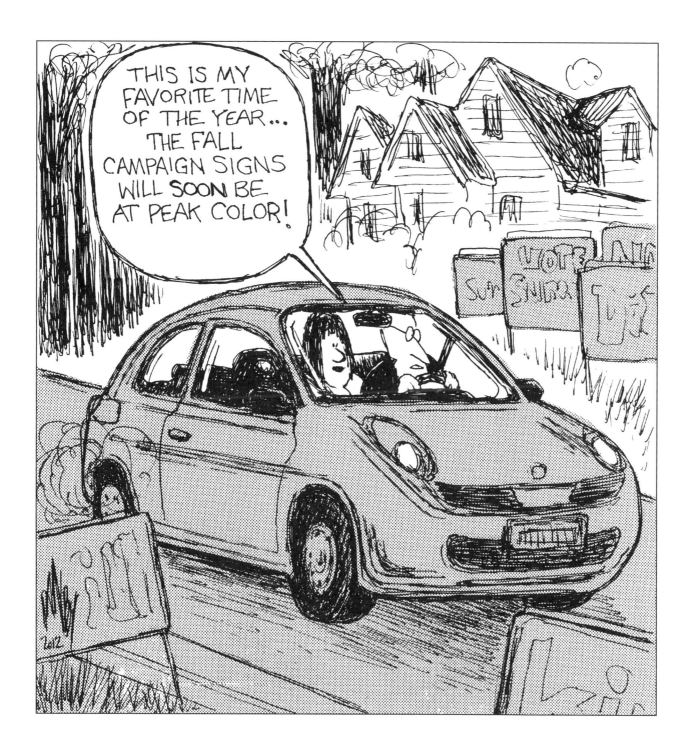

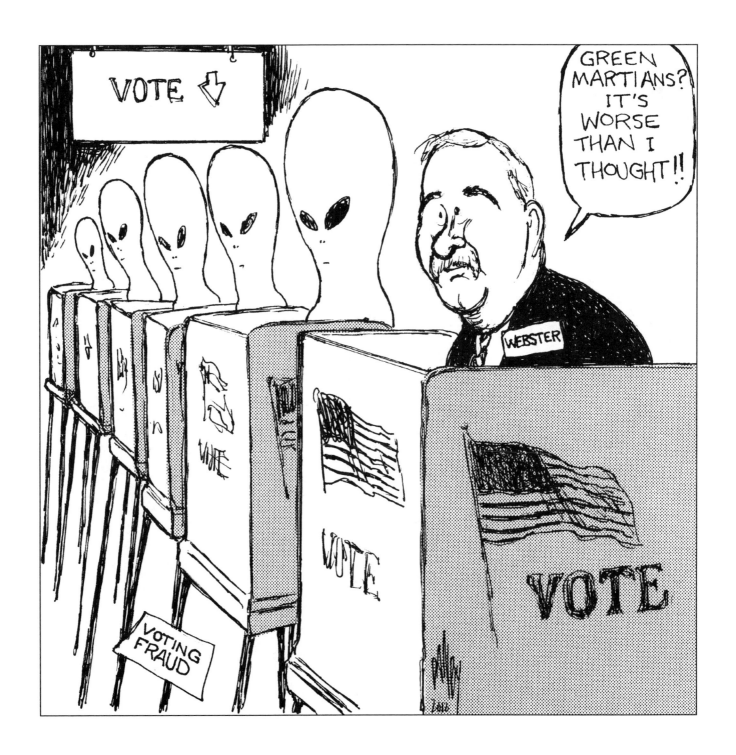

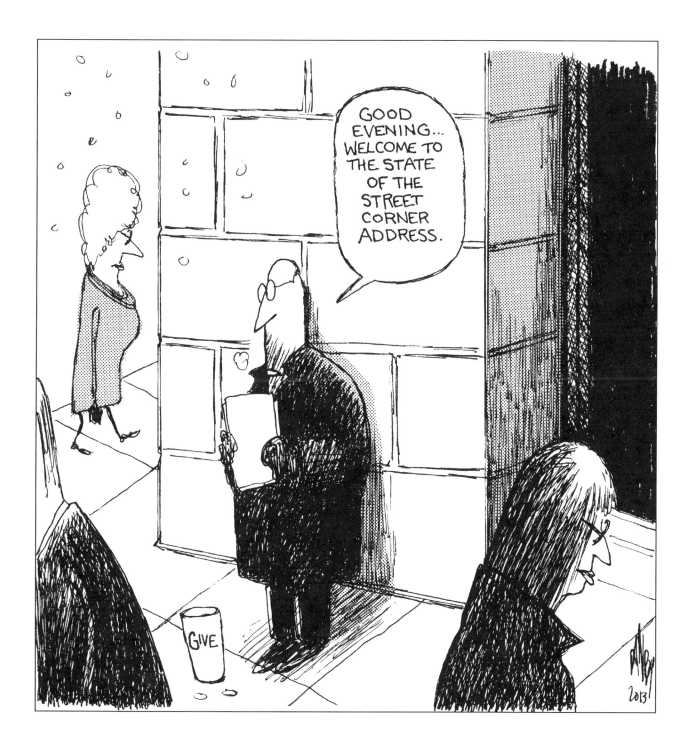

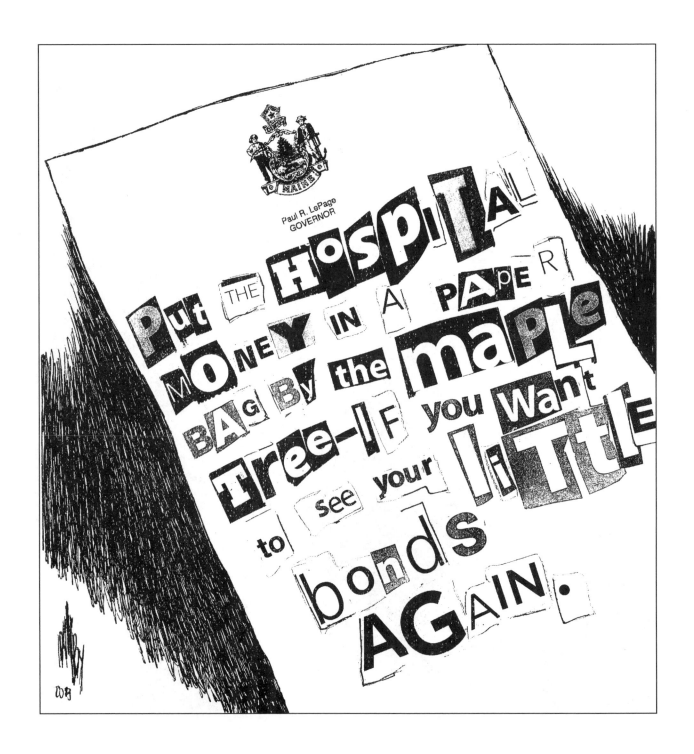

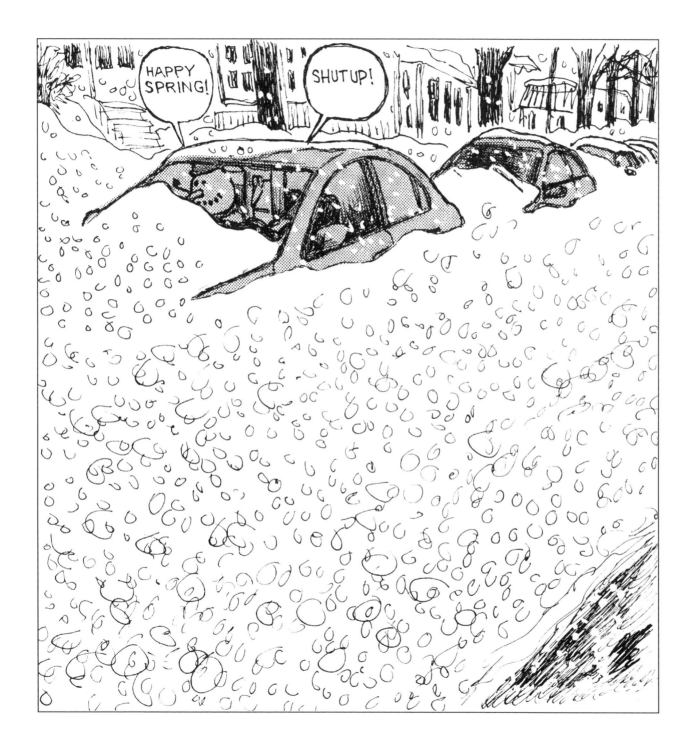

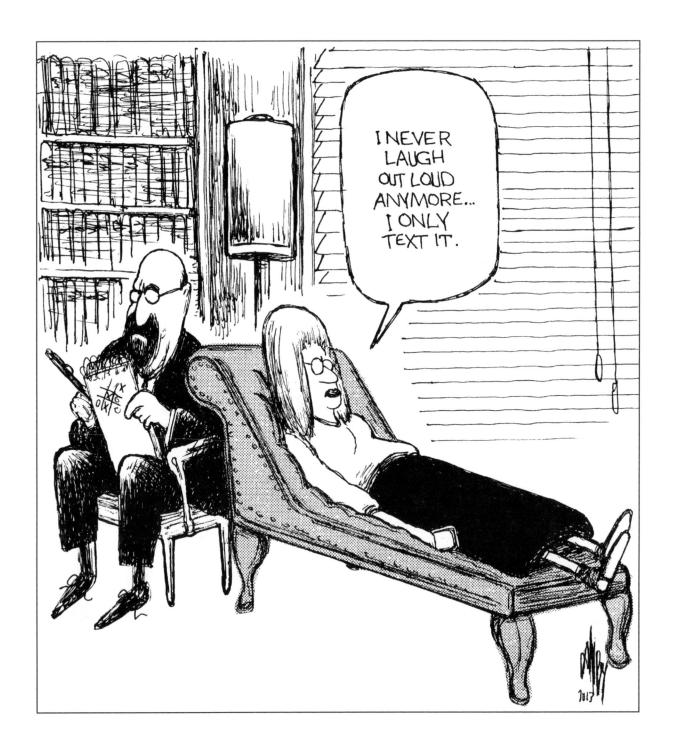

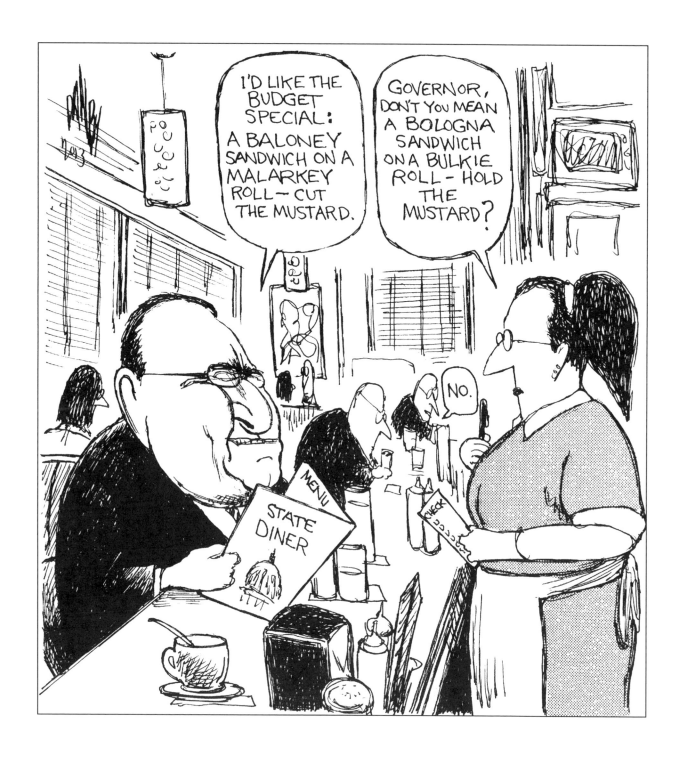

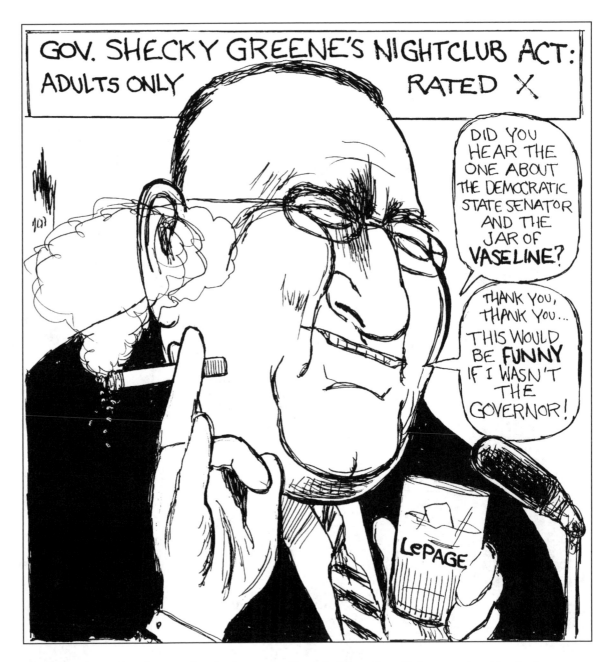

I really must take time to thank Governor Paul LePage for all the great satire he has provided me for cartoons over these last few years!

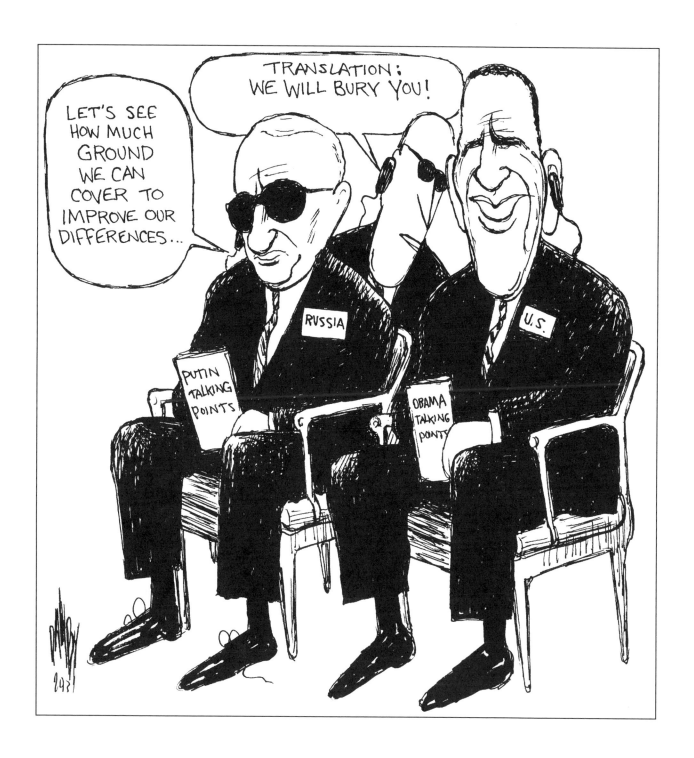

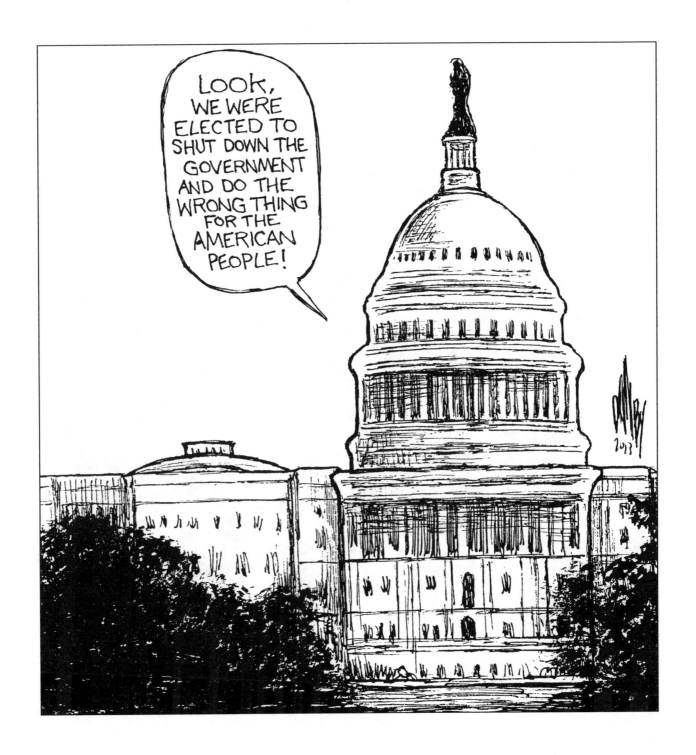

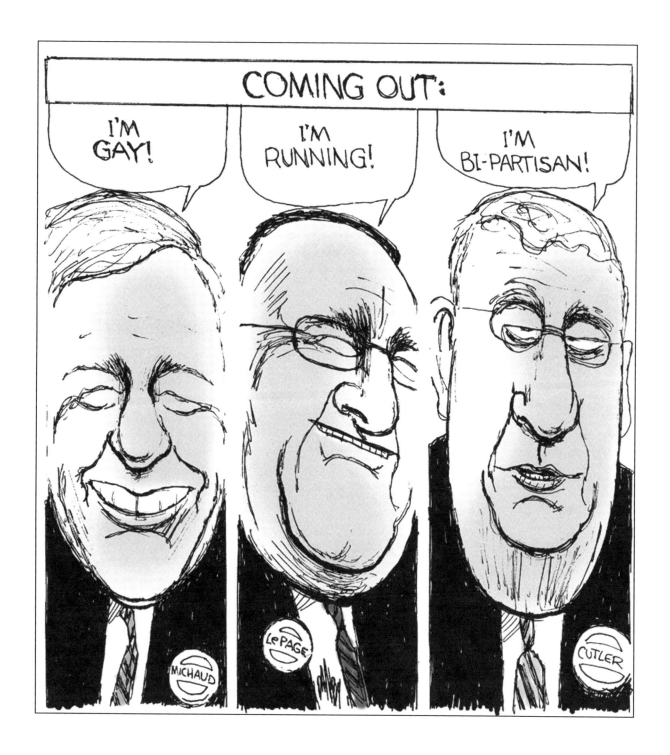

213

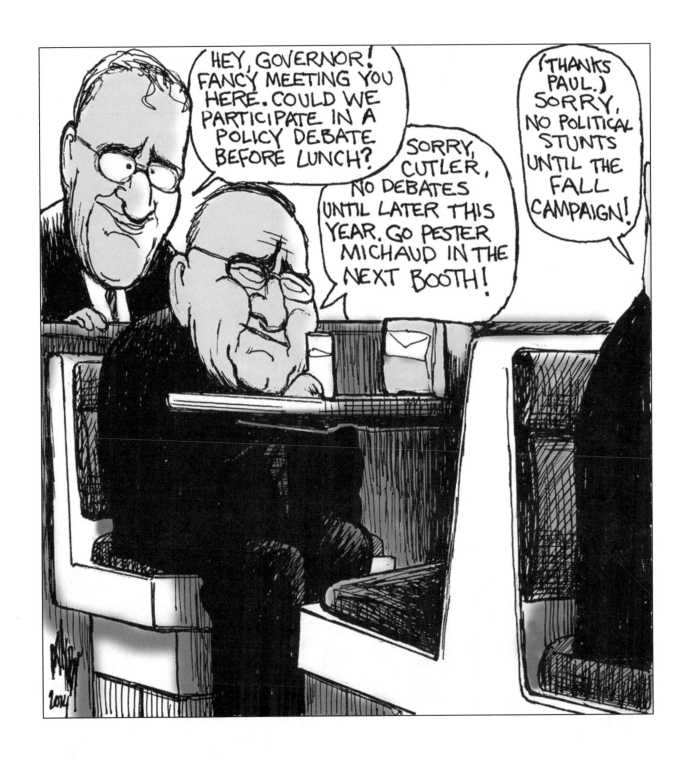

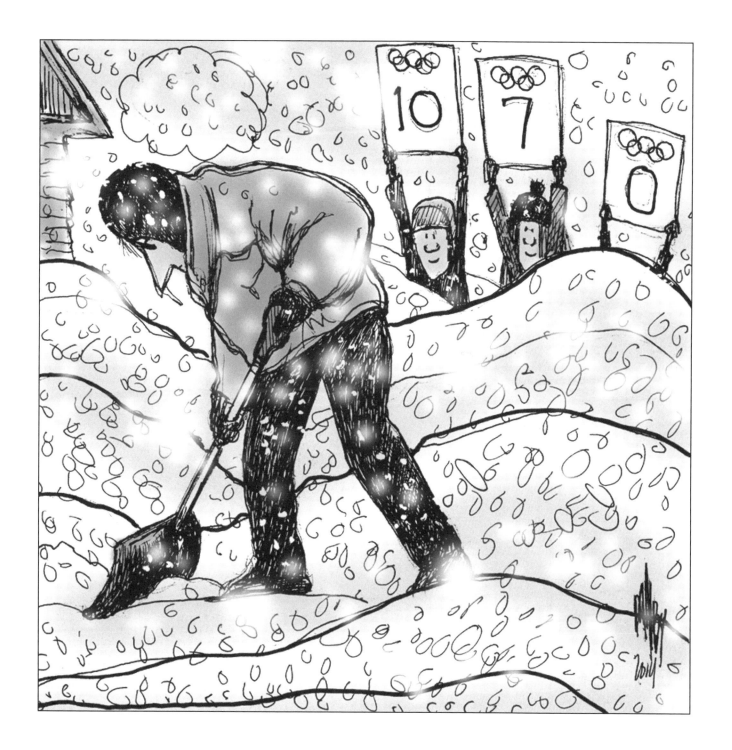

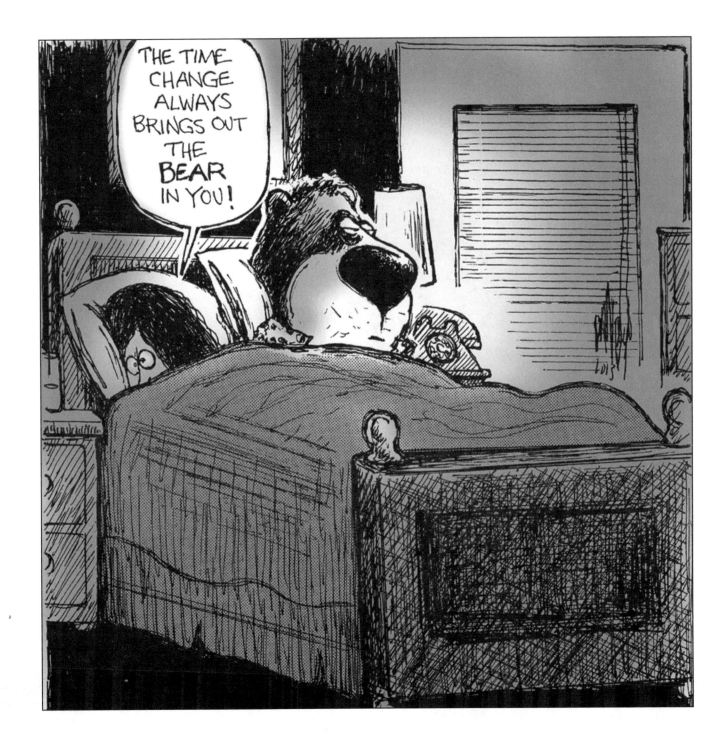

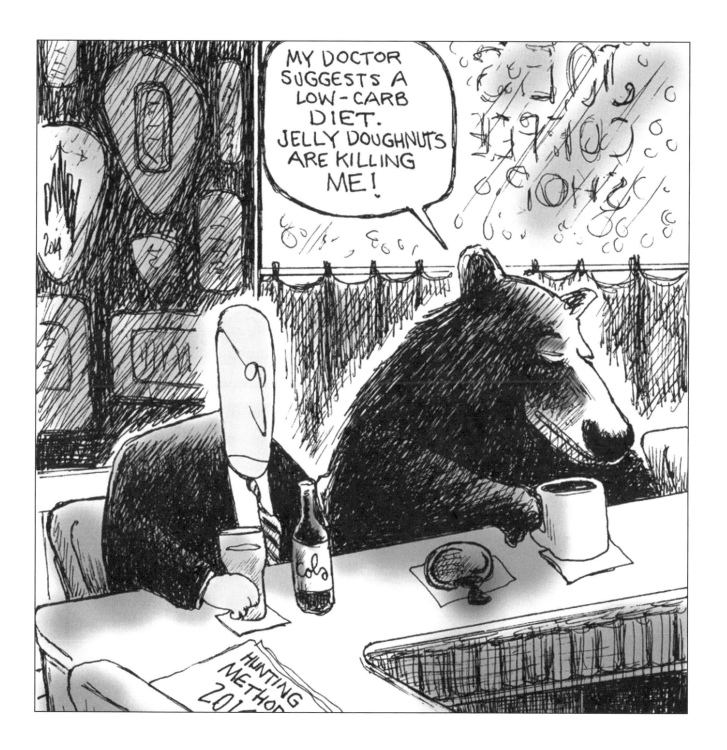

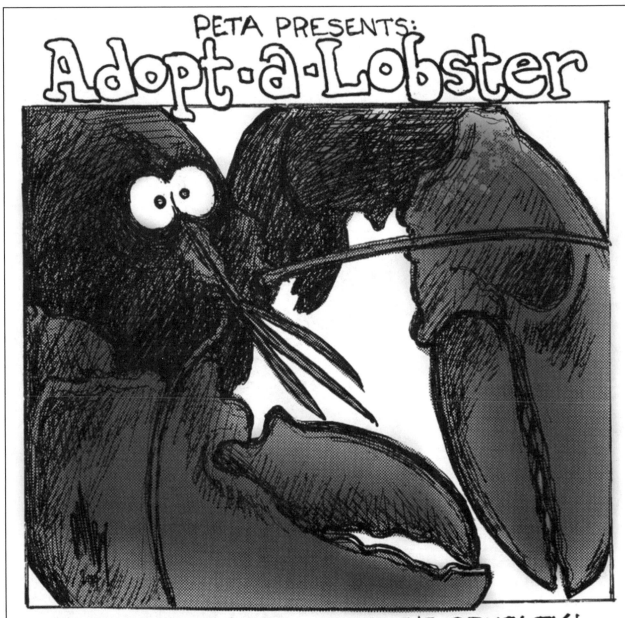

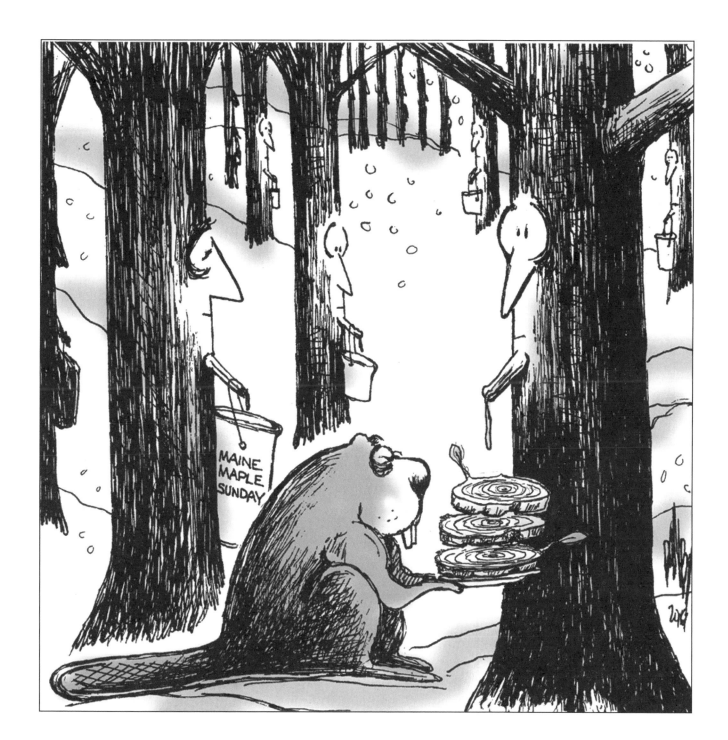

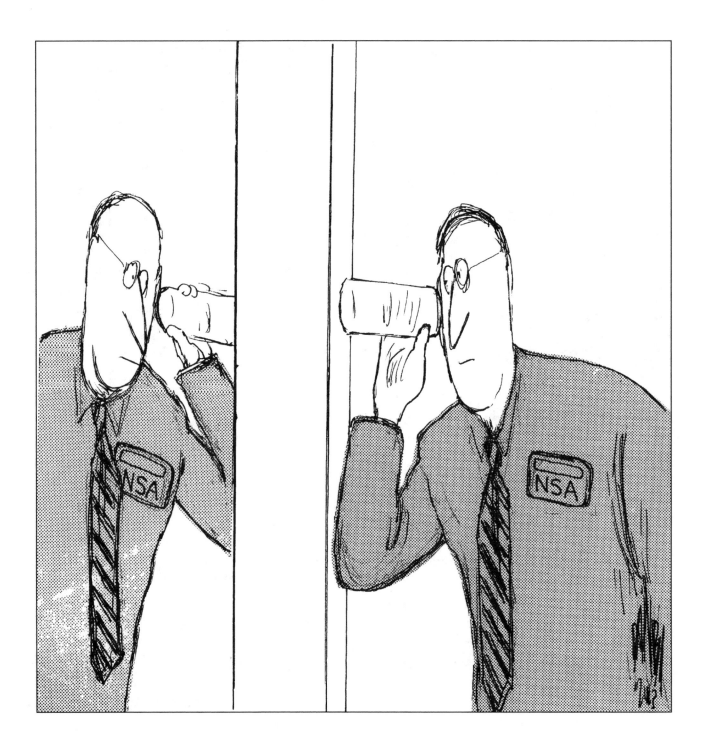

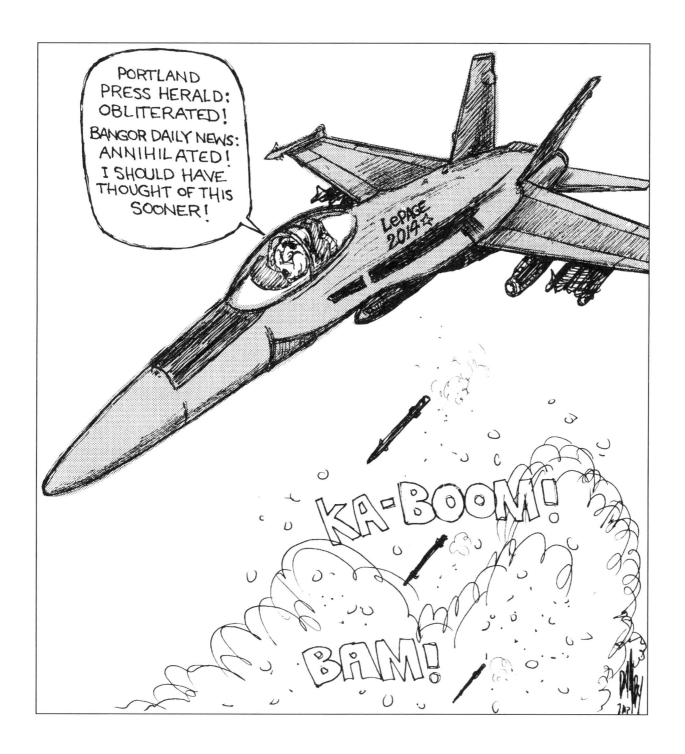

ABOUT THE AUTHOR

George Danby has been meeting a daily deadline and drawing and publishing cartoons since he was in high school. His first cartoons appeared in the *Providence Journal-Bulletin,* when Danby was fifteen years old. He worked at the *New Haven* (Conn.) *Register* and the *Providence Journal-Bulletin,* before joining the Bangor paper as its full-time cartoonist in 1988. Syndicated with McNaught Syndicate and Editors Press Service, Danby's work has appeared in *Time, Newsweek,* the *New York Times, USA Today,* the *Washington Post, Chicago Tribune,* and *National Review,* plus numerous weekly and daily newspapers. He has drawn more than 25,000 cartoons since 1974. Frankly, he's exhausted!

www.danbyink.com